MW00577234

POSSESSION

Erin L. Thompson

Possession

The Curious History

of Private Collectors from

Antiquity to the Present

Yale
UNIVERSITY
PRESS
NEW HAVEN & LONDON

Copyright © 2016 by Erin L. Thompson.
All rights reserved.
This book may not be reproduced, in whole or in part, including illustrations,
in any form (beyond that copying permitted by Sections 107 and 108 of the
U.S. Copyright Law and except by reviewers for the public press), without
written permission from the publishers.

Yale University Press books may be purchased in quantity for
educational, business, or promotional use. For information, please e-mail
sales.press@yale.edu (U.S. office) or sales@yaleup.co.uk (U.K. office).

Designed by Mary Valencia.
Set in Minion and Fournier types by Integrated Publishing Solutions.
Printed in the United States of America.

ISBN: 978-0-300-20852-8 (hardback : alk. paper)
Library of Congress Control Number: 2015954819
A catalogue record for this book is available from the British Library.

This paper meets the requirements of ANSI/NISO Z39.48–1992
(Permanence of Paper).

10 9 8 7 6 5 4 3 2 1

CONTENTS

ACKNOWLEDGMENTS

T hank you to my colleagues at the City University of New York for supporting this project with a research grant and, more importantly, through discussion and encouragement. Thank you to the librarians in the Lloyd Sealy Library at John Jay College for working tirelessly to field my endless interlibrary loan requests. Thank you to my research assistant, Emogene Cataldo, for mastery of microfiche. A very large thank you to Adrienne Mayor for suggesting that a paper she heard might deserve to be a book, and to Sandy Dijkstra, the fabulous agent we now share. Thank you to my editors at Yale University Press, Eric Brandt and Steve Wasserman. I would also like to thank the Paul Mellon Centre for Studies in British Art, the New York Public Library, the British Museum, the Tate Britain, Columbia University's Avery Library, Cambridge University's Fitzwilliam Museum, the Merseyside Museum, Liverpool, Musée du Louvre, and The J. Paul Getty Museum, sources of invaluable information on collecting and collectors. Thank you to Sara and Noah, for reading drafts, feeding me dinners, and tolerating my tendency to discuss the minutia of eighteenth-century export laws at said dinners. And thank you to Ashur, who can truly say, as Montaigne claimed, "I was familiar with the affairs of Rome long before I was with those of my own house."

Introduction

C ollecting is a curious behavior. Almost everyone has formed a collection, however small. Especially as children, we accumulate objects whose uselessness is rivaled only by the fascination we feel while sorting, touching, and contemplating them: seashells, rocks, ticket stubs. There are collectors for every category of object, natural and artificial, from Fabergé eggs to nail clippings. We find such collections throughout human history, and beyond humankind as well—certain animals also form collections.

And yet, for all its universality, the collecting impulse is surprisingly little studied or understood. We know more about the motivations of bower birds than human collectors. Male bower birds collect twigs, pebbles, flowers, and other brightly colored accoutrements to build a "bower" structure around their nest site. They happily seize on and use some of the items, such as film canisters, discarded by naturalists who observe them. They indignantly remove other items that meddling naturalists add to their bowers in their absence if they do not fit with what is evidently a strict decorative scheme. Female bower birds tour nesting sites and select their mates based on their bowers. The ways of human collectors, by contrast, are much more mysterious. The attraction of mates is hardly the usual result.

This book studies the motivations and self-perceptions of those who have formed private collections of Greek and Roman antiquities. Although I cover the history of the subject, starting with the Romans, who were the first to covet and display Greek masterpieces

in their homes, my reason for writing is a contemporary one. Investigating the motives of antiquities collectors can help stop the ongoing looting and destruction of archeological sites that currently supplies the market for collectible antiquities. A remarkably consistent set of motivations and beliefs has driven antiquities collectors throughout history. We must understand these motivations and beliefs so that they can be rechanneled into behaviors that will provide collectors with what they crave without putting the heritage of the world as a whole at risk.

In this book, the term "collectors" means those who form private collections of antiquities, excluding artists, scholars, dealers, or those collecting for public museums other than museums they themselves plan to found. "Antiquities" describes works of art produced by the ancient Greeks and Romans and found within the modern boundaries of Greece and Italy. These are artificial limits; similar stories could be told about artifacts from elsewhere in the Greek and Roman world.

Certain aspects of the history of the collecting of antiquities have received much scholarly attention. Thanks to inventory lists, household expense records, architectural plans, and other archival records, we know many practical facts about most major private collections of antiquities: how much collectors paid for them, from whom they purchased them, where in their homes or private museums they displayed them. Yet, answering the questions of who, when, and where brings us very little closer to answering the question of why.

Part of the reason that we have made so little progress here is that observers of collecting have been unusually consistent in assuming that they already know the answer. Antiquities collectors, you will read in many a scholarly text, collect out of a desire for social prestige and have little true appreciation for the beauties of what they own. This analysis is reductionist, dismissive, and not sufficient—it does not explain, for instance, why the collector acquires antiquities and not real estate or horses or contemporary art, all of which could also display social prestige. And this scholarly perspective is not that far

removed from the satirical criticisms levied against collectors since Roman times, which paint them as greedy, effeminate, stupid, uncultured, arriviste, sexually incontinent, or all of the above.

So, what does motivate the collector? Finding out is crucial, because collections can shape our perception of the world, knowledge of its past, and course of its future. Fortunately, collectors themselves have left us plenty of information to help explain what turn out to be very complex motivations. For example, J. Paul Getty, who made himself a billionaire through investments in oil and spent large portions of this fortune on art, including antiquities, wrote and spoke extensively about his reasons for collecting—which included a belief that he was a reincarnation of the emperor Hadrian. From Romans writing letters about their worries that they may have been fooled by forgeries of Greek art, to medieval churchmen chronicling their cautious admiration of the suspect beauties of a statue of Venus, to Enlightenment noblemen posing with their prized collections for portraits, to contemporary collectors dictating heartfelt introductions to exhibitions of their collections, there are many other instances of collectors speaking for themselves. This book is the first to collect and analyze these records, as found in collectors' letters, memoirs, diaries, catalogues of collections, and other publications and archival records.

The study of collectors' self-perceptions requires some caution. Those who are inclined to believe that collectors' true motivation is social prestige will likely claim that any other explanations offered by collectors are false defenses intended to cover up the unflattering true causes of their behavior. I have taken collectors' writings with many grains of salt, for example, distrusting those collectors who describe one set of motivations but whose actual purchases and other behaviors contradict their statements. I rely on texts, such as letters to dealers and other collectors, in which collectors have little need to disguise their motivations. I also avoided retelling anecdotes about collectors of the type described by the Italians as *se non è vero, è ben trovato,* on the theory that such colorful stories, unless verified by

the collector himself, are likely to be inventions. Following the same principle, I have not relied unquestioningly on the descriptions of collectors' motivations posited by biographers or curators writing introductions to exhibits of private collections. Flattery often has too much free play in such compositions.

Regrettably but necessarily, this reliance on collectors' own words leaves out the many collectors whose voices left no record. Freud, for example, had a study crammed with small antiquities, and wrote that he had "actually read more archeology than psychology."[1] Freud traveled with a selection of antiquities: "my old and grubby gods . . . [who] take part in the work as paperweights for my manuscripts."[2] Yet, Freud never wrote more than brief mentions of his antiquities and never analyzed his own reasons for collecting.[3]

The book proceeds both chronologically and thematically, examining the history of collecting from the Romans who took Greek art as spoils of war, to the eighteenth-century Grand Tourists who accumulated life-sized souvenirs of their travels, to the contemporary collectors who pay millions of dollars for pieces of the past. The first chapters focus on different types of uses to which collectors have put their collected antiquities, explaining how these uses have both literally and figuratively shaped our understanding of the ancient world. The concluding chapters then look at where collectors get antiquities, arguing that the enormous prices that collectors pay spur looting on such an unprecedented scale that it threatens to obliterate the past.

The history of the private collecting of antiquities has forged a strong yet paradoxical link between the exaltation and the destruction of ancient art. This book will ask if this link can ever be broken.

I

CHAPTER

The Powers and Perils
of the Antique
The Birth of Collecting

Collectors and their critics have always believed that classical
art has special powers: to legitimate rule, to create identi-
ties, to express wealth, to enervate warriors, or to possess the
collector—either metaphorically or literally—with the spirit of the
past. From the first, collectors of Greek art were eager to capture the
essence of the Greeks along with the physical remains of their culture.

The Attalid dynasty is the first example of this type of collecting.[1]
The kingdom was founded upon an act of treason. After the death of
Alexander the Great, one of his generals left a treasure of 9,000 tal-
ents in the care of his treasurer Philetaerus in the small but strongly
defended hilltop town of Pergamum, on the southern coast of mod-
ern-day Turkey. Philetaerus promptly betrayed his master. He locked
the town gates and used the treasure to establish his own kingdom.
Although a eunuch, Philetaerus founded a dynasty by leaving the
kingdom to his nephew, Eumenes.

Attalus I, who inherited the kingdom from Eumenes in 241 BCE,
made the kingdom great by means of a strategic alliance with the
growing superpower of Rome. He and his son, Eumenes II, worked
hard to ensure their dynasty's place in history with large art com-
missions, such as the Great Altar of Pergamum, now in Berlin. Less
well known but just as important were their efforts to acquire as

many artworks as possible from the high period of Greek art. They displayed these works, already several centuries old, in monumental palace, library, and religious complexes.

They acquired antiquities by various means. Attalus I purchased the art-rich island of Aegina, which lies just off of the Greek mainland, and then denuded its towns and sanctuaries of artistic masterpieces to decorate Pergamum.[2] He also took advantage of the relative disinterest of the Romans of that period in art. When the Pergamese and the Romans engaged in joint operations, such as the conquest of the Euboen town of Oreus, Attalus I claimed artworks as his share of the spoils.[3] He also purchased other works, including statues by the famous Greek artists Myron and Praxiteles, a painting by Apollodorus, and a group of the Graces from the late sixth century BCE by the sculptor Bupalus, which the traveler and art historian Pausanias records as placed "in the bedroom of King Attalus."

The Attalids emphasized their appreciation of Greek art because they needed to appear to be Greek. They wanted to appear to be legitimate successors to Alexander the Great, who had first conquered the territory they claimed. Alexander died young and unexpectedly, leaving a power vacuum in the vast extent of the known world he had conquered. Alexander's generals divided up the territory, founding the Hellenistic kingdoms that would rule until subsumed by the Romans.

The most powerful Hellenistic kingdoms were those of the Seleucids, who ruled much of Asia Minor; the Antigonids, who claimed Macedonia and much of Greece; and the Ptolemies, who controlled Egypt. Each of these was a true dynasty, with their rulers descended from the founding general. Subsequent rulers could thus justify their continued rule over the native populations by their connection to Alexander the Great, whose legend continued to inspire awe for centuries. Maintaining proper bloodlines was so important to the Ptolemies that their kings routinely married their sisters so as to not introduce foreign ancestry. Cleopatra, the last of the Ptolomaic rulers of Egypt before their full conquest by the Romans, was married to not just

one but two of her brothers, in succession (although she had time for affairs with Julius Caesar and Mark Antony as well).

By contrast to the scrupulously maintained biological inheritance of the other Hellenistic kingdoms, the Attalids drew their power from theft and betrayal. But to acknowledge this was to admit that anyone else with enough cunning could overthrow their reign at any time. Thus, the Attalids sought to justify their rule by connecting themselves with the legacy and aura of Alexander the Great, though they were not descended from an Alexandrian general. Their efforts to appear to be connected with the Greek culture promulgated by Alexander were thus far greater than those of the other Hellenistic kingdoms with their assured dynasties.

The Attalids are the first example of collectors crafting an identity through the acquisition and display of Greek antiquities. They set a powerful example for subsequent collectors, including their conquerors, the Romans. At first made more powerful by their alliance with Rome, the Attalids soon learned that they could not maintain their own identity within the grasp of this far-reaching partner. Seeking the least destructive option, Attalus III left the kingdom to the Roman Senate when he died in 133 BCE. The kingdom was no more. In swallowing it, Rome took in the seeds of a collecting identity as well.

Given the ultimate scope and sophistication of its empire, it is difficult to imagine just how provincial and small the city of Rome was when it first began its conquests. Its first soldiers were farmers and shepherds when they were not on the battlefield. These early Romans may have caught glimpses of the artworks decorating the homes and temples of their more cultured neighbors, the Etruscans. But Rome's early archeological record shows very little effort to create artworks of their own. The first major artworks in Rome were Greek—masterpieces that came as war booty from conquered territories.[4]

Ancient Roman writers generally pointed to either M. Curius Dentatus's triumph after the Pyrrhic War in 275 BCE or M. Claudius Marcellus's celebration of his conquest of Syracuse and other Sicilian

cities in 211 BCE as the first appearance of Greek art in Rome. Lucius Mummius's victory over Corinth was also thought to be important. When this general was auctioning off the captured property, Attalus II bid 100 talents for a painting by the Greek old master Aristides. Astonished that a mere painting, one that his soldiers had been using as a dice table, could be so valuable, Mummius withdrew it from the sale and dedicated it in a temple in Rome.[5]

Roman generals added seized artworks to the triumphal processions that wound through the city of Rome to celebrate their victories. The numbers of works on display could be impressive. The historian Livy claims that the procession celebrating M. Fulvius Nobilior's triumph over Ambracia in 189 BCE included 785 bronze statues and 230 marble statues.[6] Such processions usually also included the captive rulers of the conquered territories, able to contemplate their treasures one last time before being executed at the end of the celebration. One sees why Attalus III was content to promise his kingdom to the Romans rather than risk the chance of ending his days bound in a wagon and carted off to Rome along with his family's marbles and bronzes.

Exactly what happened to artworks after the processions is less clear. Probably the general who had held the supreme command in the campaign disposed of all seized property, including artworks, as he wished. Generals usually dedicated some artworks to the gods by depositing them in temples in Rome and then divided the remainder among their soldiers as rewards.[7] The soldiers could then sell the artworks, making them available to the Roman public.

Some dedications were very large, as when M. Fulvius Flaccus dedicated 2,000 statues in the Temple of Mater Matuta after his conquest of Falerii in 264 BCE.[8] Generals were especially likely to dedicate seized cult images of the gods in an appropriate temple, to placate the deity for conquering a city presumed to be under his or her protection. The Romans had a special ritual, *evocatio,* to ask permission from deities to transfer their cult images, and thus their patronage and protection, from conquered cities to Rome.[9]

Generals could also add inscriptions to the artworks they dedicated. After conquering Praeneste and eight surrounding allied towns in 379 BCE, T. Quinctius Cincinatus set up a statue of Jupiter Imperator from Praeneste on the Capitol in Rome with the inscription "Jupiter and all the gods granted that Titus Quinctius . . . captured nine towns."[10] The statue was made to speak in the service of the victorious general, ensuring that his reputation would survive as long as the statue remained an impressive object on public view. Another underlying message of such inscriptions was that the gods, having transferred their allegiance from the creators of their statues to the Romans, preferred to be possessed by the Romans.

Despite the importance of the public display of conquered artworks in triumphs and temples, early Roman generals rarely retained significant amounts of art for their private collections. The famed generals L. Cornelius Scipio Asiaticus, T. Quinctius Flaminius, and Lucius Mummius had no paintings or statues in their homes, though they brought back many wagons-full for their triumphs, and M. Aemilius Pallus took nothing from his conquest of Perseus in 167 BCE except a single silver cup and some books.[11] Fabius Maximus, after capturing Tarentum in 209 BCE, went further. He took no art for his triumph, saying, "Let us leave their angry gods to the Tarentines."[12] The few early commanders who were thought to have taken an undue share of art for their private benefit were criticized or sometimes prosecuted for illegal appropriation.[13]

But such moderation did not last. Neither the generals nor the other Romans who were able to buy the artworks for sale in the wake of conquests were able to resist possessing Greek art for long. The Greeks, of course, were the first to form private collections of Greek art. But the Romans were the first culture in which there was widespread private collecting of Greek artworks and in which these works were seen as the product of a different, past culture.

Roman thinkers were struck by the difference between their agrarian and aggressively militant pre-collecting past and their art-collecting present. Debates about the proper role of collecting in Roman so-

ciety began almost with the first importation of conquered Greek art in the late third century BCE and lasted until the second century CE. Jerome Pollitt has summarized the two main positions in these debates as the "Catonian" and the "Connoisseur."[14] The Catonians argued that Greek art caused Rome's moral standards to decay. The most outspoken critic of this decay was Cato the Elder, renowned for his rejection of all foreign cultures and especially for what he believed to be the "diverse vices, avarice, and luxury" and "every sort of libidinous temptation" infecting Rome from its contact with Greece and the East.[15]

Many other Romans regarded Greek art with similar suspicions. Livy thought that the artworks taken to Rome after the conquest of the Greek city of Syracuse "were no doubt the spoils of the enemy and were no doubt taken by right of war; all the same it was from these that one can trace the beginning of the craze for works of Greek art and, arising from that, the licentiousness with which all places everywhere, be they sacred or profane, were despoiled."[16] Similarly, Plutarch blamed exposure to the famously luxurious lifestyle of the Syracusans for the development in Rome for "a taste for leisure and idle talk, affecting urbane opinions about the arts and about artists, even to the point of wasting the better part of the day on such things."[17] Even Pliny the Elder, whose *Natural History* remains one of our best sources for information on ancient art, was suspicious of the works he chronicled. He wrote that the simultaneous arrival in Rome of artwork from the conquered Greek city of Corinth along with works from fallen Carthage "gave immense impetus to the overthrow of our morals" through the creation of a climate in which "there was freedom to enjoy vices."[18]

But there were also many Romans who appreciated and collected Greek art (and who undoubtedly enjoyed vices before they saw any art). By the first century BCE, during the late republican period, Rome had a busy art market, complete with professional dealers, restorers, appraisers, and forgers. Demand from Roman collectors drew living Greek artists to Italy to create contemporary works. The

Romans also employed a host of copyists, who turned out thousands of re-creations of the most well-known Greek sculptures to adorn Roman homes, villas, and gardens.

Pollitt argues that those who spent the most on art in the late Republic did so in order to display their wealth as a political tactic, seeking to attract followers for one of the numerous bloody bids for control of Rome that defined this period of near-constant civil war.[19] Hence Augustus, who would eventually consolidate a lasting control over the tumultuous empire, seems to have taken a strong position against private collecting, judging by the title of a lost oration delivered by his close ally Marcus Agrippa, "On the Subject of Making All Statues and Paintings Public Property."[20] Subsequent emperors switched back and forth between the Catonian's and Connoisseur's attitudes toward private collecting. Tiberius and Nero stripped art from public collections to adorn their private palaces, while Vespasian dismantled these collections and rededicated the works in public sanctuaries.[21]

Most Romans probably fell somewhere between the two extremes of these attitudes. Many who wrote about the Greek art they collected generally steered a careful course between enthusiasm and self-deprecation, as in this letter from Pliny the Younger:

> Out of a legacy which I have come in for I have just bought a Corinthian bronze, small it is true, but a charming and sharply-cut piece of work, so far as I have any knowledge of art, and that, as in everything else perhaps, is very slight. But as for the statue in question even I can appreciate its merits. . . . The bronze itself, judging by the genuine color, is old and of great antiquity. In fact, in every respect it is a work calculated to catch the eye of a connoisseur and to delight the eye of an amateur, and this is what tempted me to purchase it, although I am the merest novice. But I bought it not to keep it at home—for as yet I have no Corinthian art work in my house—but that I might put it up in my native country in some frequented place, and I specially had in mind the Temple of Jupiter.

> For the statue seems to me to be worthy of the temple, and the gift
> to be worthy of the god. So I hope that you will show me your usual
> kindness when I give you a commission, and that you will under-
> take the following for me. Will you order a pedestal to be made, of
> any marble you like, to be inscribed with my name and titles, if you
> think the latter ought to be mentioned? I will send you the statue as
> soon as I can find any one who is not overburdened with luggage, or
> I will bring myself along with it, as I dare say you would prefer me
> to do. For, if only my duties allow me, I am intending to run down
> thither.[22]

Pliny stresses that his purchase is funded by an inheritance, not by
money earned by a serious pursuit such as farming or war. He also
emphasizes that it is a small work, not a major one, and balances
his bragging about its quality with repeated qualifications about
his being "the merest novice" in art appreciation (despite his expert
knowledge about the correlation of certain colors of bronze patina
to the age of works). He makes sure to clarify that his purchase is
not intended to reside permanently in his home, as a private work of
art, although we should suspect that he was able to enjoy it there for
quite some time before his duties allowed him time to make the trip
necessary to order a pedestal for its placement in a temple. It is also
hard to imagine that his correspondent disagreed that this pedestal
should feature Pliny's name and titles.

 Although most Roman collectors probably followed the exam-
ple of Pliny the Younger in finding a way to navigate between the
extremes, it is important to acknowledge the fervor of these Roman
debates about the moral aspects of collecting. Just as Roman writ-
ings have shaped many modern intellectual realms, including poli-
tics, warfare, science, ethics, and religion, the Romans have also had
a lasting impact on modern thinking about private collecting. The
Romans saw important differences between older and contemporary
art, between imported and locally produced art, between art encoun-
tered in a public setting and in a private home, and between the per-

sonalities of those who had dedicated time to studying art and those who could not define art but knew what they liked when they saw it. We continue to think about art and collecting using these categories and their moral connotations. Roman opinions about collecting are so engrained that we use them even when, under scrutiny, they make little sense. For example, if admiring a work of art in one's own home is so morally suspicious, why is donating the same work of art so that it can be admired by others in public an act to be applauded?

But the real difficulty of Roman discussions about art is that they so convincingly categorized collecting behavior. Even today we are ready to believe that collectors are more luxurious and morally suspect than those simpler, virtuous souls with undecorated houses. Our continued application of Roman thought makes it difficult to recognize when and why collecting behavior differs from their neat categorizations.

The influence of the categories established by the Romans is so strong that we need add only one more aspect to fully understand the modern world's stereotype of the collector. That aspect is Christianity. From quite early on in the era of the triumph of Christianity, "pagan" art was the object of suspicion. Those who appreciated it for its own sake were even more suspicious. Christian artists quickly adapted certain techniques and styles of Greek and Roman art for their own purposes: for example, conveying the authority of Christ by showing him wearing the robes and sitting on the throne of a Roman emperor. While pagan artworks could serve as models, as possessions they were far more problematic.

The Greeks and Romans believed that statues of deities, though made by man, bore some special relationship with the divine. They thought that a god inhabited, whether permanently or occasionally, a statue representing him. The Christians largely maintained these beliefs while shifting their divine alliances. They regarded Greek and Roman statues as inhabited not by gods but by demons. These demons had some powers, but, of course, nothing compared to those of the Christian God. The best way to avoid these demons was to ignore

them. Thus, after some early and limited periods of active destruction, the Early Christians simply left most pagan statues alone.[23]

The writings of the Byzantines are our best sources for Early Christian attitudes toward antiquities. Many ancient works remained on display in Constantinople to support the Byzantine emperors' claims to be successors, though Christian ones, to the power of the Roman Empire. One chronicler claimed that, in 602 CE, the statues adorning the front of a Temple of Tyche in Alexandria, Egypt, slid down from their pedestals to tell a passing calligrapher, on his way home late at night from what must have been rather an exciting party, that the Byzantine emperor Maurice had been assassinated that day in Constantinople. Messengers who arrived in Alexandria nine days later confirmed this demonic intelligence. The chroniclers of such incidents were careful to point out that demons could not in fact predict the future; rather, they tried to trick mortals by passing off as foreknowledge the information they obtained through their ability to move swiftly from place to place.[24]

A number of Byzantine stories warned, either implicitly or explicitly, about the dangers of moving or destroying pagan statues. Saint Sabas had to intervene to stop an earthquake that began with the removal of one ancient statue, and a man who destroyed another ancient statue, discovering 133 talents of gold within it, was put to death after presenting this treasure to the emperor. Meanwhile, around 711 CE, an ancient statue fell on and killed a man who was looking at it. The emperor Philippicus ordered that the statue be buried because "it did not admit of destruction," and the chronicler of the event pointed out the moral of the story for future tourists: "Pray not to fall into temptation, and be on thy guard when thou contemplatest ancient statues, especially pagan ones."[25]

Others, deviating from the paths of Christianity, sought to take advantage of the demonic powers of ancient art. The Byzantine emperor Alexander, attempting to cure his impotence, restored the missing teeth and genitals to a statue of the Caledonian boar in the Hippodrome in Constantinople, for which impious act he was allegedly

stricken down by the Lord. The empress Euphrosyne, wife of Alexius Angelus, later cut the snout off of the same statue and also ordered that the colossal Hercules of Lysippus be flogged and that the limbs and heads of other statues in Constantinople be broken. Although the specific goal of these acts is unknown, she had a reputation for being addicted to magic and divination. Perhaps she was motivated by reasons similar to those of the empress Sophia, wife of Justin II, who ordered the destruction of a statue of Aphrodite after it exposed her. The statue was thought to have the power to reveal which women were unfaithful to their husbands by making the skirts of unchaste women fly up.[26]

A man known as Magister Gregorius, a high-ranking English cleric who wrote a guidebook to Rome after a trip there in the late twelfth or early thirteenth century, perfectly encapsulates the new attitude toward classical art that began to emerge as Europe moved into the early Renaissance:

> Now in truth I may say a few things about the marbles statues, almost all of which were either disfigured or destroyed by St. Gregory. First I shall speak of one in particular on account of its appearance of exceeding beauty. This statue, dedicated by the Romans to Venus, was in that form in which, according to the legend, Venus together with Juno and Pallas is said to have shown herself nude to Paris in audacious examination. . . . This statue of Parian marble was executed with such marvelous and inexplicable skill that it seems rather a living creature than a statue; for like one blushing it bears its nudity, the form suffused with reddish color. And to the close observer the blood seems to move in the snowy face of the image. Now this statue, on account of its wonderful beauty and some magical power of persuasion, I was three times constrained to go back to see although it was two *stadia* distant from my hostelry.[27]

Gregorius notes, without enthusiasm, the destruction of pagan statues by Pope Gregory in the sixth century.[28] Gregorius focuses rather

prudishly on the nudity of the statue but does not condemn this nudity as a violation of Christian morals. Instead, he gives a careful and erudite explanation for why the artist chose to represent Venus as nude, claiming that this statue shows a particular mythological moment during the story of the judgment of Paris. Then, Gregorius describes the "wonderful beauty" of the work in terms of the skill shown by the artist in carving it. Gregorius's prioritization of skill is so complete that he gives us little idea of the actual appearance of the statue—is it life-sized or a miniature? What position does her body take? Does she hold any accessories? We cannot tell.

Gregorius, as far as we know, did not collect ancient art, but one of the earliest post-classical private collectors shared his ambivalent attitude. Henry, bishop of Winchester and brother of King Stephen of England, traveled to Rome in 1151 and bought some ancient statues to send back to England. He defended his purchases by claiming that he bought the statues in order to prevent the Romans from starting to worship them again.[29] Henry did not deny the potential harm in possessing or over-appreciating classical art. But he is an early example of a type of collector who will reoccur countless times. This collector considers himself to have a privileged relationship with ancient art, a relationship whereby he can avoid its dangers (here, the danger of being seduced into pagan worship) by means of some special facilities of appreciation, knowledge, or moral fortitude not available to the general public.

Gregorius and Henry belonged to a new breed of audience for classical art, one that understood such works as survivals from a historical period, could discuss the works in a learned context of mythology and literature, appreciated the skill displayed by ancient artists, and sought to use ancient art as models for the improvement of contemporary production. These new attitudes toward classical art reached full flower during the Renaissance. Yet even then, the suspicions of the Romans and Early Christians did not entirely disappear. Gregorius probably did not believe that the Venus he admired was inhabited by either a demon or the goddess herself, but he was quite

clear that the work possessed "some magical power of persuasion" that caused him to visit it three times, feeling an attraction that made the experience quite different from looking at a piece of uncarved marble or a contemporary statue. And though Gregorius does not disapprove of looking at classical statues, he is not a completely enthusiastic proponent of doing so. He walks a cautious middle path, claiming that the statue compelled him to visit it rather than admitting that these visits were voluntary.

For centuries, there had been consensus about the malignant power of classical art. Henry and Gregorius are examples of the split between the majority of people, who rarely encountered antiquities and continued to regard them with suspicion, and a new minority: a small group of scholars and collectors who appreciated the power of classical art while considering themselves uniquely immune to its dangers. By the mid-thirteenth century, the distinction between two classes of audiences is already quite clear, as when the Italian monk Ristoro d'Arezzo writes about the discoveries of ancient decorated vases, known as Arretine ware, in the town of Arezzo:

> The *cognoscenti*, when they found [Arretine ware] rejoiced and shouted to one another with the greatest delight, and they got loud and nearly lost their senses and became quite silly [*quasi stupidi*]; and the ignorant wanted to throw [the vases] and to break them up. When some of these pieces got into the hands of sculptors or painters or other *cognoscenti*, they preserved them like holy relics, marveling that human nature could reach so high.[30]

Ristoro was not a supporter of the cognoscenti. He slightingly compares the ancient vases to Christian relics and characterizes the cognoscenti as acting stupidly and thus as little better than the "ignorant" who wish to smash the new discoveries. Yet, this passage shows that there was a settled distinction between those who appreciated classical art and those who feared or disapproved of it, and that these categories were used even by those who, like Ristoro, rolled their eyes at the whole debate.

Few in the medieval or early Renaissance periods deliberately sought out and purchased classical art. These purchasers, like Henry of Winchester, were generally limited to those with the highest power and authority, either sacred or secular. Those with less authority would have been hesitant to acquire ancient art, since they did not have the power to overcome the suspicions of their more fanatical neighbors.

Frederick II Hohenstaufen, the thirteenth-century Holy Roman emperor, is another example of a collector with enough power to put his collecting above reproach. He followed in the footsteps of the Attalids and the Byzantines by using the possession of ancient art to support his claims to the revival of ancient imperial power.[31] Frederick minted gold coins modeled on ancient Roman currency. They featured his portrait in profile, crowned with a laurel wreath and armed in an ancient breastplate, surrounded by an inscription reading CES/AVG/IMP/ROM (Caesar Augustus Emperor of the Romans). He ordered the construction of a gate for the city of Capua, Italy, in the style of a Roman triumphal arch, and he enacted a Roman-style triumphal procession of his trophies and prisoners through Cremona after his victory over the Lombards in 1237. He also collected ancient art, from bronze statue groups to coins and gems to entire buildings. When he ruled the city of Rome, he purchased the Colosseum, the Mausoleum of Augustus, the Septizonium of Septimius Severus, and the Arches of Titus and Constantine, all of which had been converted into private fortresses by Roman aristocratic families. He allowed the former owners to continue living in these ancient monuments, but now as his vassals.[32]

A number of medieval and early modern religious authorities also collected ancient art for display in churches, although they generally emphasized their ability to transform these works for the service of Christianity by modifying them with new inscriptions or settings.[33] These collections were a means of measuring Christianity's competition with, and victory over, pagan antiquity. For example, in Paris in the mid-twelfth century, Bishop Suger used many ancient

carved gems to decorate reliquaries and other church furnishings. He justified his actions by claiming that churches should be the repositories of all sorts of beautiful objects.[34] One particularly fine example of this type of work is the reliquary of the Majesté of St. Foy of Conques, which features a late Roman golden parade helmet as well as thirty ancient carved gems.[35]

Gradually, more and more of those who could afford to do so followed the examples of those in power and began to appreciate and collect ancient art. But a strand of distrust of classical art continued to run through Western culture. As the Russian czar Peter the Great found, the desires of a cultured elite often conflicted with a deliberately old-fashioned level of religious faith:

> His Majesty owned a small palace on an islet in the river at Voroney, where the entrance was embellished with statues of pagan gods such as Jupiter, Neptune, Minerva, Hercules, Venus, and others. While there, Peter extended an invitation to Bishop Mitrophan of Voronej to visit him. The old man came immediately, but hardly had he arrived in the forecourt and glimpsed the aforementioned statues, including a naked Venus, than he turned on his heels and left. Unaware of the reason for his precipitate departure, the Czar sent for his guest once more. The priest refused to obey, protesting to the messengers: "Until such time as the monarch orders idols that lead the people into temptation to be overthrown, I may not enter the palace." Informed by the imperial messengers that he would be liable to execution if he refused to comply, the bishop ordered the church bells to be rung throughout the city before making confession in public, so determined was he to endure the most extreme torments, in the tradition of the Christian martyrs persecuted by the pagan emperors. Peter, on the other hand, gave in and ordered the statues of the antique gods to be removed.[36]

Criticism of collectors continues to crop up in societies that otherwise seem to have wholly accepted the normalcy of antiquities.

Pope Paul II is a perfect example of this phenomenon. As a cardinal and then as pope, he collected a huge number of antiquities. A 1457 inventory of his collection, when he was still a cardinal, lists more than 500 ancient engraved gems, over 200 cameos, and over 1,000 Roman coins. As pope, he used his power to expand the scope of his collecting. He offered to build a bridge for the city of Toulouse in exchange for the Roman cameo known as the Gemma Augustea.[37] A Venetian, Paul II commemorated his hometown by moving a number of ancient works to the piazza in front of the Roman church of San Marco, Venice's patron saint, including a monumental bust of Isis and a massive granite basin. The streets surrounding the church were not wide enough for the basin, and Paul II had to buy two houses and demolish them to create enough room for its passage.[38]

Paul II also commissioned elaborate frames for many of his objects, including one for the ancient ivory panels known as the Quirini Diptych, which is inscribed: "My owner . . . delighted in his wondrous love for these works of great *ingenium*."[39] This inscription shows that, like Gregorius, Paul II loved antiquities for their beauty and skill—although he also appreciated and used their ability to show his power.

Such motivations were not acceptable in a pope. Many of Paul II's contemporaries commented on his collecting, and each ascribed him a motivation—favorable ones from his proponents and unflattering ones from his detractors—but no one was satisfied with his morally neutral stance. Gaspare da Verona wrote that Paul II collected art "for no cause other than hoarding, which was necessary so he could come to the aid of his realm and all of Christianity and for use in a crusade, especially against the Turks, a detestable and wicked people"—thus claiming that his collections were merely a form of savings to be cashed in when funds were needed to make war against the Ottoman Empire.[40] Similarly, Claude Bellièvre composed a poem claiming that after the Sack of Constantinople by the Ottomans, Paul II "acquired these divine [artworks] from the loathsome enemy" so that "this work would not be dispersed."[41] On the other side, there

was a rumor in Rome after his death that he had been strangled by a demon that emerged from one of the ancient rings he had collected, and the humanist Platina, who wrote disdainfully that Paul II spent all night "sifting through all his gems and pearls," claimed that he had died of a heart attack caused by the weight of the gold and jewels in his papal tiara.[42]

Why was Paul II subject to so much criticism? Not because he was a collector, but because his collecting went too far. Unlike Pliny the Younger or Gregorius, he did not temper his collecting behavior with self-deprecating remarks or limit it strictly to his leisure time. Even his supporters could not envision a pope who ignored his duties so frequently without good justification. They felt compelled to assign him better reasons for collecting—financial and political reasons that had little to do with any real appreciation for classical art.

More reminders of continuing belief in the power of antiquities and opposition to their appreciation can be found in the treatment of statues of Venus less fortunate than the one admired by Gregorius. In the mid-fourteenth century, in Siena, Italy, workers digging the foundation of a house discovered a Venus, and "all the expert and learned in art and sculpture ran to see this statue, made with such beautiful and marvelous artistic skill."[43] The Sienese held a feast to celebrate the discovery and placed the statue in the main city square—until one disapproving citizen protested at a public meeting:

> Fellow citizens, having come to the conclusion that since we have discovered this statue we have had naught but bad luck and considering how idolatry is abhorrent to our faith, we must conclude that God is sending us all grief for our errors. Consider too how since we have been honoring this statue, things have gone from bad to worse, and we are going to continue to have bad luck. I am of the opinion of those who recommend that it be broken and smashed and the pieces sent to be buried in [the lands of] Florence.[44]

According to the artist Lorenzo Ghiberti, author of this account, the Venus was indeed smashed and buried on Florentine territory,

to transfer its bad luck to the Florentines, then at war with Siena. Similarly, as late as 1811 we hear of a marble torso of Venus, which had been dug up in the cemetery of St. Matthias near Trier, Germany, being occasionally placed on display so that pilgrims could gain merit from throwing stones at it.[45] We have not yet outgrown our beliefs in the power of antiquities, and the efficacy of destroying them to control these powers. In 2001, Taliban forces demolished two monumental sixth-century CE sculptures of the Buddha in the Bamiyan Valley of Afghanistan, claiming that their actions would prevent the works from attracting idolatry.

2

C H A P T E R

Collecting Identities

S cholars have long studied the human habit of collecting and displaying objects in order to communicate our self-image to others.[1] However, there is a pervasive tendency to see collecting and display as a hypocritical activity, one that creates a façade of false identities to cover over the true being of the collector. For example, Joseph Alsop, the author of what is otherwise one of the more discerning histories of collecting, insists that the "true collector" lacks any "inner relationship" to what he collects and instead gathers together "objects belonging to a particular category the collector happens to fancy, as magpies fancy things that are shiny."[2] Pierre Cabanne, even more reductively, claims that "small countries, short men, [and] religious minorities" are especially inclined to collect because "the collections they bring together give them a reputation and add to their stature or distinction."[3] In reality, the process of expressing an identity through antiquities is not as simple as adding metaphorical inches to a collector's self-perception. Understanding the complex ways in which collectors have manipulated their antiquities to better express their identities is necessary to understand the ways in which these manipulations continue to shape our contemporary vision of the past.

The first great manipulators of Roman antiquities were the *bovattieri*, the "cattlemen," a new class of elites that arose in Rome in the fourteenth century. These families, whose wealth came from banking and the cloth and spice industries, were not satisfied with

being merely wealthy. They wanted to be aristocratic as well. They used their wealth to buy estates outside of the walls of Rome. On these estates, they raised cattle—hence their nickname—and dug up artworks from the ruins of ancient Roman country villas buried underneath their fields.

The bovattieri used these artworks in their quest to counter their provincialism, "proving" their noble origins by displaying antiquities to support their fabricated family lineages.[4] The Cenci family collected any ancient inscription they could find bearing the name "Cenius," and the Porcari family displayed sculptures and inscriptions associated with the illustrious ancient Roman Marcus Porcius Cato, their adopted forefather.[5] Sometimes these displays required the addition of new Latin inscriptions, which must have been intended to pass as original to the works. The Porcari placed a slab of architectural decoration, probably from the Baths of Agrippa, above the doorway of one of their houses and inscribed it "I am he, Cato Porcius, author of our progeny who, with arms and diplomacy, brought his noble name to the lips [of all]."[6] This inscription must have been placed underneath a portrait bust of Cato. The Porcari also eagerly displayed ancient images of boar hunts, pigs, Aeneas and the Lavinian sow—anything to refer to the pork underlying Porcius.

Some of the families did not hesitate to create, more or less out of whole cloth, the images they wanted. The Santacroce family, who chose the republican consul Publius Valerius Publicola as their ancestor, inscribed an anonymous ancient statue with the words "VALER. PUBL. CC" (Valerius Publicola several times consul), thus transforming the work into a portrait of their fictional progenitor.

Sometimes the naming could go the other way around. The Altieri family claimed decent from the mythological Roman Lucius Alterius. One member of the family, Marcantonio Altieri, owned a Roman altar with an authentically ancient inscription recording that it had been dedicated by one "Candidus Alterius."[7] Altieri used the altar as a tombstone for his son Candido. He must have named his son after the otherwise unknown Roman who dedicated the altar.

Such fictional ancestries were sometimes calculated with wonderful precision, as when the wealthy pharmacist Lorenzo Manlio decided that he was descended from the republican-era hero Marcus Manlius Capitolinus. Manlio decorated the façade of his house with ancient and modern reliefs and inscriptions, topped with a monumental inscription reading:

> As Rome is reborn in her ancient guise, Lorenzo Manlio, in devotion to his paternal family, thanks to his modest fortune, built from the ground up this house in the Piazza Giudea for the Manlius name, for himself, and for his descendants. 2,229 years, 3 months, and 2 days after the foundation of Rome, 11 days before the Calends of August [that is, July 22, 1476].[8]

A mere 2,000 years or so was not enough to call into question the connection between Manlio and Manlius, despite the sole evidence for the linkage being the similarity of their names.

Not everyone was fooled. As the Florentine scholar Alberto degli Alberti, in Rome to work in the Papal Curia, wrote about the city and its inhabitants in 1443, "the modern buildings are rather sad, and Rome's beauty is found in her ruins. Men who now call themselves Roman are in every aspect of their appearance and behavior completely different from the ancients. To put it bluntly, they all look like cow herders."[9] Many modern scholars have, like Alberti, seen the bovattieri as provincial rubes, deceiving no one but themselves with their clumsy attempts to fabricate a lineage. But they were cleverly and deliberately manipulating the past. They knew that their antiquities would not impress the social or the scholarly elite. Rather, they intended that these displays would impress the lower levels of Roman society, whose loyalty they were competing to claim from the medieval Roman aristocrats who had taught the people that an ancient lineage was a necessary accompaniment to power.

In order to fabricate these lineages, the bovattieri needed fragmentary antiquities. Unbroken objects would speak too clearly in their own voice. The bovattieri instead used fragmentary, hard-to-

interpret antiquities to impose meaning on the past. They were the first major group of collectors to realize that antiquity can be more useful as a fragment than as a whole, and they were far more interested in manipulating the interpretation of an antiquity than faithfully reconstructing its original use.

In following centuries, some collectors would continue to use their collections to imply descent from the Romans. In the sixteenth century, Cardinal Federico Cesi displayed in his garden a large number of ancient inscriptions mentioning the similarly named ancient Roman Caesii, Caesonii, and Caesellii families.[10] In 1630, the Barberini family commissioned a memorial portrait of Carlo Barberini to be created from an ancient Roman torso with an added portrait head by Lorenzo Bernini and arms, legs, and drapery by Alessandro Algardi.[11] But such uses of the antique moved away from the claims of direct, literal descent made by the bovattieri, which became less plausible with the growth of historical scholarship.

Instead, collectors began to claim a new type of relationship with the past: that of being the spiritual, rather than literal, heirs of the Greeks and Romans. Instead of collecting inscriptions with similar-sounding ancient names or manipulating ancient portraits, collectors from the sixteenth century to the present day have used their collections to stand as physical manifestations of their spiritual identification with the past. Doing so does not mean, however, that each subsequent collector has stood in the same relationship with the past. Individual collectors and groups of collectors have found very different meanings in the past and have used their collections to express very different things about themselves. And like the bovattieri, they have taken advantage of the fragmentary nature of antiquities and manipulated the context, display, and physical integrity of collected objects in order to better project their beliefs about the past.

To better understand how this use of antiquities to display an identity becomes the dominant type of modern collecting, we have

to look at the first era when antiquities collecting preoccupied a significant percentage of an entire population outside of Italy. This story begins in England in the sixteenth century, and it begins with one man: Thomas Howard, the Earl of Arundel (1585–1646).[12] Arundel's habits of collecting set the pattern for centuries of subsequent British collecting. He was the first to use a private antiquities collection to display wealth and power. He established the preference for imported rather than the local antiquities of Roman Britain; the habit of heavily restoring of any works in less than perfect condition; the willingness to obtain antiquities both through purchases from existing collections and through new excavations; and, above all, the belief that the collector was in a better position to appreciate and cherish the antiquities than the current possessors, and thus that the collector was justified in circumventing export restrictions and all other manner of laws and regulations in order to acquire his antiquities.

> And here I cannot but with much reverence, mention the every way Right honourable Thomas Howard Lord high Marshall of England, as great for his noble Patronage of Arts and ancient learning, as for his birth and place. To whose liberall charges and magnificence this angle of the world oweth the first sight of Greeke and Romane Statues, with whose admired presence he began to honour the Gardens and Galleries of Arundel-House about twentie yeeres agoe, and hath ever since continued to transplant old Greece into England.[13]

So wrote Henry Peacham, the Cambridge scholar, in his 1634 book of manners, *The Compleat Gentleman*. Arundel was Peacham's patron, but Peacham was not exaggerating greatly when he claimed that England owed its first sight of original classical art to Arundel.

Arundel's path to antiquities collecting was a winding one.[14] The Arundel family had long held a primary place in English aristocratic history, but its wealth and prestige were almost extinguished when Thomas was born, thanks to a series of political and personal blunders. King Henry VIII beheaded both Thomas's great-grandfather, the Earl of Surrey, and his cousin, Catherine Howard, while Queen

Elizabeth beheaded his grandfather, the fourth Duke of Norfolk, and imprisoned his father, Philip, for Catholicism. Philip died after ten years in the Tower of London, without ever seeing his young son.

Arundel's fortunes began to rise at the accession of James I in 1603, when Arundel was in his late teens. Around this time, Arundel came under the influence of Gilbert, the seventh Earl of Shrewsbury, a traveler and art collector and, after 1606, Arundel's father-in-law. With the help of Shrewsbury, Arundel cultivated a friendship with Henry, the Prince of Wales, and a reputation as a connoisseur of paintings. Arundel's friendship and reputation led to his appointment as part of the retinue that accompanied Prince Henry's sister Elizabeth in 1613 to Heidelberg, the home of her new husband, the Elector Henry Frederick.

Arundel and his wife took advantage of this journey to make a trip to Italy, where they stayed, studying art and language, for more than a year. They visited Venice, where Arundel made a ceremonial entry as King James's ambassador extraordinary, then Vicenza, Bologna, Tuscany, Naples, and Rome, where they stayed with the Marchese Vincenzo Giustiniani in his palace near Piazza Navona. Giustiniani's palace had a large gallery of ancient sculptures, and he entertained his guests by organizing an excavation in the Roman Forum, where Arundel found some fragments of ancient art (probably strategically placed there in advance).

Despite his exposure to the way in which Italian aristocrats expressed their status through collections of antiquities, Arundel returned to England with only a few contemporary statues in ancient style. His father-in-law died soon afterwards, leaving his daughter enough money to restore Arundel House. The long wing that extended toward the Thames River was refurbished to accommodate some of Arundel's new collections, including the contemporary marbles from Rome. He also began to collect books, heraldic and genealogical materials relating to his family, and paintings by old and modern masters, including Raphael, Titian, Correggio, Dürer, Rubens, and Van Dyck. He wanted these collections to restore the

glory of his family; this is especially evident in the numerous works by Hans Holbein that he purchased—more than thirty in one room alone—many of them portraits of members of his family, painted during the height of their power in the Tudor period.[15]

Arundel struggled for decades to achieve political power and regain his family's prestige. Although he renounced Catholicism, he was never a favorite of James I. Arundel did accumulate enough wealth through the management of his estates that James found it impossible to ignore him, and in 1621 he was created Earl Marshal, a post his family had traditionally held. James also bestowed on Arundel the taxes levied on currants imported into England. This privilege brought Arundel £3,000 a year and put him in direct contact with the merchants who imported the dried fruit from Greece and Asia Minor. With his political ambitions frustrated, Arundel had time on his hands, funds, and access to ships. His dormant interest in antiquities revived.

Arundel wrote to Sir Thomas Roe, the English ambassador to the court of the Ottoman Empire, headquartered in Constantinople, to ask for his help in acquiring antiquities. Arundel also sent agents to search for antiquities; first the ill-fated John Markham, who died not long after he arrived in Turkey in 1622, and then the Reverend William Petty, who reached Smyrna in December 1624. Petty had previously been a Cambridge don, then tutor to Arundel's children, and had spent time in Italy. Apparently this varied résumé gave him the appropriate experience for searching for antiquities in Asia Minor. Roe reported back to Arundel that

> there was never man so fitted to an employment, that encounters all accidents with so unwearied patience, eats with Greeks on their worst days, lies with fishermen on planks at the best, is all things to all men, that he may obtain his ends, which are your Lordship's service.[16]

Arundel was especially fortunate in the choice of Petty. Roe, although skilled and resourceful (before being appointed ambassa-

dor to the Ottomans, he had paddled up the Amazon and served as England's first ambassador to India), frankly admitted that he knew little about antiquities and could not tell good from bad or authentic from false, as when he wrote to Arundel, telling him that he had purchased "a stone taken out of the old palace of Priam in Troy, cut in horned shape; but because I neither can tell of what it is, nor hath it any other beauty, but only the antiquity and truth of being a piece of that ruined and famous building, I will not presume to send it you; yet I have delivered it to the same messenger that your lordship may see it, and throw it away."[17]

Despite his lack of knowledge, Roe was optimistic about his ability to procure antiquities at first, writing Arundel that such artworks were "unesteemed here; and, I doubt not, easy to be procured for the charge of digging and fetching."[18] A few seasons later, Roe had discovered that the Ottoman authorities, even if they did not esteem antiquities, were extremely reluctant to grant permission to excavate and export them. He wrote to Arundel about the "innumerable pillars, statues, and tombstones of marble, with inscriptions in Greek" along the coast of Turkey that "may be fetched . . . secretly; but if we ask leave, it cannot be obtained."[19] Roe suspected that the authorities cared about his efforts to obtain antiquities because they "suspect treasure in every place where Christians break the earth." The authorities thought that searching for antiquities was an excuse to dig up and steal buried treasure.[20]

A year later, Roe's hopes had fallen further. He told Arundel that the "sordidness of barbarism" had destroyed the majority of the classical remains in Turkey, claiming that builders of mosques had carried out so many excavations in search of building materials that, for those now seeking antiquities, "there is little to be hoped for by industry, if chance assist not." He also wrote that "statues, or figures of beasts, because they are forbidden in their law," had almost all either been defaced or already exported, "so they are become very rare."[21]

Roe also complained that his attempts to purchase those few works that remained were hindered by the fact that his duties tied

him to Constantinople. He could not travel to verify reports he received about works. Instead, he had to pay for them to be transported to him, often resulting in unpleasant surprises:

> I have in my endeavor bad success, by the ignorance of those I am forced to employ, who send me heavy stones at great charge, that prove new images where I seek old idols.... From Angory [Ankara], I had a half-woman, brought 18 days by land, upon change of mules, which wants a hand, a nose, a lip; and is so deformed, that she makes me remember a hospital: yet the malicious Turks brought troubles on the buyers, by a false command, accusing them of a great wealth stolen out of the castle; it has cost me money to punish them, and that is all I have for my labor.[22]

Roe hoped to make more progress with Petty's help. Together they plotted to remove twelve ancient reliefs embedded in the Golden Gate of Constantinople, originally a triumphal arch erected by the Byzantine emperor Theodosius the Great in 390 CE. Petty climbed a ladder and examined the reliefs, declaring that "he hath not seen much better in the great and costly collections of Italy."[23] Roe then tried for more than two years to get permission from the Ottoman authorities to remove the reliefs, although he continued to be somewhat suspicious of their value. He wrote, "The glory of taking them from the gate of Constantinople incites me farther than any beauty I see in ruins, that only show there was once beauty; good emblems of one that had been a handsome woman, if an old woman were not a better; yet few love them."[24]

Roe's negotiations were complicated by military considerations, since the bricked-up Golden Gate was now part of a fortress. Its commanders were reluctant to allow the construction of the scaffolding necessary to remove the reliefs. Roe resorted first to bribes and then to paying an imam to declare that the reliefs were contrary to Islamic law:

> There is only one way left; by corruption of some churchmen, to dislike them as against their law; and under that pretense, to take

them down to be brought to some private place; from whence, after the matter is cold and unsuspected, they may be conveyed. I . . . am offered to have it done for 600 crowns. To send them home chested, and freight, with some other bribes at the waterside, may cost 100 more.[25]

Roe's plots failed. The official who had seemed persuaded by the imam's condemnation of the reliefs (and by Roe's bribes) changed his mind, conveniently remembering that there was an old legend that disaster would strike Constantinople if the reliefs were ever removed. Neither Roe nor Arundel ever succeeded in obtaining the reliefs, which have subsequently simply disappeared.

Petty had better luck. Roe gave him an official pass with permission to travel throughout the Ottoman Empire, which at that time included Greece, and Petty dodged pirates, learned Modern Greek, and managed to acquire ancient statues in Pergamum and Samos. He promptly lost these in a shipwreck near Ephesus, which also destroyed his papers. Without them, he was briefly imprisoned as a spy until he obtained replacements. He then hired divers to retrieve his sunken purchases. Although he suffered his own troubles, Petty was not above taking advantage of the misfortunes of others. Hearing that the agent for a French scholar, Nicolas Peiresc, was in prison in Smyrna, he swooped in to purchase from his jailers the collection of thirty ancient inscriptions the agent had bought and left undefended.

After a final voyage through the Greek mainland in 1626, Petty returned to London, having "raked together 200 pieces, all broken, or few entire," as Roe rather dismissively reported.[26] Arundel was more satisfied, establishing a special workshop on the grounds of his house so that workers could make the heavy restoration he thought necessary for the figural statues, architectural fragments, and inscriptions collected by Petty.

Both Arundel's collection and his political fortunes benefited from the death of George Villiers, Duke of Buckingham. James I and

his son Charles I preferred the handsome Buckingham to the morose Arundel, who regarded the new favorite as an insufficiently noble upstart. Buckingham, like Arundel, had traveled abroad in connection with a royal marriage, accompanying the then Prince Charles to Spain in his ultimately unsuccessful attempt to woo the Infanta Maria. Both Buckingham and Prince Charles were impressed by the art collections, including antiquities, of the Spanish court.

Buckingham thus wrote to Roe, asking him to acquire antiquities for him as well. Unlike Arundel, who was willing to restore works in imperfect condition, Buckingham insisted to Roe that "neither am I so fond of antiquity (as you rightly conjecture) to court it in a deformed or misshapen stone; but where you shall meet beauty with antiquity together in a statue, I shall not stand upon any cost your judgment shall value it at."[27] Roe tried his hardest to find works that would satisfy Buckingham, but after much labor he accumulated only two statues and some fragments. These arrived in London, where they were purchased by Arundel, Buckingham having been assassinated in the summer of 1628. His main rival out of the way, Arundel soon became one of Charles's most trusted courtiers, and his art played a role in his ascent. Charles and his queen visited Arundel House to view his collection in December 1628.

Arundel continued to collect over the next decade, although many of his plans were frustrated. He sent Petty to Italy, where he tried and failed to purchase antiquities from a number of noble collections as well as an entire obelisk lying in the Circus of Maxentius (instead, it became the centerpiece of Bernini's Fountain of the Four Rivers in the Piazza Navona). Arundel was more successful with purchasing ancient gems and cameos, of which he possessed hundreds.[28]

Arundel did not have much time to enjoy his collection. From the late 1630s on, he was almost continually out of England on diplomatic and military missions for Charles. He left England for good when civil war broke out in 1642, dying in Italy in 1646. Arundel's collection of marbles stayed intact for barely thirty years. His heirs were uninterested in antiquities. They sold some and donated others to

Oxford, but they also left some in the gardens to be destroyed by the weather, used some as building materials when renovating Arundel House, gave others to a family servant who used them to decorate a pleasure garden in Lambeth, and dumped some of them into a marsh in Kensington to stabilize it. Oxford received 136 inscriptions in 1667. The rest of what was once a collection of around 250 had disappeared.

The size of Arundel's antiquities collection is uncertain. One source claims 37 statues and 128 busts as well as a large number of sarcophagi, altars, and fragments, but another source lists just 103 statues.[29] Whatever the precise number, Arundel's collection and display of original antiquities exported from Italy and Greece was unprecedented in England, and the way in which he collected—especially his eagerness to excavate, bribe, and smuggle antiquities—set the pattern for centuries of Englishmen. This pattern would come to full fruition during the eighteenth century with the institution of the Grand Tour.[30]

Arundel was the first great English antiquities collector in part because of his pioneering tastes but also because he was one of the few Englishmen of his generation who could travel in, or send his agents to, Greece and Italy. For others, Greece was simply too distant and inconvenient. And Italy, although relatively easy to reach, presented other difficulties. English authorities, both civil and religious, remained suspicious of those who wished to travel to Italy after England's break with the papacy and the establishment of the Church of England in 1530. Religious differences meant that even the many English scholars and students who continued to have an interest in Greek and Latin literature and history had an entirely opposite opinion about traveling to Italy: "Some Circe shall make him, of a plain Englishman, a right Italian. And at length to hell, or to some hellish place, is he likely to go," as one don wrote in 1570.[31]

Even if a curious Englishman had wanted to visit the centers of antiquities dealing in sixteenth- and seventeenth-century Italy, he would not have found it at all easy. He would be liable to arrest for

treason if he traveled to Rome, since English travel permits usually specifically prohibited exposure to this city and its numerous, and apparently dangerously persuasive, English Catholic exiles. The Protestant traveler to Italy did well to avoid the Papal States altogether. Officers of the Inquisition occasionally arrested non-Catholics. Travel to the Kingdom of Naples and the Duchy of Milan was hardly easier. Both were Spanish territory, and England and Spain were frequently at war.

But when James I sent Arundel to make a ceremonial entry into Venice, he paved the way for Arundel's collecting and for the collecting of all those who adopted Arundel's example. James established a permanent embassy in Venice to strengthen diplomatic and trade relations with northern Italy. He also ended the wars with Spain, allowing the English to travel in the south. The intensity of English distrust of the papacy and power of the Inquisition lessened, and the pan-European political situation increasingly favored travel after the end of the Thirty Years' War in 1636 and the War of the Spanish Succession in 1713. More and more young Englishmen began to follow Arundel's example and make what became known as the Grand Tour: a slow progression across the Continent, culminating in a stay in Italy, to mark the completion of their university education.

Of course, not every Grand Tourist loved ancient art. A certain Lord Baltimore, although he hired the famed art historian Johann Joachim Winckelmann to guide him through Rome, ran through the Villa Borghese in less than ten minutes and claimed that the sole ancient statue he enjoyed in the whole city was the Apollo Belvedere.[32] Similarly, Lord Tavistock declared he would "not give a guinea for the finest torso ever discovered."[33] At times, the avoidance of antiquities was a principled stance, as when Lord Chesterfield ordered his son, traveling in 1749, not to run through Italy "(to use a ridiculous word) *knick-knackically*. . . . I beseech you; no days lost in poring upon almost imperceptible *intaglios* and *cameos;* and do not become a virtuoso of small wares."[34]

But so many other Grand Tourists were eager to purchase

antiquities that only the popes purchased more antiquities in eighteenth-century Italy. Winckelmann indignantly proposed to a correspondent that "perhaps it will occur to some mad Englishman to have even Trajan's column transported to London."[35] Their purchases were aided by the willingness of Italian officials, especially those in the extensive and antiquities-rich Papal States, to grant export and excavation licenses to the British as victors of the Napoleonic Wars and possessor of Europe's most powerful navy. As a result, British purchasers received many more export licenses than those of other nationalities.

Unlike Arundel, whose collecting was slowed by his need to find and send his own agents to discover and purchase antiquities, Grand Tourists could choose from four British antiquities dealers resident in Rome during the second half of the eighteenth century: Thomas Jenkins, Gavin Hamilton, Colin Morison, and Robert Fagan. All four had originally moved to Italy to be artists, and they continued to produce the occasional canvas. They soon found that supplying antiquities to visiting Englishmen and those who ordered from abroad was a far more profitable career. They acquired antiquities from private Roman collections and from excavations, whether of others or their own. Between them, they carried out almost eighty excavations in Rome and the surrounding countryside in search of antiquities to sell.

Arundel was essentially different from the Grand Tour collectors. Whereas Arundel was born in a time when England without a king was unthinkable, the Grand Tourists passed through the Roman Forum after the English Civil War, the execution of Charles I, and the Glorious Revolution had firmly established that ultimate power in England resided in its Parliament, not in its king.[36] English philosophers and politicians from the late seventeenth through the eighteenth century eagerly sought historical models and justifications for political systems ruled by a parliamentary body. Englishmen had long read Sallust, Livy, Tacitus, and other Roman republican political thinkers during a traditionally heavily classical education. Thus, it is not surprising that the newly powerful English oligarchy justi-

fied their power by comparing themselves to the senators of ancient Rome. The model was so useful that both Tories and Whigs identified themselves with the Roman Senate.[37]

The English elite displayed their claimed links to Rome not only in their writings and speeches, but also by commissioning portraits of themselves in Roman garb and displaying antiquities, both original and casts, in their homes and gardens.[38] Such continuing reminders were necessary because the idea of republican Rome was not important merely as a onetime justification for oligarchic rule. The English elite remained concerned that their power could be undermined, either through invasion by pro-royalists from the Continent or, as happened in ancient Rome, through infighting and decadence among the aristocracy that gave rise to civil war, to be stopped only through the rise of an emperor. Rome provided a cautionary model as well as one to emulate.

Grand Tourists were encouraged to use their experience of ancient art during their travels in order to strengthen the lessons offered by the Romans, as when Lord Chesterfield advised his son, traveling in Italy in 1749, to

> view the most curious remains of antiquity with a classical spirit, and they will clear up to you many passages of the classical authors; particularly the Trajan and Antoine Columns; where you find the warlike instruments, the dresses, and the triumphal ornaments of the Romans. Buy also the prints and explanations of all those respectable remains of Roman grandeur, and compare them with the originals.[39]

Those who purchased antiquities, either on or after their Grand Tours, also did so with the goal of reinforcing their spiritual identification with Rome, as is clear from the overwhelming preference shown for portrait statues and busts, since these would bring the model personages of Rome back to life—and back home to England.

3
C H A P T E R

"By Means of a Little Castration"
Restoration and Manipulation

Restoration—the practice of repairing damaged artworks and replacing their lost elements—has a long history. The tombstone of one ancient Roman, M. Rapilius Serapio, specifies that he made his living restoring missing eyes to statues.[1] Ancient statues frequently were made with eyes inlaid with other materials, such as semi-precious stone or different colored metals, to give a more realistic effect. Over time, the solder or pitch holding these materials together loosened and the inlays scattered. The owners of these damaged sculptures would have gratefully employed Serapio to repair their suddenly piratical-appearing ancestors or household gods.

When we think of restoration, we tend to see it as this type of operation: picking up some broken pieces and putting them back together, or perhaps fabricating a missing element to mimic as exactly as possible the original appearance of the work. Here, restoration is a minimalistic task, similar to sending off a car to be washed, polished, and have a dent repaired. For many types of artworks, this conception of restoration is valid. But not for antiquities.

Antiquities have rough afterlives. Consider marble statuary. The majority of ancient marbles were completely destroyed: sliced up into slabs for building materials, burnt to make quicklime for mortar, chiseled into cannon balls in times of war, or repurposed for any of a hundred other uses. Those statues that were not fully destroyed

were often heavily damaged by invading armies, followers of new religions, natural disasters, or simply the passage of time. Even statues that were carefully buried in tombs suffered the slow disintegrations brought on by penetrating roots, chemical interactions with the surrounding soil and moisture, and the pressure of the earth pressing down overhead through the centuries.

To be sure, a few ancient sculptural works, including some masterpieces, have survived in very good condition. Viewers have long regarded this unbroken and complete state as the ideal. But the pristine ancient statuary on display in museums and private collections today is almost all the result of intensive restoration work. And unlike our conception of minimalistic restoration, where the restorer has a good idea of what the original once looked like and is able to seamlessly repair a few damaged or missing areas, antiquities are often missing such large portions that it can be impossible to ascertain their original subject matter.

A surviving torso, missing the hands that might have held attributes or a head that might have been a portrait, could have represented a god, an athlete, and emperor, or a merchant. To turn this torso into a work fit to be displayed in the halls of an art collection at any time from the Renaissance through the nineteenth century, a restorer would have combined it with other ancient fragments or entirely newly carved replacement limbs. The restorer would then have given the whole statue a pleasingly snowy white surface by chemically stripping and mechanically polishing off most of the surviving original surface. The final product emerging from this restoration was very different than the original statue. Imagine dropping off several totaled cars and a heap of scrap metal at the body shop and returning several months later to pick up a shiny, newly constructed boat.

Restoration practices have changed dramatically. No longer do we insist on creating wholes out of fragments. But we tend to forget that most antiquities that passed through private collections underwent dramatic restorations. The owners of these restored antiquities made very specific decisions about what the restorations would look

like, and thus what we would see. Their decisions generally were motivated less by concern for historical accuracy than by their desires for and beliefs about their collections.

Perhaps the best way to explain the impact of collectors upon their collections is to consider the curious case of Henry Blundell (1724–1810) and his Hermaphrodite. In 1793, Blundell, already one of England's preeminent antiquities collectors, had a problem. He was at a sale of artwork from the estate of William Ponsonby, second Earl of Bessborough. His attention was drawn to a large Roman statue of a reclining figure, its head thrown back in sleep (fig. 1).[2] Blundell, or any other English collector with enough means, would have been much tempted by the figure. Although obviously severed from a larger sculptural group, the figure itself was reasonably complete, with its original head, limbs, and attributes. It had already been restored, probably before its sale to Bessborough. The restorer had flattened the original modeling while polishing away the pitting caused by weathering (still visible in parts of the drapery). Blundell, if he purchased it, would not have to bear the heavy expenses of restoration. And the statue was already in England, meaning that Bessborough had already dealt with the trouble and expense of obtaining an export license or smuggling it out of Italy.

The problem, as Blundell put it in the catalogue of his collection, was that the statue represented "an Hermaphrodite, with three little brats crawling about its breast. The figure was unnatural and very disgusting to the sight."[3] The sleeping figure had female breasts, but the drapery wrapped around its lower body fell open at the waist to reveal male genitalia. Two infants, tucked under one of its arms, wrestled each other, and another nursed from one of its breasts. The figure was a character from Greek mythology: Hermaphroditus, the son of Aphrodite and Hermes. Images of Hermaphroditus with infants are rare but occassionally survive from antiquity, and we are not sure of the message they conveyed. Whatever this message was, Blundell was not happy with it.

In 1793, Blundell was nearly seventy years old and had been col-

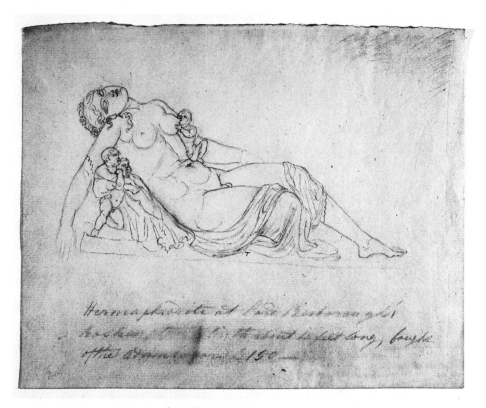

Figure 1. Drawing from the Charles Townley collection of an ancient
Roman statue of a sleeping hermaphrodite with three infants, inscribed
"Hermaphrodite at Lord Besborough's about 4 feet long, bought of the
Adams's for £150," c. 1793. British Museum (2006,1101.1).
© Trustees of the British Museum.

lecting antiquities for almost twenty years.[4] Unlike most other Grand
Tour–era collectors, whose interest in antiquities was sparked by their
post-university trip to Italy, Blundell was slow to develop an interest
in the classical past. He did not take a Grand Tour as a young man,
probably in part because he and his family were Catholic. English
law prevented Catholics from holding public office, and so Blundell
did not need a Grand Tour to polish him for Parliament. Instead,
he led the comfortable life of a country gentleman on his family's
estates near Liverpool. Until his early fifties, he devoted his time to

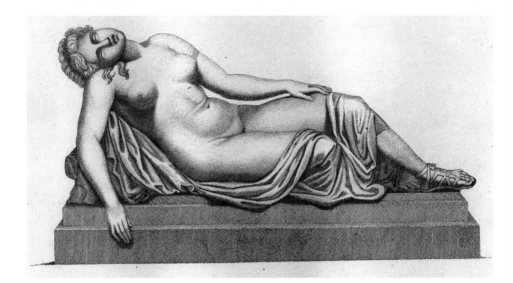

Figure 2. Engraving of an ancient Roman statue of a sleeping hermaphro-
dite, modified to be a sleeping Venus, from Henry Blundell, *Engravings and
Etchings of the Principal Statues, Busts, Bass-Reliefs, Sepulchral Monuments,
Cinerary Urns, etc. in the Collection of Henry Blundell, Esq. at Ince*, 1809.

improving the returns from his properties and renovating his house
and its grounds, but by 1777, with his wife long dead and his proj-
ects completed, he was looking for something else to fill his time. He
found it when, during a "most pleasant ramble" to Italy, he encoun-
tered a friend from boarding school, Charles Townley, whose "great
knowledge in antique marble & the arts not only instructed me but
inspired me with a desire of being proficient in that line."[5] Townley,
a fellow Catholic whose country estate was near Blundell's, had one
of the most extensive private collections of antiquities in England.
His example inspired Blundell to buy a steadily increasing stream
of antiquities as they progressed through Italy: first a few vases and
marble table tops in Naples, then, in Rome, a statuette of Epicurus,
and finally more than eighty marble statues from the English antiq-
uities dealer Thomas Jenkins.

Blundell's purchases were from collections formerly in the hands

of Roman aristocratic families in the Villa Mattei, Palazzo Capponi, and Villa Borioni. The later half of the eighteenth century brought financial disaster for much of the Roman nobility, who were forced to sell the antiquities that they had so carefully accumulated as signs of their grandeur in previous centuries. Blundell, with a large income from his estates, benefited from their misfortunes both on this and on three subsequent trips to Italy. During these trips, Blundell bought antiquities, mostly from Jenkins. Between trips, he employed an agent, Father John Thorpe, with whom he had studied in his youth, who kept him informed of possible purchases coming on the market in Rome.

Both Blundell's travels and his purchases were restricted after 1790 by the French Revolution and then the Napoleonic Wars. Instead, he turned his attention to sales of antiquities from the estates of fellow English collectors. In one strange twist of fate, he purchased the same object twice, once in Rome and once in London. It was the front panel of a Roman sarcophagus. Blundell had paid £10 for it in Rome, buying it from the Villa d'Este, where it had been used in a fountain and had accumulated an encrustation of mineral salts. Its finely carved subject matter—the myth of Phaeton and Helios—was revealed only after Blundell paid for its cleaning. Pope Pius VI learned of the now much more interesting and valuable work and requested that it stay in Rome, and the Catholic Blundell presented it to him as a gift. Years later, the relief was up for auction by Christie's, along with forty-five chests' worth of other art pillaged from the papal apartments by the French and later intercepted at sea. "The above particulars being very interesting to the owner, he was induced to re-purchase it at a high price," as Blundell described, in the third person, his decision to spend 260 guineas to acquire the relief.[6]

Although this relief was unusual in the amount of cleaning required to reveal the subject, all of the works in Blundell's collection —and, almost without exception, all of the works in Grand Tour collections as a whole—underwent a process of intense cleaning and polishing. We can often see the dramatic effect of these procedures

by looking at the hair of ancient statues. The more elaborate the hair-style, the more likely that the restorers left it alone, because of the time needed to remove encrustation, smooth out weathering, and repair minor damages in the elaborate surfaces of curls and locks of hair.[7] The stained, pitted, encrusted, and chipped surfaces of ancient sculptures' hair, especially that on the back of heads (which would have been invisible when placed on display in niches), are good indications of what the entire surface of the works would have looked like when they were first excavated. The contrastingly smooth surfaces of the faces, bodies, and draperies of the sculptures in the Blundell and other eighteenth-century collections were the product of much restoration work.[8] To achieve this smoothness, restorers used a variety of techniques. They bathed statues with hydrochloric acid, saltpeter, or sulfuric acid, smoothed them with rasps, and chiseled and peeled off layers of marble. These techniques removed encrustation and the stains of weathering. They also removed the original surface of the work. We simply have to trust that the restorers were competent enough to follow the outlines of the original surface in the cleaner marble they found beneath it, but there is no way to know for certain. Restoration of this type cannot be reversed.

Blundell accumulated 599 ancient works, many of them sizable sculptures, by the time of his death in 1810. He realized that his expenditures were unusual. Before the Bessborough sale, where he bought the Hermaphrodite along with other works, he wrote to his son-in-law, "You will think me extravagant about them, but if I lay out £1000 it is no great affair to me; so don't lose for a few guineas more than I mention purchasing what I want. The money is no object with me."[9] After the sale, he commented to Townley that "I shall be thought marble mad and very extravagant" but defended himself by insisting that "money is better spent so, than at new markets."[10]

As late as ten years after he had started collecting, Blundell was still insisting to Townley, "I do not aim at a collection, or crowding my home with marbles, nor will I ever build a Gallerie."[11] But five years after this letter, in 1792, he completed an outbuilding on the

grounds of his main residence, Ince Blundell Hall, to display his an-
tiquities. This building, in the shape of an ancient temple, could not
hold the additional works he began to purchase in a renewed spate
of collecting around 1800. In 1802 he began to construct another
building, modeled after the Pantheon. His display of antiquities was
then opened to the public. After tourists from nearby Liverpool over-
whelmed him, he restricted visitors to pre-booked parties, one day a
week, but compiled a catalogue for their benefit as well as a book of
engravings of his more notable works for those who could not visit.
The later project dragged on for years because Blundell refused to
have any "foreigners" in his house to draw the works, and qualified
English artists were difficult to find.

It is from these catalogues that we discover the fate of Blundell's
hermaphrodite: "By means of a little castration and cutting away the
little brats, it became a sleeping Venus, and as pleasing a figure as any
in this Collection" (fig. 2).[12] Blundell's treatment of the hermaphro-
dite was a moralistic manipulation rather than a restoration.[13] But
Blundell's employment of "a little castration" stands within a con-
tinuum of restorations from the Renaissance through the nineteenth
century. These restorations routinely changed the characters of an-
cient works in the name of restoring them to their original appear-
ances (or what these appearances should have been).

We can see the profound effects of restoration at work in yet an-
other sculpture in Blundell's collection that underwent a sex change.
He purchased this sculpture from the Mattei collection, where it had
been identified by Winckelmann as a pregnant woman and had ac-
cordingly been restored as Sabina, the wife of the emperor Hadrian.[14]
Blundell, anticipating its delivery, described the work to Townley
as "my big-bellied Lady."[15] However, before the work reached him,
Blundell was writing his friend to mourn his "poor Lady, after so
many years to have her character impeached . . . particularly after
my having so imprudently confessed my partiality to her; is it
not *très mal fait*, in you to take away Ladies characters, as well as
in Visconti?"[16] Visconti, the papal antiquary and noted scholar, had

compared the sculpture to a figure on a relief in the Mattei collection and reidentified it as a male Egyptian prophet, carrying a waterpot underneath his robe. Before it reached Blundell, the sculpture was re-restored with the addition of a male head and Egyptian attributes.

In the case of this sculpture, both restorers thought that they were completing the work along the lines of its original appearance. The second restoration is probably more correct—but we cannot be certain. The effect of restoring the work based on the model of the male priest is merely to make it much more difficult for subsequent audiences to imagine the fragmentary ancient core of the sculpture as belonging to any other subject.

Blundell's catalogues and letters to Townley provide a view into his curiously paradoxical opinions about the power of restoration to create beliefs about the original subject matter of unidentifiable fragments. In the *Engravings,* he fulminates:

> It is often found difficult to ascertain the primeval characters, or real names, of ancient busts and statues. . . . Where there remains no distinguishing symbol or attribute on the marble, names are often given them by caprice, or from their restorers: for instance, a celebrated statue bought at Rome from Mr. Jenkins, was at that time called a *Venus,* owing to the arm being restored with a mirror in the hand. The figure was afterwards thought not delicate enough for a *Venus;* the mirror was removed, and it was pronounced a *Hebe,* that character being more suitable for it. The owner some time after called it an *Isis,* as a character more mysterious. At present it belongs to the British Museum, and is denominated an *Adriane.*[17]

Blundell recognized that ancient sculptures often share so many similarities that their identification depends on a few, easily lost attributes and that restorers often added attributes, and thus identities, where there had previously been none. And yet, though Blundell commented disdainfully that "when no symbol or attribute can be distinguished on them, it is generally allowed to every virtuoso to

give such names to his busts and statues as he thinks most appro-
priate,"[18] his publications give identifications to almost all his busts
and statues. Despite the notorious difficulties in identifying similar-
looking ancient portrait busts, Blundell's publications provide iden-
tifications for fifty-five of the sixty-three ancient portraits he owned.

A letter to Townley provides a hint of Blundell's state of mind:

> I am quite of your opinion that every statue should have some re-
> mains of its real character, otherwise without its head & extremities,
> it . . . may be made into an emperor or a Merry Andrew or a Bru-
> tus, as that [in the collection of William Weddell] at Newby is so
> dubbed by having a sever countenanced head put on its shoulders
> and hands on with the dagger in them.[19]

Blundell must have believed that he could identify the subject matter
of the majority of works in his collection because he had purchased
works with "some remains of [their] real character"—with some at-
tributes or features that identified their original subject. If this was
so, then he could accept the additional attributes added by restorers,
as long as these restorations merely confirmed the surviving indica-
tions of the work. Thus, for example, he purchased the back of the
head of an ancient marble portrait of the dissolute emperor Com-
modus (identifiable by his curls) and was happy to have a restorer
remove any remaining portions of what must have been a heavily
damaged face, smoothing the surface for the planned application of
a wholly modern marble face (fig. 3).[20]

But Blundell was often very wrong about the "real character" of
the works he purchased. Although he saw a few of them in an unre-
stored condition, when he purchased them from Jenkin's excavations
in Rome, the majority of his purchases had already passed through
other collections and were already restored. Blundell believed that he
could distinguish between the original and restored portions of these
works, but his perception often failed him.

Failing to discriminate between the ancient and the restored por-
tions of works he purchased was not Blundell's only problem. His

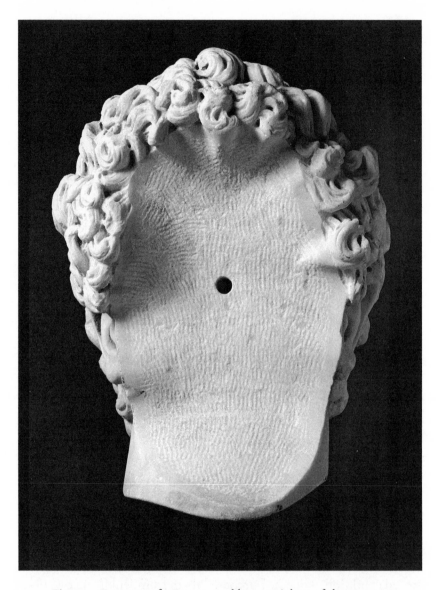

Figure 3. Fragment of a Roman marble portrait bust of the emperor
Commodus, late second century. Liverpool, Merseyside Museum (Ince 438).
Courtesy National Museums Liverpool.

collection features a number of forgeries. Examining these and other eighteenth-century forgeries is valuable because it shows us how blurred was the line between restoration and forgery, and how collectors' desires for their collections served as covert orders to forgers seeking profit. After all, someone who is willing to castrate a statue to make it into a Venus is not very likely to question a pleasing Venus if it is delivered to him readymade.

A porphyry bust of a man in Blundell's collection reminds us that a forgery can be literally destructive of the past as well as figuratively destructive to our knowledge of the past. The bust is identifiable as modern from its technique (slabs of porphyry veneered on a concrete core). A flat, polished patch on the back of the head suggests that the forger obtained the porphyry from an ancient architectural fragment, which was destroyed in the process of making the forgery.[21] Blundell's portrait of Caesar is also a forgery, with "restorations" indicated by incised groves cut into the surface to imitate the joins of ancient and new marble necessary to repair an authentic ancient fragment.[22] Several of the funerary ash chests in his collection are also modern forgeries,[23] and his writings make clear that the forgers took care to make their forgeries convincing by means of accessories. Blundell describes the tear bottle, lamp, and bones that filled one ash chest, inscribed with the name Hylas, when he purchased it. He took these as proof of its authenticity, although its style marks it as an eighteenth-century forgery.[24]

Who were these enterprising forgers? Another strange work in Blundell's collection begins to provide an answer. At first glance, it is a double bust—two heads joined together back to back, with their hair flowing together. Such double-sided works were fairly common in antiquity and were beloved by eighteenth-century collectors. On closer examination, the style of the heads is jarringly different, and modern scholars have concluded that far from being carved as a single work in antiquity, the present object is actually composed of two separate original Roman heads. They were made at least 100 years

apart and were trimmed and joined together by use of a modern in-
tervening spine and base.[25] Blundell's records show that this bizarre
object came from the studio of a man who perfectly understood the
desires of his eighteenth-century collecting clients and their suscep-
tibility to over-restored, heavily manipulated, or completely forged
works: Bartolomeo Cavaceppi (1716–99).

Cavaceppi's skill in restoring ancient statues had been recognized
by Cardinal Alessandro Albani, a Roman collector and dealer and
Cavaceppi's first major patron.[26] Cavaceppi became the official re-
storer for the papal collections as well as an intimate of the art histo-
rian Johann Joachim Winckelmann. He worked for King Gustav III
of Sweden (who visited his studio in 1783), Catherine the Great, sev-
eral Spanish cardinals living in Rome, and, thanks to his close affili-
ation with Winckelmann, a number of noble German collectors. His
greatest success with foreign patrons, however, was with the English.
Both Albani and Winckelmann were well known among English
connoisseurs. As a result, Cavaceppi's studio became a required stop
on the itinerary of all the Grand Tourists of the later eighteenth cen-
tury. He restored antiquities for almost all of the eighteenth-century
English collections of note.

Whether they visited his studio in person or conducted business
via letter or agent, Cavaceppi's clients bought the casts he produced,
the original antiquities he had for sale, and arranged for him to re-
store antiquities purchased from other dealers. Many of the works
that ended up in the collections of foreign collectors passed through
his hands. These hands had a very particular type of skill. In the
words of one critic:

> In this kind of jugglery the Italians excel all mankind—they gather
> together the crushed and mutilated members of two or three old
> marbles, and by means of a little skill of hand, good cement, and
> sleight in coloring, raise up a complete figure, on which they con-
> fer the name of some lost statue, and as such sell it to those whose
> pockets are better furnished than their heads. . . . And the rejoicing

virtuoso treasures up in his gallery another legitimate specimen of the wonderful genius of Greece![27]

Collectors were well aware of the "jugglery" of Cavaceppi and other restorers, but they mostly saw the suspicious motes of marble dust in the collections of others rather than casting out the forgeries in their own.

A statue of Dionysus purchased in the eighteenth century for the collection at Holkham Hall in England was heavily restored in Cavaceppi's workshop, which added the head; the left lower arm; the right upper arm, hand, and wrist; the supporting struts; the lower legs; and the plinth. The purchaser's records list only the right hand and left arm as restored.[28] Cavaceppi took every chance he had to introduce this type of "complete figure" crafted out of small, battered remnants of original ancient sculptures. Cavaceppi did not sign his restorations, but the records of some collectors, which note his services, along with his distinctive style, make his work easy to identify. When he carved new pieces to replace missing portions, he favored tree-trunk supports, with bark peeling back in triangular wedges; bases for busts in the shape of Attic-Ionic columns; and a distinctive selection of added attributes—grapes, pitchers, parchment rolls, flutes—which his figures hold with characteristic spatulate fingernails.

Cavaceppi's restoration techniques for repairing the ancient fragments are also easily spotted, especially the manner in which he joined together ancient pieces and modern replacements with slowly curving edges that are intended to look like ancient, accidental breaks, confusing the viewer as to what is ancient and what modern. The modern portions were carved in new marble or, for smaller additions, made out of plaster or a mixture of plaster and marble dust (or more exotic materials—the eighteenth-century sculptor and restorer Louis-François Roubillac, a Frenchman working in England, was said to use a mixture of plaster, grated Gloucester cheese, grounds of porter, and an egg yolk).[29] Cavaceppi frequently stained, cracked, carefully damaged, and then "repaired" modern additions to make

them look ancient. Then, he reworked and polished the entire sur-
face of the repaired figure to produce a homogenous texture.

The resulting figures do not look undamaged; any moderately
close level of scrutiny reveals that the work is assembled from broken
and repaired pieces. However, Cavaceppi adds so many false breaks
into the modern portions that it is extremely difficult to tell which
portions are new and which are old. His work deceives the viewer
into thinking that the sculpture was recomposed from a complete set
of ancient pieces, broken but found together.

At other times, Cavaceppi reduced rather than amplified ancient
fragments, trimming the well-preserved portions from the broken in
order to produce smaller but seemingly complete works. The upper
portions of full-body statues became busts; sarcophagi became relief
panels; and reliefs became busts, or busts became reliefs, depending
on what he thought would look best.

More interesting and important are the decisions Cavaceppi
made about how to restore the subject matter of antiquities. His res-
torations assigned new identities to anonymous fragments and also
frequently entirely changed ascertainable subjects. The Lansdowne
Discobolus is one of the most notable examples of Cavaceppi's ma-
nipulations (fig. 4). He began with an ancient torso, whose curving
thrust clearly identifies it as an image of a discus thrower—one of
the innumerable ancient Roman marble copies of the popular *Dis-
cobolus* carved by the Greek sculptor Myron around 450 BCE (fig. 5).
Not satisfied with the sales potential of yet another version of this
anonymous athlete, of which several better-preserved versions had
already been found, Cavaceppi turned the torso into a much more
marketable figure from mythology: Diomedes stealing the Palla-
dium, a small cult image on which the safety of Troy, and later of
Rome, depended. Cavaceppi added a left arm with the Palladium; a
right arm with a dagger; the right leg from the knee down and the left
leg from the mid-shin down; and a head which, though ancient, was
not original to the torso. Lord Shelburne paid Hamilton £200 in 1776
for the resulting work, after the dealer sent him this description:

I have never mentioned to your Lordship one of the finest things I have ever had in my possession, as I was not sure of getting a license to send it out of Rome. Now that I have got it safe on board the felucca for Leghorn, I have ventured to recommend it to your Lordship as something singular and uncommon. It is a Diomede carrying off the Palladium. Your Lordship when in Rome mentioned to me particularly subjects of this sort as interesting to you, but besides the subject, give me leave to add that the sculpture is first-rate, and exactly in the style and size of the Cincinnatus [a sculpture which Lord Shelburne had already purchased from Hamilton] to which I mean it as a companion, being a Greek Hero to match the Roman. The legs and arms are modern, but restored in perfect harmony with the rest. . . . Your Lordship will ask me why I suppose this statue to be a Diomede. I answer because it would be to the last degree absurd to suppose it anything else.[30]

There is indeed a degree of absurdity here, but not the type Hamilton claims. The dealer's letter hints at the probable origin of the idea to transform a *Discobolus* into a Diomedes by recalling that the purchaser had "when in Rome mentioned to [the dealer] particularly subjects of this sort as interesting to you" and that the work for sale was "exactly in the style and size of" another antiquity already in the purchaser's collection. Hamilton and Cavaceppi probably worked together to create an object that would find an eager buyer in Shelburne by appealing to his taste for difficult-to-find mythological subjects and his desire to find a work of comparable size to balance a sculpture already on display.

The letter also illustrates the strange complicity of collectors in the manipulations of restorers and dealers, since Hamilton makes no secret of the fact that "the legs and arms are modern," which means that the things that serve to identify the work as Diomedes—the Palladium and the dagger—are also modern. In the end, it seems that dealer, restorer, and customer agreed that it would be absurd to imagine that the statue originally had any other identity simply be-

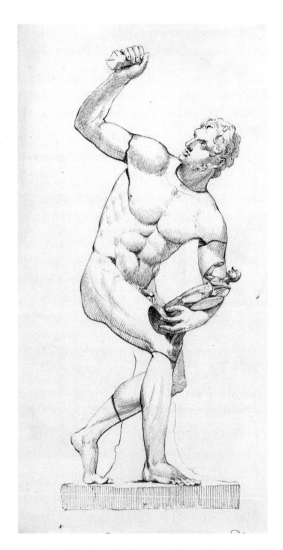

Figure 4. Drawing from the Charles Townley collection of the Lansdowne
Discobolus restored as Diomedes carrying the Palladium, with restoration
indicated by inked lines, c. 1772–1805. British Museum (2010,5006.1686).
© Trustees of the British Museum.

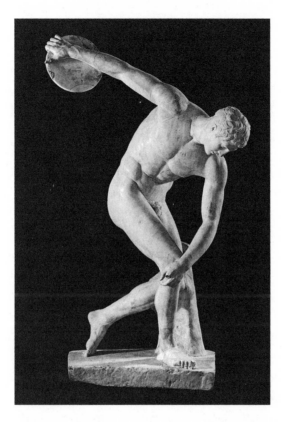

Figure 5. Roman marble copy of a fifth century BCE Greek statue of a
Discobolus, c. second century CE, purchased by Charles Townley in 1791.
British Museum (1805,0703.43). © Trustees of the British Museum.

cause it would be ridiculous to pass up the chance to acquire a work
that fit so well into Shelburne's collection.

Cavaceppi was exceptional in his skill, but not in his aims. He was
the foremost but by no means the only sculptor making similar elab-
orate restorations and recreations in Rome at the time. And he drew
on a long tradition of restoration, dating back to the first Renaissance
collectors of antiquity. In the 1540s, Benvenuto Cellini added an eagle
to a fragmentary and anonymous statue of a boy to transform it into
the mythological figure of Ganymede, Zeus's cupbearer, for Cosimo
de' Medici.[31] The Borghese family ordered even more extensive resto-

rations later in the sixteenth and into the seventeenth centuries, most famously in the case of the *Dying Seneca*. The restorer transformed an ancient statue of an emaciated fisherman into a depiction of the Roman philosopher Seneca committing suicide in the bath by adding a basin inlaid with red porphyry to represent blood (fig. 6).

Not all such extensive restorations were confined to the ancient world. Another example of a Renaissance transformative restoration decorated the façade of the Ca' Zorzi-Bon in Venice, where an ancient Roman bust of an emperor, probably Lucius Verus, was given a halo, an arm holding a lance, and a shield, thus becoming an image of St. George, the patron saint of the Zorzi family.[32]

Another manipulating collector was Ludovico Ludovisi, who was made a cardinal in 1621 by his cousin, the newly crowned Pope Gregory XV. Ludovisi then purchased land in Rome, near the Porta Pinciana, to build a villa. His purchase also included many of the antiquities already decorating the houses and gardens on the property. To these, Ludovisi added whole collections of antiquities, including 102 sculptures he purchased from the heirs of Cardinal Cesi. Ludovisi ordered aggressive restorations for all of his antiquities, even those in a relatively good state of preservation. Though the Ludovisi Ares was missing only a foot and some details of its attributes, it was entirely resurfaced by its restorer, the famed sculptor Lorenzo Bernini.[33]

Other works in the Ludovisi collection are more modern than ancient. One sculptor transformed four unrelated ancient fragments—two torsos and two heads—into a pair of figures, the nymph Salmacis and the object of her love, Hermaphroditus, by attaching the torsos and heads to modern arms and legs. The sculptor added newly carved breasts to one ancient male torso in order to make it into a female figure.[34] This deliberate creation of a Hermaphroditus was diametrically opposed to Blundell's act of castration and shows how dramatically collectors' desires can change the fate of antiquities.

Not all restorations added portions to works. Restorations could also manipulate a work by removing portions, whether as significant

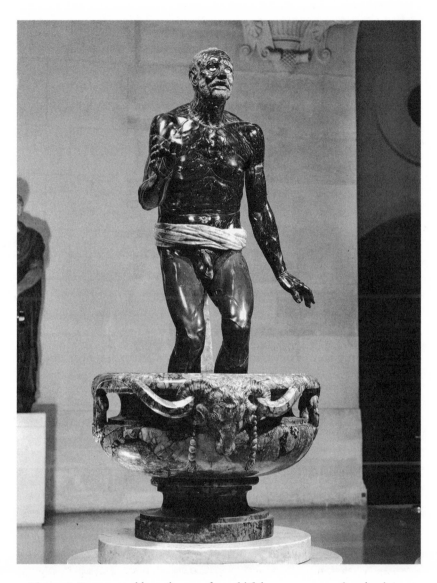

Figure 6. Roman marble sculpture of an old fisherman, restored as the dying
Seneca, c. second century CE. Musée du Louvre (MA 1354). Gianni Dagli
Orti / The Art Archive at Art Resource, NY.

as a penis or some more prosaic part. Blundell himself ordered several more such prunings. He purchased, as he records in the *Engravings,* "a fragment of the lower part of a colossal statue of Aesculapius. . . . This fragment being very unwieldy, it was thought better to separate the feet. . . . The feet and part of the legs serve as two good pedestals."[35] That is, Blundell had the feet chopped off and apart in order to serve as stands for other antiquities. The backs and sides of eight Roman ash chests and lids in Blundell's collections were cut off so that the fronts could be embedded in the interior walls of the Garden Temple.[36] We do not know whether the removed portions were damaged or if the trimming was merely decorative.

Blundell's manipulation of his antiquities to fit a decorative scheme is entirely characteristic of eighteenth-century English collectors. Some collectors sought to avoid expensive restorations by buying antiquities that would fit into niches or other areas already designated for their reception. The Earl of Leicester wrote to the architect for his seat, Holkham Hall, about a Roman sarcophagus that the architect's son, then traveling in Italy, had proposed buying for the collection, commenting that if the dimensions he gave were correct it would

> do to stand before the verd antique side board table in the nich in my dining room as a bason to wash the glasses in, but if so big as to crowd up that nich [could] be of no use to me, therefore I wish you'd send your son a drawing of that nich, wth. the verd antique table on the porphry feet, that is to stand in it, & then he will see how that sarcophagus can stand before it without filling it too much, & if it will stand will desire he'll buy it, whc. I shall leave to his judgment whither to do so or no, now he knows wt. it is designed for.[37]

Here and elsewhere in his correspondence the earl, who accumulated a large collection of antiquities, demonstrates that his main goal was the creation of a pleasing display of paired statues of the right sizes for preexisting niches.[38] He was not interested in the works' subject matter or meaning. Indeed, his plan to use the sarcophagus as a

basin for rinsing glasses during dinner parties shows a rather complete lack of appreciation of its original use.

Another eighteenth-century English collector, William Holbech of Fanborough Hall in Warwickshire, came up with a simpler solution to the problem of ensuring a pleasingly symmetrical display.[39] Having collected an odd number of ancient portrait busts and medallions but wishing to place an even number of works on each side of the entrance hall of his home, he simply created a pair of relief profiles by ordering one complete bust sliced down the middle, applying the resultant profiles to the wall.

Castrations, infanticides, head splittings, and cobbling together of unrelated body parts to make a new creation rise from the dead: today these sound more like elements of the plot of a horror movie than descriptions of the inner workings of a restorer's workshop. Thankfully, the era of this type of restoration is over. The change is usually attributed to the arrival of the Parthenon marbles in Britain. Both sculptors and the general public stood so in awe of the skill shown in their unrestored, somewhat fragmentary state that a consensus was quickly reached that no modern hand could better them. However, the urge to beautify has been slow to fade. As late as the 1930s, the Parthenon marbles were scrubbed with wire brushes to make them more attractively white.[40] Still, contemporary restorers generally limit themselves to lightly cleaning and reconstructing works, and speculative additions to transform anonymous fragments into complete and identifiable subjects are carried out on paper rather than in marble.

The era of manipulative restoration might be over, but its effects live on. Indeed, these effects are even harder to recognize now that we, unlike past collectors, are not so aware of the probability that restoration has occurred. In some cases, past restorations intrude on the present in very physical ways, as when the iron pins inserted to hold together new and old marble pieces rust or expand, staining and cracking the surrounding ancient stone. More often, restorations

continue to function as they always have: convincing the audience that they are looking at a work as it would have appeared in antiquity. Unless we are aware of all the ways in which modern collectors' taste influenced the course of restoration, we cannot distinguish between what is ancient and what is a mistaken vision of antiquity.

At times this is because the restorations are so confusing that modern scholars cannot agree which portions, if any, are ancient on a particular sculpture. This is true, for example, of a statue of Isis-Fortuna, purchased in Rome in 1749 for the collection of the Earl of Leicester at Holkham Hall. One prominent scholar argues that the statue is entirely a modern forgery from Cavaceppi's workshop, proposing that Cavaceppi must have carved the entire statue, then damaged it by breaking off sections and reattaching them as restorations after using chemicals to deteriorate the surface of the core fragment. Another scholar argues that the core of the statue is antique, although heavily restored.[41]

These types of debates may never be settled, especially given the limitations of the scientific testing of marble. We can sometimes narrow down the quarries from which particular types of marble came, which is helpful if the core ancient statue is Greek and the later restorations were carried out elsewhere, using stone from a morphologically different quarry.[42] But we do not yet have reliable scientific means of dating stone statues. Stone is old, whether lying in a quarry or shaped into a statue. Some scholars believe that certain chemical changes on the surface of cut stone develop over long periods of time and thus think that modern additions or complete forgeries can be distinguished from ancient originals. Other scholars have convincingly argued that such changes can be reproduced in a modern laboratory.[43] In any case, such examination is not helpful when, as happened with almost every statue collected before the twentieth century, the ancient surface has been stripped away in the course of restoration.

Restorations are thus not merely harmless additions that we can mentally or physically remove in order to see the original. The fate of Roman frescoes is another surprisingly little known example of the

pervasive way in which the original collectors' taste continues to shape the way we see the past. The Bourbon kings of Naples controlled the excavations at Pompeii and Herculaneum, taking the ancient artworks to decorate their palaces and form a private museum. The painted frescoes that adorned the walls of many rooms in the houses and businesses of the cities were one of the most admired products of the excavations.[44] These works were created as harmonized, whole-wall interior decoration for entire houses, with individual figural panels, surrounded by vegetal, architectural, or abstract decorative work, echoing or making reference to panels in the same or other rooms.

In the eighteenth century there was a rigid hierarchy for paintings. Historical and religious subjects could be celebrated in large canvases, but still-life, erotic, and genre works were limited to much smaller "easel" paintings. Used to these rules for paintings, the kings ordered the excavators to search out the figurative scenes and cut them out of the surrounding decorative work. These ancient still lifes and erotic and mythological figural panels coincidently were similarly sized as the same subjects in eighteenth-century art, and the kings were thus happy to frame and display them as if they were small paintings on canvas.[45] Looking at any book of ancient art history published today will reveal that we still tend to think of Roman wall painting in the small snippets cut out of the walls of Pompeii and Herculaneum in the eighteenth century. Contemporary reproductions show individual scenes without reference to their surrounding elements, even when these have survived. We continue to see the past through eighteenth-century eyes.

Even when we are aware of the problem, we cannot always make an effort to reconstruct the past more faithfully. Another practice of the Bourbon kings has imposed their taste on us even more dramatically. The court was always extremely protective of its prerogative and sought to prevent the theft and sale of works from the ancient cities to other collectors. However, it soon became clear that the cities contained many hundreds more frescoed panels than the royal museum

could accommodate. The excavators cherry-picked the finest for the royal collections. Fearful that any panels left on the walls would be surreptitiously removed, from 1757 to at least 1763 the court's official orders were to deface the remaining panels so that they could not be sold. Our knowledge of Roman wall painting is filtered not only through the chance survivals of time but also—or mainly—through the taste and power of long-dead collectors.

The Bourbons were not quite as manipulative of the past as was a certain Furstenberg prince, whose workman discovered a hoard of several thousand ancient Celtic gold coins in 1771. Despite being the chairman of his national scientific society, the prince ordered nearly all of them melted down and reminted with his own portrait.[46] But the line between restoration and transformation of the past is closer than it might at first appear. Decisions about restoration are made on the basis of what the owner believes about the past and his or her own relation to it. Rarely are these beliefs as simple as those held by the prince who thought that the ancient coins' highest purpose was to glorify him. More often, the beliefs are more subtle and thus more difficult to ascertain.

Take, again, the case of Blundell's Hermaphrodite. The changes he ordered were not motivated simply by moralistic qualms or a distaste for the "loathsome." If that were the case, removal of the male genitalia, and perhaps of the nursing infant, would have sufficed to erase anything overtly strange or sexually suggestive. But Blundell ordered the removal of all three infants, including the pair playing by the side of the main figure. He did so in order to complete his transformation of the sculpture into a figure of Venus simply because this was the identity of the statue he wished to have for his collection.

Collectors from the twentieth century to the present have, like Blundell, expressed their identities through their collections and thus have also wished to manipulate these collections to better express what they want to communicate about these identities. Modern collectors no longer manipulate the physical structure of antiquities—but this does not mean that manipulation is no longer possible.

4

C H A P T E R

Irresistible Forgeries

Accarding to one scholar, forgeries, like sexually transmitted diseases, are "the punishment for excessive desire and bad judgment."[1] And as with a disease, we often think that science will cure the infection by revealing what is a forgery and what is authentic.

If only it were that simple. As we have seen, there are no reliable means of testing the age of stone sculpture. Indeed, one of the most-analyzed marble works in the world, the Getty Kouros, is exhibited with the label "about 530 B.C., or modern forgery."[2] We ought to be able to determine whether or not metal artifacts are authentic because different ages and cultures have different characteristic impurities and admixtures in their gold, silver, bronze, and so on. But we simply have not collected and tested enough samples of genuine antiquities to form a reliable body of comparative information. When there are reliable tests, such as the use of thermoluminesence testing to determine the age of fired clay artifacts, forgers have found clever ways around them. In the case of terra-cottas, forgers build a new work around a chunk of authentically ancient clay, so that the tested sample, drawn from the ancient piece, will deceive the buyers into thinking that the whole work is ancient.[3]

Forgers are enterprising. Why not be, in a field where the rewards are high and the punishments are low and unlikely to be brought to bear by buyers who are more willing to cover up embarrassing mistakes than make known the presence of forgeries in their collections?

The Romans describe the production of falsely aged and worn marble and silver statues falsely signed with the names Myron, Praxiteles, or other famous ancient Greek artists.[4] Forgers have operated continuously since then, aging their creations by burying them, baking them, breaking them—even by feeding small works, such as carved gems, to turkeys so that the polished surfaces could be gently scuffed by digestive processes in the craw.[5] Some forgers specialize in pastiches, knitting together ancient parts with new enhancements. For example, someone removed the top of an ancient clay lamp now in the British Museum and substituted a new decorative panel with an erotic scene more likely to appeal to a modern buyer.[6]

Strict export controls on antiquities create fertile soil for forgeries. Marking certain objects as special and restricting the supply stokes the desire to own examples. At the same time, the controls prevent buyers from seeing authentic examples to compare with a potential purchase. The English artist Richard Evans specialized in forging fragments of mural paintings from Pompeii and Herculaneum. Such paintings were nearly impossible to procure, thanks to Bourbon control of the sites. The British Museum and the Victoria and Albert Museum own two examples of Evans's work, presented to them as antiquities in 1865 by Sir Matthew White Ridley, who believed they had been found in Rome.[7] Such forgeries could cater to specific tastes. The excavations at Pompeii and Herculaneum produced a large number of ancient erotic statuettes and wall paintings. As their fame spread, so too did the desire to own them. One forger who took advantage of this desire was Giuseppe Guerra, a mid-eighteenth-century Venetian artist who specialized in producing fake frescoes featuring enormous figures of Priapus.[8]

Forgeries are often accompanied by stories designed to distract the purchaser from closer inspection of the object itself, usually by leading the purchaser to believe that he needs to act quickly while he has the opportunity. A claim that other collectors are avidly pursuing the object can inspire the purchaser to rush to beat his rivals, and the suggestion that authorities are closing in on a work's whereabouts

in order to seize it for the state can lead the purchaser to agree to its being hastily smuggled out of the country. When pressed to make swift decisions, a buyer has no time to conduct the careful inspection that might reveal a forgery. Another, related tactic is for a dealer to convince the purchaser it would be insulting and impolitic to bring up the possibility that he might be selling a forgery, as the purchaser will need the dealer's services for help with future purchases, export paperwork, or so on.

A crafty dealer can mix together all of these elements, as did Hamilton when writing to Townley in 1774, attempting to convince him to buy a portrait bust of the Roman empress Sabina. After providing a detailed, but imaginary, description of the excavation of the bust—which is in fact an eighteenth-century forgery—Hamilton applies the spurs:

> Upon receiving this bust . . . I got it carried up to my painting room, to be out of the way of people till I gave it the aquafortis, I happened to go out for half an hour on business & upon my return found the present [papal] Treaserour with Visconti [the papal antiquarian] in raptures with it in so much that it was fixed for the Pope, my demand being 400 scudi; this done I had visits from different people & some of those rich such as Lord Clive & Mr. Grenville. . . . Some days after they heard that it was secured by the Pope, its reputation begun to increase in proportion to the impossibility of possessing it, & I believe that latterly they woud have given any money for it. . . . The fact is that Lord Clive nor other person coud ever aspire at this acquisition without a special order from the Pope.[9]

Hamilton's letter informs Townley that, though he attempted to keep its existence a secret, the bust was so remarkable that it had already inspired admiration and offers from the papal collections as well as by prominent English collectors. The letter claims that only Hamilton could help Townley acquire the bust, first by persuading the pope to relinquish the right of purchase he held over every newly discovered antiquity, and then by honoring his special relationship

with his loyal customer and selling it to him instead of its many other admirers. This promise contains an implicit threat. Hamilton's privileging of Townley as a customer would come to an end if Townley did anything as foolish as not trust him to tell genuine from false antiquities. Few collectors could resist such a combination of threats and promises.

Hamilton's elaborate story about the excavation of the bust is not surprising, since forgers and unscrupulous middlemen have also long perfected the skill of making up stories to explain the origins of a forged work. Sometimes a forgery is passed off as a long-lost acquisition unearthed in the attic of a world-traveling grandfather. Sometimes the forgery is literally unearthed, as was the case of the "inexhaustible well of Orvieto," in which forgeries were buried at night to be dug up as antiquities the following morning under the eyes of nineteenth-century visitors.[10] And sometimes the seller, like Hamilton, provides detailed but entirely false descriptions of the archeological context of the object.

The noted eighteenth-century English connoisseur Richard Payne Knight owned a brown onyx cameo carved with the head of Jupiter and signed with the name Dioscorides, a famed ancient Roman gem engraver. Although the cameo is not ancient, but rather a neoclassical work, it was supplied to Payne Knight with a "certificate of authenticity," which explained that the gem was found in excavations for the foundation of the garden of Santa Trinità de' Monti in Rome in 1576.[11] Of another cameo head of Jupiter in his collection, this one in white onyx, Payne Knight commented both on its perfect state of preservation, claiming that its ancient polish could still be seen, and on the fact it was found when a marsh was drained. A gem lost in a marsh for thousands of years cannot have retained its perfect polish. The bold, harsh style of the carving, typical of nineteenth-century gem engraving, suggests that the cameo was manfactured shortly before Payne Knight bought it—along with the fiction of its find-spot.[12] Payne Knight, though he considered himself an expert in ancient art, was fooled by these forgeries. Indeed, he was fooled by them precisely

because he considered himself an expert, for the easiest way to convince a collector to buy a forgery is to appeal to his self-conceit of being someone uniquely qualified to tell geniuine from false.

But this chapter is not about the creation or the detection of forgeries; it is about their collectors. This is a much less examined aspect of the question of forgery. Usually, we assume that the purchaser of a forgery is merely ignorant or incautious. In reality, the relationship between collectors and forgeries, like the relation between collectors and manipulated antiquities, is much more complex. Forgeries reveal collectors' desires and motivations even more clearly than restorations. A restoration must begin from some actual and perhaps unwieldy fragment of the past. A forgery can exactly mirror what the collector wishes were true about the past and his connection to it. Nowhere is this complex web of relationships more evident than in the cases in which the forger and the collector are one and the same.

Thomas Herbert, the eighth Earl of Pembroke (c. 1656–1733), had a respectable public career: First Lord of the Admiralty, Lord Keeper of the Privy Seal, and president of the Royal Society.[13] But as he aged, he became more and more eccentric, as one visitor, William Stuckley, describes:

> He is very busy from morning to night in marshaling his old fashioned Babies . . . he is distributing them in proper classes, such as Busto's, Inscriptions, basso rilievos, Statues, etc. These he is placing in distinct Rooms, his Egyptian, Syrian, Lydian, Thracian, Greek, Roman Marbles. Then he is mustering by themselves the old Greek Persons, the learned Persons, the Consular, the Emperors, the Divinities, etc. So that you may suppose that he generally walks 10 miles a day in his own house and sometimes in his Slippers and sometimes is so busy that unless Ladies come to visit him he will fob off his beard (as he calls it) for two or three days.[14]

Pembroke had invited Stuckley, a noted antiquarian, to catalogue this collection of antiquities, displayed in the rooms and gardens of

68 IRRESISTIBLE FORGERIES

Wilton Hall. Stukeley soon quit the project, unable to work because of the constant interference of his unshaven, beslippered, constantly prowling and rearranging host. Instead, Pembroke handwrote his own rambling description of his collection of 133 busts, 36 statues, and 15 bas-reliefs, in a "Book of Antiquities at Wilton."[15] Pembroke purchased the bulk of these works from the sale of the collection of Cardinal Mazarin, with more pieces coming from sales from the Arundel collection.

Pembroke believed that he was an exacting buyer. He did not purchase small antiquities, carved gems, or undecorated ash urns because he though these were too repetitious. He distrusted restoration and thus preferred not to buy damaged works. He occasionally made exceptions, commenting on the restoration of several torsos he purchased from the Arundel collection that they "look now well with their new Heads on."[16]

Far more problematically, Pembroke had a number of other requirements for his purchases. He claimed that he would not buy any modern copies, any works not carved either in Athens during the classical age of Greece or in imperial Rome, or any anonymous portraits. Even during his lifetime, when his collection was respected as the largest and most learned accumulation in Britain, there were doubts about how able Pembroke was to accomplish his lofty goals:

> Sir Isaac Newton, though he scarce ever spoke ill of any man, could scarce avoid it towards your virtuoso collectors and antiquarians. Speaking of Lord Pembroke once, he said, "Let him have but a stone doll and he's satisfied. I can't imagine those gentlemen but as enemies to classical studies; all their pursuits are below nature."[17]

Subsequent observers have tended to agree that Pembroke was not the classical scholar he considered himself to be, since the majority of the works in his collection are modern forgeries. When Townley visited Wilton in the later eighteenth century, he annotated a copy of the guidebook, concluding that 45 of the 275 items he saw were "of sufficient merit to be admitted into a collection of marbles," while

the rest were "modern," "mere defaced rubbish," or "mutilated so much as to be unworthy of notice."[18] Frederik Poulsen, when examining the collection in 1968, determined that only 22 of the 142 busts then remaining at Wilton were ancient.[19]

Pembroke was well aware of the problem of forgeries, but he boasted of his ability to spot them. One visitor recalled being shown an entire collection of fake ancient coins:

> a strange variety of counterfeits, in some the metal genuine, but inscription false; in others, one side of the medal genuine, the other counterfeit; in others, one part of the metal right, the other side soldered to it wrong; with a medal of the two famous Paduan brothers, whose counterfeits are not only hard to be distinguished from the originals, but to be preferred to bad ones, though genuine.[20]

And yet, the "Book of Antiquities" describes a number of unquestionably modern works as ancient and gives elaborate details about the histories of these objects. One of the stars of the collection was a relief panel showing the mythological hero Curtius on horseback, fulfilling the gods' demands to sacrifice himself by leaping into a split that had opened up in the ground. Of this relief, Pembroke wrote, "It is the finest Work by a Greek Sculptor, brought from Corinth by Polybius who was sent thither by Scipio after it was burnt." In reality, the relief is wholly modern. Even if it were ancient, it would be impossible to verify the truth of the very specific details Pembroke claims, such as the identity of the person who brought the relief to Rome. And the details themselves are not credible per se: it is impossible to believe that a Greek sculptor in Greece would have concerned himself with an obscure Roman foundational myth before Corinth's conquest by Rome.

Pembroke made many other improbable claims about his collection. He repeatedly describes as ancient pieces that were known to be modern in the collections from which he purchased them. He told Stuckley that he owned "the three oldest Statues in the World."[21] He was so proud of the near completeness of his collection of imperial

portraits that the "Book of Antiquities" notes that "no one of the Emperors is wanting" from Julius Caesar to Alexander Severus. He did admit that his collection was missing a few subsequent emperors but explains this by writing that "several after him [Alexander Severus] lived not long enough to have any [portraits]."[22] That is, his collection was deficient not because it lacked the portraits of these short-lived emperors, and not because any such portraits were made but did not survive into the modern world, but because no such portraits were ever made at all!

Pembroke was obsessed with connecting the works in his collection with known personalities from antiquity. He ordered Latin or Greek inscriptions carved into his sculptures in order to cement the identities he had "discovered" in the course of his researches (or within the reaches of his imagination). The later eighteenth-century art collector and wit Horace Walpole described the results: "An ancient virtuoso indeed would be a little surprised to find so many of his acquaintances new baptized. Earl Thomas did not, like the Popes, convert Pagan chiefs into Christian; but many an emperor acts the part at Wilton of scarcer Caesars."[23]

Pembroke was not the most extreme of those who desired to possess identifiable ancient portraits. Duke Albrecht V of Bavaria and his successor, Wilhelm V, were so insistent on acquiring ancient portraits for their Antiquarium in Munich in the later sixteenth century that their agent, Jacopo Strada, ordered restorers to recarve the busts he purchased, using ancient coins as models, to be better likenesses of the desired emperors.[24] But Pembroke's mania for inscriptions far outpaced that of many collectors.

Restorers often added inscriptions to any objects, such as ash chests, that had a panel for text in cases where this text did not survive, due to the weathering away of the original painted or carved lettering.[25] Restorers would usually smooth the surface of the panel before adding a new inscription, but sometimes they did not bother. One ash chest in the Blundell collection still shows traces of the original inscription around the edges of the new one.[26] And inscriptions

were not the only things added to otherwise genuine antiquities. Undecorated ancient vases often tempted sellers to add figured scenes, either by painting them on or scratching though the ancient glaze.[27]

But Pembroke was not fooled by inscriptions added by restorers. Rather, he was the one adding them. And inscriptions giving illustrious names to anonymous portraits were not the only questionable writings carved into Pembroke's collections. One ash urn gained a new inscription identifying it as the final resting spot of the ancient Roman poet Horace. Pembroke was also interested in inscriptions in archaic Greek, and collected many examples. But after negotiations with the counsel in Smyrna failed to produce examples of some of the early inscriptions he wanted, he had similar inscriptions carved on items already in his collection. A returning visitor noticed that one of Pembroke's altars had gained a new archaic inscription and a new figural relief since his last visit.[28] And no less than three of his statues and one relief were inscribed with the name of the sculptor Cleomenes. This name is mentioned only once in ancient sources, but it was carved at some point during the modern era into the base of the famed Medici Venus in Florence. Pembroke's Cleomenes signatures are forgeries of a forgery.

Pembroke, padding around Wilton Hall in his slippers, unshaven and plotting his next inscription, combined the collector and the con man. But there have been collectors who were even more systematic manipulators of forgeries. One of the most fascinating was Prince Stanislas Poniatowski (1754–1833), who inherited a small collection of ancient, Renaissance, and modern carved gems from his uncle, King Stanislas Augustus of Poland.[29] By 1791, Poniatowski was living in Rome, dedicated to using the income from his vast estates to increase the ancient portion of his gem collection. Poniatowski became known for this collection despite the fact (perhaps because of it) that he allowed few others to see it, although he did write and publish a catalogue of his gems in 1831, shortly before he died.[30]

The catalogue reveals that most of Poniatowski's gems were of

similar size and shape: large ovals with flat or lightly convex faces. Poniatowski's taste in subject matter was similarly strict. The gems are almost all portraits or fairly elaborate scenes from mythology, usually drawn from Ovid, Homer, or Virgil. Most astonishingly for Ponia-towski's contemporaries, 1,737 of his gems bore signatures of ancient gem carvers. A characteristic example from the collection is a carved oval cornelian with a prominent signature reading "Dioskourides" running along the bottom. It shows a relatively obscure but still iden-tifiable mythological scene, the story of Zeus and Kapaneus (fig. 7). Kapaneus was a hero, one of the seven who vowed to conquer the city of Thebes to restore its rightful ruler. Kapaneus had boasted that not even Zeus could prevent him from completing his mission, and for this presumption Zeus killed him with a lightning bolt as he scaled the city walls. The gem shows Zeus on the right, identifiable by his characteristic curly beard and accompanying eagle, about to hurl the lightning bolt at Kapaneus, who interrupts his charge toward Thebes to look back over his shoulder at the deity.

The skill of those who were able to carve the exquisite detail of these miniature scenes into precious or semiprecious stones means that engraved gems have been highly valuable since antiquity. In the eighteenth century, however, collectors and scholars began to appre-ciate the carved signatures on some of these gems. The wider dissem-ination of ancient writings that mention gem carvers by name and the increase in publications of images of known signed gems allowed connoisseurs to know whether the signed gem they owned was the product of someone famous in antiquity or, at least, someone whose other works had also survived.

Forgers had long been crafting "ancient" carved gems, but the task was always a difficult one. The work requires the skill of a great sculptor along with keen eyesight and an ability to work with tiny tools in an unforgiving material. Always alert to changes in taste, forgers were quick to realize that adding a signature to an existing gem had become a profitable maneuver—and a far easier one than carving an entirely new gem. Dealers were complicit in the addition

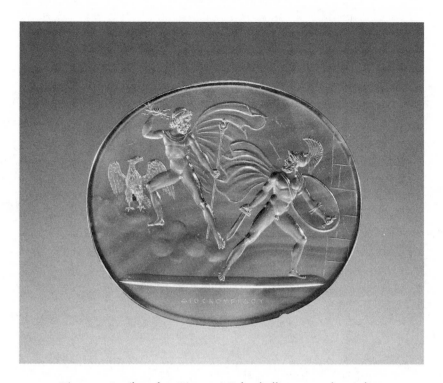

Figure 7. Attributed to Giovanni Calandrelli, engraved carnelian
gem of Zeus and Kapaneus, c. 1816–1827. H: 3.4 x W: 3.9 x D: 0.3 cm.
The J. Paul Getty Museum Villa Collection (83.AL.257.9), Malibu,
California, Bequest of Eli Djeddah.

of false signatures. Customers who expressed a preference for signed
gems usually got what they wanted, even when this meant adding a
forged inscription to an existing ancient gem.[31]

Sometimes the process of the creation of a signed gem was com-
plicated. In 1724, Cardinal Ottoboni's collection in Rome included an
onyx cameo carved with a mythological scene of Meleager offering
the Calydonian boar to Atalanta.[32] The cardinal believed the cameo
to be ancient, but its style, with high relief and projecting, undercut
limbs, mark it as a sixteenth-century creation. The cameo was signed
in Greek characters with the name "Sotratus," which is one letter re-
moved from "Sostratus," a gem engraver praised in ancient Roman
texts. Such a skilled artist would hardly have left a letter out of his

Figure 8. Jacques Louis David, *The Sabine Women*, 1799. Musée du Louvre
(3691). © RMN-Grand Palais / Art Resource, NY.

own name. The signature was most likely added in the early eigh-
teenth century, making this gem a double forgery.

We should not judge those who were taken in by added signa-
tures too harshly. It remains extremely difficult to distinguish genu-
ine from forged examples. A forged signature can be copied more or
less exactly from a genuine example, whereas reproducing an entire
figural scene would be a clear sign of forgery. But despite such dif-
ficulties, both the style of the figures of Poniatowski's gems as well
as the sheer number of signatures were suspicious to the scholar
Nathaniel Ogle. Ogle examined them upon the request of Colonel
John Tyrell, who had purchased 1,140 of the gems when they were
auctioned at Christie's in London in 1839, following Poniatowski's
death. Tyrell paid £65,000 for the collection, as well as incurring

the expenses of an elaborate new catalogue illustrated with photo-graphs.[33]

Desperate to protect his large investment, Tyrell battled Ogle in a series of newspaper articles, arguing that it was "not probable that a nobleman of [Poniatowski's] high character and honour would have asserted that which he did not believe to be true."[34] Sadly for both Tyrell and the concept of the inviolate honor of the nobility, the publicity surrounding the fight between Ogle and Tyrell led to the revelation that not only some, but *all*, of the gems from Poniatow-ski's collection were fakes—and that he was fully aware that they were. Artists came forward to reveal that Poniatowski had ordered his gems from contemporary Italian gem carvers. He then paid other engravers to add the false signatures.

In retrospect, this seems obvious. How else would Poniatowski have been able to form a collection of such striking uniformity of style, subject matter, and shape? How else would he have managed to find over 2,000 beautiful and perfectly preserved gems without any of them having been previously known or published? And, at least to our eyes, the style of the gems is clearly neoclassical. In the case of the Kapaneus gem, which has been attributed to the Italian artist Giovanni Calandrelli, both Zeus and Kapaneus stand in similar postures, with one bent and one extended leg and with their heads turned back over their shoulders, which the carver copied almost di-rectly from the figure of Romulus in the influential 1799 neoclassical masterpiece, Jacques-Louis David's *The Intervention of the Sabine Women* (fig. 8).

Many collectors have been fooled by forgeries. But unlike the col-lectors who were deceived into thinking that they were purchasing genuine antiquities, Pembroke and Poniatowski were fully complicit in the creation of forgeries. Neither was motivated by profit since neither sold the resulting forgeries; indeed, Poniatowski went to con-siderable expense to purchase the gems and publish his catalogue.

Pembroke's reputation, like Poniatowski's, did not long survive his death, although the results in his case were more tragic. Poniatow-

ski's gems are quite beautiful, and though less valuable than if they were ancient, they are still today sold for high prices.[35] By contrast, growing knowledge of the prevalence of forgeries in Pembroke's collection tarred his genuine antiquities with the same brush, and the works were sold as decorative items by his heirs or simply neglected. A visitor to Wilton Hall in 1810 described "floors . . . half-rotten, and the poor antiques, thrown about higgledy-piggledy, sans nose, sans fingers, sans every other prominent member, form a marble field of battle, half melancholy, half ridiculous."[36]

Poniatowski did not leave evidence of his motivations for forging an entire collection of antiquities, but it seems that he was motivated by the desire to outdo his fellow collectors and maintain his reputation as a gem expert.[37] Pembroke's motivations were a bit more complex. His explanation for why he preferred to collect portraits above other types of antiquities begins to explain why he was driven to forgery. Using the third person, Pembroke described portraits ("Persons")

> not only as Ornamental Furniture, but more *Instructive & Pleasant* . . . to those who have read of them; and an *Incitement* even to young Folks (as my Lord has observed among his Children) by *seeing* the Persons to *learn* something of them, both by Questions, & Reading the Works of such Learned Persons.[38]

For Pembroke, then, the purpose of collecting physical antiquities was to ensure a connection to certain past personalities.

Many collectors have used their collections to reinforce their sense of spiritual identity with some version of the past, as when British Grand Tourists claimed connection to republican Rome. As Sir Thomas Roe put it in a 1626 letter to the Countess of Bedford, antiquities allow this type of connection to the past because they "carry in them a shadow of eternity, and kindle an emulation of glory, by seeing dead men kept long among the living by their famous deeds."[39]

But Pembroke's collecting behavior bears a key difference from these other collectors, who may have been fooled by forgeries but

who did not deliberately seek them out or create them. Pembroke began with an idea of the identity he wanted to possess, both for himself and for his children (seven sons and six daughters in the course of three marriages), and then proceeded to create a collection to support this identity. While other collectors who emulated the past sought to purchase genuine antiquities, Pembroke was not satisfied with the available authentic material. Instead, he forged a past fitting in with his delusional self-conception as brilliant classical scholar and a collector with an astounding ability to possess the choicest works from antiquity. If his collection fooled its visitors about the past, it would also fool them about its owner.

Pembroke and Poniatowski are rare (although by no means unique) in their knowing deployment of forged works. But the impulse they show—of manipulating the past to use it to support their self-conception—is a very common one among collectors. Instead of creating physical forgeries, many collectors have elaborated fantastical visions of the past and then inserted themselves into these visions in order to claim the identity they imagine for themselves in the present. They forge identities.

One of the most enterprising of these collectors was Christina, queen of Sweden (1626–89), who used antiquities as part of her master plan to change her country, her religion, and even, it seems, her gender. Christina was born a boy.[40] At least, as she somewhat wistfully recalls in her memoirs, she was thought to be a boy for a while, long enough for her mother's attendants to announce her as a prince to her father. They had been fooled by the hair that covered her body, her harsh, strong cries, and their hopes that this pregnancy would finally produce a male heir, unlike the short-lived princesses who had come before her.

King Gustavus Adolphus, though he soon learned that his vigorous child was a daughter, still needed an heir. His younger brother had died, and there were no other legitimate males in his family eligible for the throne. The problem was urgent. The king was in his early thirties when Christina was born, but he correctly anticipated that

his life would not be a long one. He was a famed military commander in a tumultuous era of near-continuous war, and had led Sweden's armies since his accession to the throne at age sixteen. He died in the Battle of Lützen in 1632, when Christina, an only child, was six years old.

But Gustavus had arranged for the young Christina to succeed him. He ordered that she have the education of a prince, and so she learned to ride, fence, and hunt like a boy. She studied philosophy, classical literature, mathematics, and astronomy, and later claimed that she learned to speak fluently in nine languages, including Latin, Greek, Hebrew, and Arabic. Not trusting his wife, Gustavus appointed a chancellor to supervise Christina's education and to rule as regent until she assumed the throne. The chancellor effectively removed Christina from contact with her mother, who went insane upon her husband's death. She insisted on having the king's coffin reopened nearly every day so she could kiss and touch his body. Gustavus was not buried until nearly eighteen months after his death, when the chancellor overruled the queen mother's orders and posted guards to ensure that she did not further embrace him.

Christina wrote in her memoirs that she was happy to "escape" her mother, who "could not bear to see me because I was a girl and because, she said, I was ugly."[41] Unlike her famously pretty mother, Christina was not a beauty. Her portraits are heavily idealized, but descriptions by observers and an examination of her skeleton carried out in the twentieth century reveal that her face was dominated by a beaky nose and that she had a hunched back and one leg shorter than the other.

Christina thought that her masculine education was a gift—a way to avoid what she considered the awful deformity of being a woman: "I escaped, even in a spiritual sense, the feebleness of my gender; my soul as well as my body having been rendered masculine by the grace of God."[42] Sentiments about the inferiority of women appear many times in her writings, which are filled with such opinions as, "The female sex is a great embarrassment and a great obstacle

to virtue and merit. This fault is the greatest that one could have; it is practically uncorrectable and very few escape with honor from this quandary."[43] At least once she thought that the grace of God was literally rendering her masculine: in 1682, in her mid-fifties, Christina spent a few days believing that she was in the process of regenerating into a man, although what she took to be an emerging penis was probably a prolapsed uterus.[44]

As Christina's power grew, especially after she became queen upon turning eighteen, she discarded or modified the expectations placed on her as a female. She seems to have begun dressing in almost wholly masculine clothes after a physician told her that she had made herself ill due to the stress of trying to be feminine.[45] Her political advisors grew concerned about her reluctance, and then outright refusal, to marry.

In 1654, Christina abdicated the throne in favor of her cousin; when asked why by the Senate, she answered that she was not made for marriage and her intentions had not changed, though she had prayed that they would do so. But they did not, as was signaled by her decision to travel for several weeks after her abdication in men's clothing, incognito as "Count Dohna." This proved a thin disguise in the light of the publicity surrounding her abdication, which fascinated Europe. Many wondered about the meaning of the curious behavior of the recent queen. One observer recorded some of the "strange stories of the Swedish queen with her Amazonian behavior," writing that it was believed "that nature was mistaken in her, and that she was intended for a man, for in her discourse, they say, she talks loud and sweareth notably."[46]

Another factor in her decision was her desire to convert to Catholicism. She had been receiving secret instruction from priests covertly sent to Sweden, a Protestant stronghold. After abdicating, she made her way to Rome, where Pope Alexander VII received her in triumph. As a Protestant who gave up a throne to come to the True Church she was a great prize for the church.

In Rome, despite persistent financial difficulties, Christina's col-

lecting impulse came into full flower. She had shown an early interest in collecting, although she focused mainly on rare books while she was in Sweden. The difficulties of travel to her remote capital meant that she rarely had access to other types of artistic goods. She did manage to acquire a few antiquities as booty from the Thirty Years' War when, in 1648, the captured art collections of Rudolph II were taken from Prague to Stockholm. Around the same time, she dispatched agents to Italy, Germany, and Holland to purchase antiquities, including coins and sculptures. Most of these antiquities remained in Stockholm after her abdication, and the majority were lost when the royal palace burned in 1697.

In Rome, Christina rented the Palazzo Riario and decorated it with over fifty large ancient sculptures, as well as other smaller antiquities. She purchased some of her sculptures from Roman noble collections, including the Mattei, Del Drago, Clementini, and Savelli. Others she obtained through the excavations she financed in Rome's Palace of Decius, Baths of Diocletian, and another site near San Vitale.

Christina, always short of funds, was also capable of resorting to less regular ways of adding to her collections. A long letter from Monsignor Falconieri to Cardinal Leopoldo de' Medici, written in 1671, illustrates her machinations after she learned that Falconieri had acquired an ancient metal mirror with a bas-relief of the Three Graces:

> It is with no ordinary mortification that I am compelled to bring to Your Highness' attention what has befallen me with the Queen of Sweden concerning a particular antique mirror, both the acquisition and the loss of which I must announce to Your Highness in the same breath. . . .
>
> Last Tuesday after dinner I was called to attend the Queen. . . . Her Majesty told me that she had learned of a certain antique mirror in my possession which she was curious to see. Not expecting what in fact happened and fearing to be caught in a lie if I were to say that I had already sent it on to Florence, I replied that I would

obey Her Majesty. At the same time, I made it clear in the course of conversation that I was only holding the mirror for Your Highness. The next Wednesday Her Majesty sent for me, since it perhaps seemed that I was delaying excessively in bringing it to her. As soon as she had it in her hands, she began to make much of it. Then getting down to business, the Queen told me that I should do her the favor of contenting myself that the mirror should remain in her possession, adding as a joke that it was better suited to women than to churchmen.

At this moment, a message arrived . . . and the Queen set about taking her leave of me without returning the mirror. Seeing the game already lost, there appeared no other solution than in bowing to mutter through my teeth that Her Majesty was the boss [*era padrona*], and thus I made my exit like a wet hen [*come una gallina bagnata*].[47]

Christina could take advantage of her womanhood when strategic, as her joke about mirrors being more suitable for women than priests shows. Her ploy was successful. The cardinal decided to treat the mirror as a gift to the queen, hoping for future favors from her instead of incurring her disfavor by demanding payment or the mirror's return. Christina's rapaciousness for any antiquities not well secured was famous. When she visited Paris, Colbert reported on her visit to the royal collections to Cardinal Mazarin, who wrote back to instruct Colbert that, in case the queen asked to see the cardinal's rooms at the Louvre palace, "I beg you to take care that that crazy woman does not open any cupboards, because she could steal my small paintings."[48]

However they were acquired, Christina's life-sized ancient sculptures were displayed in nine consecutive rooms in the most public area of her palazzo, its ground floor. These sculptures included an unusually large number of notable ancient female figures. She possessed a Dea Roma (the patron goddess of Rome), two Ledas with swans, three Venuses, a work that was either a Cleopatra or an Adri-

ana, and a number of statues of anonymous draped women, as well as a modern statue of Cleopatra.

The focal point of the collection was the Room of the Muses.[49] Christina's public audience room, it featured ancient sculptures of eight seated muses and a modern statue of Apollo playing the lyre. The elaborate room also had columns of yellow Numidian marble supporting a gilded cornice topped with busts of emperors, walls and doors covered with Venetian mirrors painted with flowers, and a ceiling fresco of Pegasus. Christina intended the room to invoke Mount Helicon, gathering place of Apollo and the muses. The image in the ceiling fresco set the specific scene as the myth of the creation of the Hippocrene Fountain, source of poetic inspiration, by a kick from Pegasus's hooves.

The statues were heavily restored after Christina purchased them, with the restorer adding all of the attributes that identify each statue as a specific muse.[50] And Christina's manipulation of the sculptures was not confined to the existing ones. Her erudite visitors would have noticed that, with eight surviving sculptures, one muse was missing. Christina, seated in her throne across from Apollo, filled the missing slot. By looking at the attributes of the restored muses, we can identify the missing muse as Melpomene, the muse of tragedy. Christina was probably attracted to this role because Melpomene is usually shown holding either a sword or the club of Hercules. These are masculine attributes, reflecting the heroics, battles, questions of statecraft, and other masculine subjects of tragedy.

Christina's antiquities collection provided other role models as well. Christina spent her life searching for ways to reconcile her masculine soul with her feminine body; to this quest was added, after her abdication, a desire to find the proper course for a queen without a country. Christina still believed herself fully a ruler. Until her death she was addressed and honored as such by the papal and Roman elite, who remained proud of their most famous convert, but her actual power was limited. Early after her abdication, she ordered the execution of a servant whom she felt had betrayed her trust, but this

act was deeply controversial. She never again put her authority to such a test. Later, she made an unsuccessful bid for the throne of Poland upon the death of its king, a distant relative, and also, in another failed plot, attempted to persuade the French to invade the Spanish Kingdom of Naples and make her its queen.

At times, Christina considered her abdication to be "the most splendid of victories," as when she commissioned an artist to design a commemorative medallion showing an allegorical figure of Victory holding a laurel wreath and a palm frond above a portrait of Christina, explaining that this imagery invoked

> the glory of [Christina's] victorious reign and that of her abdication. This great Queen brought forward so many celebrated victories over all of her enemies . . . so many as to expand her reign with many and beautiful provinces . . . but so much glory she has surrendered to her abdication in which she herself triumphed with the most splendid of victories, placing the world at her feet, and this is the victory that deserves to be called the largest, Victoria Maxima.[51]

Other works produced by Christina indicate that at other times she held a gloomier view of her position, as when she wrote, "A Queen without a state is like a Goddess without a temple, to whom one quickly ceases to offer worship or sacrifices."[52]

So, how to live as a queen without a state and as a woman whose true nature was masculine? Christina's solution, after her failed attempts to gain another realm in Poland and Naples, was to use ancient role models to revise the definition of a "state." These models— Melpomene, Dea Roma, and Athena—did not directly rule any territory. They were patronesses who assured the success of, respectively, tragedians, the Roman Empire, and the Athenians (Athena, the goddess of wisdom, was the patron deity of Athens). Each operated in a masculine realm, and each was unmarried or even, like Athena, an avowed virgin.

Christina was probably especially attracted to Athena as a role model for what she considered to be their shared masculine qualities

Pingere Suecorum Numen dum tentat Apelles.
Omnis in effigie luditur uſſq labor.
Attamen agnorint que ſit quam fecimus, inquit
Dixit et expreſſit Pallada docta manus
Sic bene prognatam Suconum Iove pinxit in uno
Dum genus et faciem pinxit et ingenium.
SACRÆ REGIÆ MAIESTATI SVECIÆ
Humillimo ac devotiſſimo animo offertur dedicaturq̃ à M. le Blon

Figure 9. Jeremias Falck, *Christina, Queen of Sweden, as Minerva*, 1649.
Fitzwilliam Museum (P.7095-R). © The Fitzwilliam Museum, Cambridge.

of intelligence, education, prowess (even if merely theoretical) in the art of war, and close relationship with a powerful father. As with Melpomene, Christina displayed her relation with Athena by appearing in her guise, in a series of allegorical portraits on commemorative medallions and engravings. As early as 1649, Christina commissioned a medallion that shows her on both sides dressed as Athena, wearing classical robes and a helmet. On the reverse, she carries an olive branch, the symbol of peace and prosperity and a reminder of Athena's patronage. Christina commissioned two further medallions showing her as the goddess, one in which she wears the aegis, Athena's snake-fringed breastplate, and the other with the word *makelos* written in Greek characters. Christina challenged scholars to discover the meaning of this word, which is Swedish and offers the double meaning "unmarried/incomparable."[53]

Christina also appears as Athena in an engraving by Jeremias Falck, again with a helmet, aegis, laurel wreath, and olive branch (fig. 9). The increased space of the print allows for the inclusion of another of Athena's attributes, the owl, as well as a stack of books to reinforce Christina's/Athena's wisdom. Most intriguingly, Christina is not shown directly as the goddess but as a statue of Athena. Here, again as in the Room of the Muses, Christina cast herself as both an ancient statue and as the deity represented by this statue.

Unwilling to play the roles given to her at birth—Protestant, female, heir to the Swedish throne—Christina used antiquities to help her create and display a new identity. A new, false identity, for she remained a woman, never achieved the levels of patronage she desired, and was suspected of being a rather bad Catholic (among other things, she read ancient philosophy to pass the time during Mass). In short, like Pembroke or Poniatowski, she created a forgery based on antiquity. But her forgery was herself.

5
C H A P T E R

The Privileges of Lovers
Erotic Connections with Antiquities

On Tiber's banks have they but passed a week!
They ever after rave of the antique
In loud delirium Nature's charms disown,
And like Pygmalion, fall in love with stone.

—Martin Archer Shee, *Elements of Art* (1809)

The myth of Pygmalion, the Greek sculptor who scorned women until he fell in love with a beautiful statue he carved, speaks to the deep connections between art, beauty, love, and sexuality. Pygmalion did not have to content himself with stone, though; his prayers to Aphrodite were answered, and his statue came to life.

Not everyone who has fallen in love with an artwork has been so fortunate. Take the case of another ancient Greek, although not, like Pygmalion, a mythological one. He visited the shrine of Aphrodite in the town of Knidos, on the Turkish coast, and saw its famed fourth-century BCE statue of the goddess, carved by Praxiteles. The statue represents a nude Aphrodite laying aside the final piece of her clothing in preparation for a bath, teasingly concealing and yet emphasizing her genitalia with a hovering, barely covering hand. The visitor was "overcome with love for the statue and . . . after he had hidden himself [in the shrine] during the nighttime, he embraced it and . . . it thus bears a stain, an indication of his lust."[1]

This anonymous ancient art viewer took his appreciation to an unusual extreme, but love and lust have been of crucial importance to many less demonstrative collectors. Classical art's sensuality was recognized from the first, as Romans worried about the decadence of Greek art and early Christians criticized the nudity of pagan sculpture. A certain type of collector has long been attracted to this sensuality, and the way that these collectors seek out and treat antiquities continues to have important consequences. As we shall see, the lover of antiquities both seeks to control the object of his love and believes that he (and it is almost always he) has special powers to understand and interpret his beloved.

One early and clear example of this type of erotic control is the incident of the Roman emperor Tiberius and the *Apoxyomenos*, a Greek bronze masterpiece of around 330 BCE showing an attractive nude athlete using a scraper to clean his body after a workout or competition:

> Lysippus as we have said was a most prolific artist and made more statues than any other sculptor, among them the *Apoxyomenos*, which Marcus Agrippa gave to be set up in front of his Warm Baths and of which the emperor Tiberius was remarkably fond [*mire gratum*]. Tiberius . . . could not resist the temptation, and had the statue removed to his bedchamber . . . but the public were so obstinately opposed to this that they raised an outcry at the theatre, shouting "Give us back the *Apoxyomenos*"—and the Emperor, although he had fallen quite in love [*quamquam adamatum*] with the statue, had to restore it.[2]

This anecdote describes with an unusual level of specificity two dueling modes of collecting, public versus private, which took place in very different display contexts—the public baths versus Tiberius's bedroom. When cast by Lysippus, the *Apoxyomenos* was probably intended for display on a low, freestanding pedestal in a sanctuary where its viewers would have appreciated it from all sides and seen at close range its highly realistic details, including copper and silver in-

sets for the lips, hair, and eyes, set into bronze polished to the color of suntanned skin.[3] One reason for the exposure of such a statue from multiple viewpoints would have been to allow the viewers to see the back of the statue—a view with a potentially specially erotic charge, as we know from Greek discussions of, for example, the back of the Aphrodite of Knidos.[4]

Judging by the surviving architecture of Roman bath complexes, a valuable work such as the *Apoxyomenos* would have most likely been placed in a niche high over viewers' heads, thus creating a single, predetermined viewpoint, out of reach of potentially damaging hands. A viewer would not likely engage in prolonged contemplation of the work in the bustling crowd of the baths. By contrast, the *Apoxyomenos* in Tiberius's bedroom would presumably have been on, at most, a low podium, allowing for an intimate, eye-level, uninterrupted viewing that could have encompassed all viewpoints of the statue. And yet, compared to the ample skylights offered by bath architecture, Tiberius's bedroom, if it were similar to those known from Roman architecture in general, would most probably have lacked windows. The *Apoxyomenos* in the bedroom would have been seen by dim or artificial light—not seen clearly, but perhaps more attractively, with the moving glints and shadows of lamplight falling on its polished bronze.

Even today it would be considered somewhat eccentric to have a nude, life-sized statue in one's bedroom, but it would have been especially strange in ancient Rome. Thanks especially to architectural information from sites like Pompeii, we know that the Romans generally placed any large statuary in their houses in public areas, for example the entryway, atrium, and garden. In part this placement was motivated by a desire to keep prestigious, expensive statuary visible to guests, but there was also the practical reason of lighting. Bedrooms generally lacked windows, relying on lamps or light coming in the doorway from the skylights in the central rooms. Statues in dimly lit bedrooms would have been difficult to see.

However, viewing the nude body of a youthful male privately, in

a bedroom, by lamplight, is in full accord with stories about Tiberius's pleasures later in life. He retired from public life to the island of Capri to enjoy the company of an assortment of beautiful boys. This reputation shows that the public's reaction to Tiberius's removal of the statue involved more than anger at the loss of the work from the baths.

Tiberius is far from alone in his status as a collector with an erotic attachment to his antiquities. The Roman general Sulla owned a small golden statue of Apollo, taken from Delphi. It accompanied him on all his campaigns so that he could kiss it before each battle.[5] The English Lord Coleraine wrote to his dealer on Valentine's Day 1695 that "medals [ancient coins] are now become my Mistresses."[6] Also in the seventeenth century, the English writer John Evelyn noted that Ippolito Vitelleschi, the Vatican librarian and an antiquities collector, "frequently talkes [to his antiquities] & discourses, as if they were living . . . sometimes kissing and embracing them."[7]

Thomas Jefferson, a noted enthusiast for the classical world, traveled to Nîmes in southern France in 1787. There, he saw the well-preserved Roman temple known as the Maison Carrée and joked about the association between love and the antique. In a letter, he described himself as "gazing whole hours" at the temple "like a lover at his mistress. The stocking weavers and silk spinners around [the temple] consider me as a hypochondriac Englishman about to write with a pistol the last chapter of his history."[8] The poet Goethe also drew a close parallel between erotic possession and collecting. He purchased a cast of an antiquity and wrote that "for my eyes' delight, I set up in the hall outside my room a new cast, a colossal head of Juno, the original of which is in the Villa Ludovisi. She was my first Roman love and now I own her."[9]

Comparisons of women to ancient statues could range far afield, as when the eighteenth-century explorer Joseph Banks wrote of Tahiti that its "Elegant women" were like the ancient Greek women "from whose model the venus of Medicis was copied."[10] But antiquity need not be in human form to inspire love, as was the case for

the late nineteenth-century French traveler Charles Maurras, who, arriving at the Athenian Acropolis, embraced a column of the Propylaea and "kissed it tenderly, like a woman friend."[11] And sometimes the erotic attraction to antiquities takes a turn for the literal, as the American art collector Peggy Guggenheim described:

> At this time I was worried about my virginity. I was twenty-three and I found it burdensome. . . . I had a collection of photographs of frescos I had seen at Pompeii. They depicted people making love in various positions, and of course I was very curious and wanted to try them all out myself. It soon occurred to me that I could make use of Laurence [Guggenheim's boyfriend] for this purpose. . . . I think Laurence had a pretty tough time because I demanded everything I had seen depicted in the Pompeian frescoes.[12]

Even the actions of those who disapprove of antiquities often serve to point out their erotic power. The late fifteenth-century pope Hadrian VI, who condemned the Vatican's collection of antiquities as idols and restricted access to the works, closed off eleven of the entrances to the collection. The only door he left open was the one that led there from his own bedroom.[13]

Hadrian VI left the Vatican antiquities unmolested, but other owners of antiquities have been driven to damage the works because of their suspicion of the statues' erotic charge. One notable case was the French Armand-Charles de La Porte de La Meilleraye, duc de Mazarin, who inherited a large collection of ancient sculpture in 1661 from his wife's uncle, Cardinal Mazarin. In 1670, the duc de Mazarin had had enough of his shameful collection:

> He awakes Tourolles, his curator, bids him open one of the galleries, enters there with a mason, takes from his hand a heavy hammer, and casts himself with fury upon the statues. Tourolles, bursting into tears, in vain protests the ruin of so many masterpieces; weariness was the only stop to the work. . . . M. Mazarin goes tranquilly to supper, and about nine o'clock, accompanied by five or six of his

domestics, gives a hammer to each and returns to the gallery with his escort. Some he animates by his example; the lagging of others he reproaches. He chooses as his portion the sex which he flees and yet desires. . . . One might see well by the fury of his blows . . . that his repentance was perchance avenging the errors of his imagination. It was a Saturday; midnight sounds; that signal of Sabbath repose cuts short the task.[14]

The duc de Mazarin was unusually sensitive to eroticism (he also "wished to pull out the front teeth of his daughters to prevent co-quetry, and he forbade the women on his estates to milk the cows for fear of the evil thoughts that such an employment might suggest"), but many surviving antiquities bear the mark of centuries of less dramatic moralizing.[15] We can see the results of the efforts of restorers to efface the genitals of ancient statuary in many collections. At their least destructive, they affixed fig leafs or other coverings or simply failed to restore missing genitals. At their most destructive, they broke off and discarded penises and polished away pudendal clefts. Fortunately, most viewers can imagine what is missing—at least in the case of male statues. Ancient nude female statues are rarer and have been more vigorously patrolled, with the smoothing so complete that many contemporary viewers are not aware that the originals had any indications of genitalia.

The above examples give a general picture of the ways in which attractive antiquities can be subject to the desires and revulsions of collectors. To understand these impacts in greater detail, we turn to a gallery of statues that came to life in late eighteenth-century Naples.

In the winter of 1778, a monkey named Jack entertained distinguished English visitors to Naples by picking up a magnifying glass and "very gravely" examining the tiny figures on ancient Greek and Roman carved gems and cameos.[16] Jack's owner, Sir William Hamilton, the English ambassador to the Kingdom of Naples, had trained him to look at antiquities "by way of laughing at antiquarians"—

as a parody of overserious connoisseurs and collectors of ancient art.[17]

If Jack the connoisseur failed to amuse, he had other tricks that Hamilton could show a selected few guests, who were invited to observe the monkey during his morning swim. Jack and Gaetano, Hamilton's young Italian servant, would plunge into the sea. The naked Gaetano struggled to control the mischievous Jack; at crucial moments, Hamilton would bark orders, distracting Gaetano enough for Jack to slip free and perform his favorite stunt of giving a good yank to the boy's testicles ("and then he always smells his fingers," Hamilton wrote in a letter describing the entertainment).[18]

Hamilton's visitors laughed at Jack's examination of antiquities precisely because Hamilton was one of the obsessive collectors he had trained his monkey to mock. And the monkey's fondling ancient gems is not as far removed from pulling at a servant's testicles as it might seem. Creating links between ancient art and sexual play was a habit of Hamilton's. Hamilton, like Tiberius before him, is an example of a collector who formed an erotic obsession with his antiquities. The wealth of his surviving letters and other personal documents allows us to understand the depths of this obsession and the ways in which it drove him to ignore the social, political, and legal rules that otherwise would have controlled his life.

Jack was not the only creature Hamilton trained to show off his ancient art collection for guests—by far his greatest creation was his mistress, Emma. Emma came highly recommended. George Romney and other prominent London painters had used her as a model for years. For one of his canvases, Romney painted the then seventeen-year-old Emma as Circe, the ancient Greek sorceress who enchanted Odysseus (fig. 10). Emma's wide eyes, untroubled brow, and abundant brown tresses, coiled and flowing around her head, speak of candor and innocence. Her red rosebud of a mouth and the depths to which her milky white décolletage plunges hint at the spice mixed in with the sweet.

Figure 10. George Romney, *Emma Hart as Circe*, c. 1782.
Tate Britain (No5591). © Tate.

The painter knew Emma though her lover, the Honourable
Charles Francis Greville. Greville was not Emma's first lover. Al-
though she became his mistress when she was barely sixteen, she
was already pregnant by one of Greville's friends. Despite the baby,
Emma and Greville lived together quite happily for a time. Greville's
finances were bad, though, and when Emma was eighteen, he found
a rich woman to court. Thanks to the fame Emma had achieved as a

model, she was far too conspicuous a mistress for a man wishing to persuade an heiress of his love. Greville, the son of Hamilton's sister, wrote to his uncle with a novel proposal.

Hamilton's wife had died the year before, and he had mentioned in his frequent correspondence with his nephew that he was lonely in Naples without her. Hamilton had both met his nephew's mistress and seen examples of the paintings inspired by her. Perhaps, Greville wrote, his uncle could do him the favor of taking his lovely mistress, quite compliant, off of his hands. She would make Hamilton a good companion, since "she is the only woman I ever slept with without having ever had any of my senses offended, and a cleanlier, sweeter bedfellow does not exist."[19]

After some hesitation, Hamilton sent enough money to pay for Emma and her mother to travel to Naples, and he permitted himself to think that everything would go smoothly:

> The prospect of possessing so delightful an object under my roof soon certainly causes in me some pleasing sensations, but these are accompanied with some anxious thoughts as to the prudent management of this business; however, I will do as well as I can and hobble in and out of this pleasant scrape as decently as I can.[20]

Nobody consulted Emma. She was not as compliant as Greville had promised. She loved him, and it took some months after it became clear that Greville was not, as he had sworn he would, coming to join her on a pleasure excursion. Her remonstrances to Greville, with imperfect spelling and grammar, were in vain:

> I am poor, helpeless and forlon. I have lived with you 5 years, and you have sent me to a strange place, and no one prospect, but thinking you was coming to me. Instead of which, I was told to live, you know how, with Sir William.[21]

Emma at last succumbed to the charms (or at least the necessity) of Hamilton, who had been wooing her with picnics, new clothes, and singing lessons. And art, of course. "A beautiful plant called *Emma*

has been transplanted here from England, and at least has not lost any of its beauty," Hamilton wrote to the botanist Sir Joseph Banks.[22] Long before she became his mistress, Hamilton owned Emma and her beauty in paintings, sculptures in wax, clay, marble, bronze, paper silhouettes, and cut into precious stones—so many artworks by so many artists that Emma reported in a letter to Greville, with whom she continued to correspond, that a special room in Hamilton's villa had to be fitted up as a studio for their work:

> The house is ful of painters painting me. He as now got nine pic-
> tures of me, and 2 a painting. Marchant is cutting my head in stone,
> that is in cameo for a ring. There is another man modeling me in
> wax, and another in clay. All the artists come from Rome to study
> from me, that Sir William as fitted up a room, that is calld the
> painting-room.[23]

But Hamilton never permitted Emma to be represented as Emma. She was always shown as someone else, as a character, most usually someone from Greek or Roman antiquity: Berenice, Euphrosyne, or Iphegenia; a nymph, a muse, or a bacchante. The famed beauty, toast of London's gentlemen, had become another element of Hamilton's collection of antiquities.

When Emma arrived in Naples, Hamilton was already an estab-lished collector of ancient art. The latter half of the eighteenth cen-tury was an ideal time to be a connoisseur of antiquities in Naples. The royal excavations at Pompeii and Herculaneum were producing a wealth of new discoveries, often with erotic themes—from attrac-tive nudity to priapic imagery to frescoes from the walls of brothels that served as an illustrated menu—that appealed equally to the an-cient imperial Romans and the titillated viewers of the Enlighten-ment era.

Hamilton was no exception. About the recent discovery at Pom-peii of a "Venus of marble coming out of a Bath & wringing out her wet hair" he wrote to a correspondent, "What I thought most re-markable was that all her *tit bits* such as *bubbies mons Veneris* &c are

double gilt & the gold very well preserved, the rest of the marble is in its natural State."[24]

Because the discoveries from Pompeii and Herculaneum were rarely available for sale, Hamilton focused on another field: ancient Greek painted vases. These vases, produced in Greece and southern Italy in the sixth to fourth centuries BCE, were decorated with images of gods, heroes, and morals. Some showed mythological scenes and some episodes from everyday ancient life, and the decorations of most, with images of grape vines and inebriated revelers, made reference to their purpose—holding wine for ancient celebrations.

At first, Hamilton bought vases from dealers or collectors, but soon after his arrival in Naples, he sought out more direct sources. The vases survived from antiquity because the ancient inhabitants of the area surrounding Naples had buried themselves with them, holding one last drink of wine for the long road ahead. Hamilton ordered his agents to bring him word of newly discovered tombs, unearthed by peasants' plows, earthquakes, or other disturbances. He even commissioned a joint portrait of himself and Emma attending the opening of a tomb. The workmen strain at a covering stone while Hamilton stoops eagerly forward and Emma, wearing an enormous hat and towering over Hamilton, smiles blandly at a skeleton and the vases nestled around it.

Hamilton's sensitivity to erotic nuances served him well in his vase collecting. He records that he purchased a vase showing Silenus, a drinking companion of the god Dionysus. The vase was unusual because it showed Silenus clothed and had thus been the subject of a previous scholarly publication by a certain Passeri, who "had displayed in his dissertation much of his erudition to explain the reason why a Silenus was represented thereon completely clothed, and not naked, as in most monuments of antiquity." Hamilton archly explains the mystery by noting:

> I soon perceived that the drapery on the Silenus had been added with a pen and ink, as was the case on the figures of many other

vases in the same collection, the late possessor, being very devout, having caused all nudities to be covered. However, as soon as the vase was mine, a sponge washed off both modern drapery and Passeri's dissertation![25]

Hamilton's collecting led him into financial difficulties. His hundreds of surviving reports to the Crown are filled with complaints about his debts. He was the British ambassador in Naples for nearly forty years, and paying a visit to him became a required part of the itinerary of English visitors making a Grand Tour; his expenses for all this entertainment grew the longer he stayed.[26] His pay never enough and the income from his wife's estates always small, he was forced to sell the collection of 730 vases formed during the first seven years of his stay in 1771. The British Museum paid him £8,400.[27]

Emma kept him distracted for a few years, but he began buying vases again in 1789. "He came to me one day full of joy and said he had been unable to resist and had begun buying vases again," wrote one of his friends, a German artist resident in Naples, who also records coming across Hamilton, in full court regalia, carrying one handle of a basket full of newly purchased vases, the other handle being manned by a ragged beggar.[28]

Both he and Emma recognized the intertwined nature of his love for her and his love for his collections. He wrote to Greville about how, having arranged some of his newly acquired vases in a new apartment (a room or suite of rooms) in his house, "Emma often asks me, do you love me? But as well as your new apartment?"[29]

Hamilton's love for his collections led him to commit some unambassadorial behavior. Goethe, who visited Hamilton, alleged that the ambassador stole antiquities from the private museum of Ferdinand I, king of Naples:

> Sir William [Hamilton] showed us his secret treasure vault, which was crammed with works of art and junk, all in the greatest confusion. Oddments from every period, busts, torsos, vases, bronzes, decorative implements of all kinds made of Sicilian agate, carvings, paintings

and chance bargains of every sort, lay about all higgledy-piggledy; there was even a small chapel. Out of curiosity I lifted the lid of a long case which lay on the floor and in it were two magnificent candelabra. I nudged [Philip] Hackert and asked him in a whisper if they were not very like the candelabra in the Portici Museum. He silenced me with a look. No doubt they somehow strayed here from the cellars of Pompeii. Perhaps these and other such lucky acquisitions are the reason why Sir William shows his hidden treasures only to his most intimate friends.[30]

The Portici Museum held the riches of Pompeii and Herculaneum, excavated by Ferdinand's ancestors. If Hamilton did steal from the king, he probably did so with no danger of apprehension. Ferdinand cared mainly about hunting (his scrupulously maintained personal diary contains almost no information other than whether or not he went hunting on that day). The only collection he maintained more than a passing interest in was his "museum of mummies," which housed the embalmed corpses of his enemies, dressed in their own clothes.

King Ferdinand collected the dead; Hamilton collected the living. He told visitors that he loved Emma because she looked like an ancient beauty on one of his Greek vases. In turn, visitors called her a "Breathing Statue"[31] or Hamilton's "pantomime mistress," his "gallery of statues."[32]

Emma could be a whole gallery because she and Hamilton had invented a new art form, performances of "Attitudes" (fig. 11). Emma appeared before Hamilton's guests in a specially made Greek-style dress, a shawl or two, and seductively unpinned hair, then took a series of poses, each with a different arrangement of shawl and hair, to imitate ancient mythological or historical characters such as Medea or Cleopatra:

With the assistance of one or two Etruscan vases and an urn, she takes almost every attitude of the finest antique figures successively, and varying in a moment the folds of her shawls, the flow of her

Figure 11. Engraving, after Angelica Kauffman, of Emma Hamilton
as the comic muse Thalia, 1791. British Museum (1843,0513.1008).
© Trustees of the British Museum.

hair; and her wonderful countenance is at one instant a Sibyl, then a Fury, a Niobe, a Sophonisba drinking poison, a Bacchante drinking wine, dancing, and playing the tambourine, an Agrippina at the tomb of Germanicus, and every different attitude of almost every different passion. . . . This wonderful variety is always delicately elegant, and entirely studied from the antique designs of vases and the figures of Herculaneum.[33]

Hamilton's antiquities came into play as accessories for these performances. Some guests noted in their diaries that he was nervous when Emma handled an ancient vase a bit too energetically.[34] But most guests recorded their awe at Emma's dramatic ability and the utter commitment of Hamilton: Goethe reported that "the old lord holds the lights for it and has given himself wholeheartedly to his subject." The poet thought that Hamilton found in Emma "all the statues of antiquity, all the lovely profiles on the coins of Sicily."[35]

The lovely profiles on ancient coins do not speak, and neither did Emma during her Attitudes. Her silence was probably a key benefit to her chosen art form as she retained to the end of her life the Cockney accent that instantly revealed her childhood in the slums of London. Many visitors noted their disgust at hearing Emma's voice, so ridiculously incongruous with her beauty and setting. They probably guessed at the past the voice belonged to—a miserable childhood followed by drudgery as a servant, first for a respectable family, then for questionable actresses in a theater, until finally she fell. Better to inspire thoughts of Cleopatra and other past beauties with questionable morals than thoughts of her own life. Better to be a living, mute statue.

Emma was such a fitting addition to Hamilton's collection that he married her in 1791, when he was sixty and she was twenty-six. The collector who would struggle home with a basket of newly excavated vases, their dirt rubbing on his silk and ermine robes, did not scruple at the stains on Emma's reputation. Instead, he seemed to regard her as a special discovery that few were capable of appreciating,

just as he frequently wrote that only a handful of connoisseurs could see the beauty of his ancient vases.[36]

Hamilton was right—there were many who failed to appreciate the new Lady Hamilton. Visitors to Naples, a far-flung and famously lax outpost, had been tolerant of the convenient fiction that Emma was merely Hamilton's protégé. But now, a Cockney Lady Hamilton, dancing in shawls, appeared ridiculous. This was especially true if the visitors recalled Hamilton's aristocratic first wife, a woman with a gentle temperament whose playing of the harpsichord a young Mozart, touring Europe, had described as "uncommonly moving."[37]

Disapproving visitors also recorded in letters and diary entries Emma's increasingly zaftig appearance. Emma was losing her beauty, but Hamilton, the great connoisseur, did not seem to notice. Jack the monkey was dead, unable to survive the cold of another winter, and Hamilton, gazing lovingly at the former beauty, was as grotesque as Jack, pondering antiquities through a microscope. He was his own parody.

To some, at least, Emma still had her charms. Sir Horatio Nelson, a naval commander fresh from striking a devastating blow to Napoleon's navy during the Battle of the Nile, was unable to resist her when he arrived in Naples in 1798. The gaunt Nelson, whose battle wounds had cost him an eye and his right arm, was an unlikely match for the plump lady of leisure, but her adoration won him. Emma personified the congratulations flowing in from England and the rest of Europe while Nelson was detained in Naples.

Hamilton, now in declining health and an admirer of Nelson, either fully tolerated or indeed had no idea about their affair. He permitted Nelson to remain a guest at his house and left no record of any reaction to the news that Emma was pregnant. She hardly bothered to make a secret of her daughter's parentage, naming her Horatia (although that could also have been interpreted as a general tribute to the hero without his personal involvement). Hamilton even resigned his ambassadorship and moved back to England in 1800, seemingly because Emma wanted to follow Nelson when he

Figure 12. James Gillray, *Dido, in Despair!*, 1801. British Museum
(1868,0808.6927). © Trustees of the British Museum.

left Naples. They lived together—Hamilton, Nelson, Emma, and her
mother—in a house paid for by Hamilton.

Their strange arrangement caused endless scandal. Caricaturists
published parodies of the trio. One showed an obese Emma, sur-
rounded by liquor bottles, scattered antiquities in licentious poses,
and a deeply slumbering husband, mourning the departure of Nel-
son as if in one of her Attitudes, impersonating Dido, the tragic
queen of the *Aeneid,* who threw herself on a funeral pyre when her
lover sailed away (fig. 12). Another shows the withered Hamilton,
peering shortsightedly at a broken Roman statue and ignoring the
cavorting of Emma and Nelson, shown as portraits of Cleopatra and
Mark Antony, his gloves falling limply out of his pocket to symbolize
his lack of sexual ability (fig. 13).

Figure 13. James Gillray, *A Cognocenti Contemplating ye Beauties of ye Antique*, 1801. British Museum (1851,0901.1045).
© Trustees of the British Museum.

Hamilton's limited energies were taken up by other matters during these last years of his life. There were his vases to mourn—a part of his second collection of Greek vases had gone down with the ship transporting them to England. Hamilton was horrified because he believed that

> my Collection wou'd have given information to the most learned & have convinced every intelligent Being that there is but one Truth, & that God Almighty has never made himself known to the miserable Atoms that inhabit this globe otherwise than bidding them to increase & multiply & to leave the rest to Him—So thought the Wise Ancients when the Mysteries of Bacchus & Eleusis were established.[38]

And there were his debts. He was constantly writing petitions and making visits to ask for reimbursement for expenses incurred during his years as ambassador. He was always surprised at his failure to obtain more funds, blind to the possibility that his superiors would consider the huge amounts he spent on art a clear demonstration that he had had enough.

Or perhaps he saw but did not care. Certainly he did not trouble himself much about Emma's future; he died in 1803, leaving her only a small pension. Nelson was killed in the Battle of Trafalgar two years later. His stated desires that the nation provide for Emma as if she were his widow were pointedly ignored, and she was harassed by debt for the rest of her life. Of all of the products of Hamilton's life and work, only the antiquities retained their serenity and beauty.

Many subsequent collectors, like Hamilton, have loved their antiquities and believed that this love gave them a special power to understand their collections. In 1984, George Ortiz, who used the Bolivian tin-mining fortune he inherited to form an extensive collection of antiquities, wrote that these objects, "imbued with the spirit of their creator . . . came to me because they knew I would love them, understand them, would give them back their identity and supply

them with a context in keeping with their essence, relating them to their likes."[39] The erotic quality of the connections between modern collectors and their antiquities is most powerfully manifested in collectors' discussions of the importance of touch. Arthur Stone Dewing recorded his history with one ancient coin, a diadrachm of Selinus, on a catalogue card for his collection, writing that it "was the first expensive Greek coin I bought (June 1929). Much pleasure. Soon after acquiring it, I took it with me to Chicago, taking it out of my pocket and playing with it."[40] The undoubtedly unintentional eroticism in his description of his pleasure in carrying and playing with his acquisition highlights the fact that, for the collector, the pleasure of touch does not always require that an antiquity have a human form.

Touch is a modern obsession because it is only in the modern world that we limit it. Modern collectors often point to touch as a key distinguishing feature between owning an antiquity and seeing one in a museum:

> While pottering about for many years in various museums and enjoying looking at Greek sculpture and pottery, I remarked that I missed the forbidden pleasure of touching, holding, turning and scrutinizing any of the pieces displayed behind glass.[41]
>
> To possess a [rare, old coin] is to directly control contact with the past. It is a powerful experience that defies rationality. We want to touch [rare, old coins] like talismans. And we can! This is the power of ownership; this is why viewing one in a museum will never suffice. *It is all about the power to touch it at will.*[42]

For modern collectors, touch is not important merely because of an erotic thrill, but because touch increases the toucher's understanding of the past—hence the links between touching and scrutinizing and contact with the past in the views of the above collectors, or, again, in the exhortation of another twentieth-century collector, Leo Mildenberg, who specialized in ancient figurines and other small works of art showing animals and told visitors to his collection, "Here, take it in your hands. Look at it! It speaks to you!"[43]

Modern collectors think of antiquities, like modern works of art, as objects that speak for themselves directly to the viewer about the lives of their makers, such as the collector who praised cameos for being "a very private art object, not intended for public display. Cameos ... form a window onto the private world of someone who lived in the ancient world. Although the religious and amuletic qualities are no longer meaningful to a modern observer, none the less there is an intimacy in the sharing of an aesthetic experience which transcends the ages."[44]

Ortiz is especially eloquent about this type of interaction with antiquities. He writes of his initial choices of antiquities to purchase as "purely intuitive, instinctive." When he began to collect, he had not been to museums, much less attained archeological knowledge. The objects themselves convinced him to begin collecting, since "certain objects struck me viscerally, then they came to fascinate and move me, I let them speak to me, I let their content and spirit nourish me."[45]

Ortiz claims that he first encountered antiquity and the idea of collecting at a moment of crisis: "It all goes back to my adolescence. I lost my religious faith, studied philosophy and became a Marxist. I was looking for God, for the truth and for the absolute. In late Summer 1949 I went to Greece and I found my answer. The light was the light of truth and the scale of everything was on the scale of man. And Greek art exuded a spirit which I was much later to perceive as what I believe to be the spiritual birth of man."[46]

He defines that "spiritual birth" as the "awareness that man is the centre of things" and also as "a humanism wherein the rational mind helped by observation, pragmatism and logic has the potential to learn everything there is to know about man and the cosmos." After this realization, Ortiz began to collect Greek art because "I instinctively hoped that by acquiring ancient Greek objects I would acquire the spirit behind them, that I would be imbued with their essence." Ortiz believed that the message he received when touching antiquities was not merely a figment of his imagination, but that the same spirit in the works would transmit the same message to all: "Let

these works of art speak to you, hopefully some of them will move you by their beauty and reconcile you to your fellow men however different their religions, customs, races or colour."[47]

Ernest Erickson, an immigrant to the United States who made his fortune selling wood pulp to paper manufacturers, began to collect a variety of objects from ancient and non-European cultures during the Depression. He wrote about the "delight" of the connection between a collector and an object, which he characterized as "a kind of nirvana":

> It is a very complex feeling which is extremely difficult to express in words to someone else. It is not enough to say that your conception is made up of a number of details like composition, form and balance, surface texture, color values, etc. The thing that gives an object life and meaning must come from inside yourself, a synthesis of years of accepting and rejecting what you have been fortunate in seeing and experiencing.[48]

Many modern collectors believe that antiquities create connections with their possessors and convey important knowledge of the past, and that it is precisely the collector's own reactions that bring this knowledge to light: "Our only knowledge of people who once inhabited most of this planet is derived from the material remains of their cultures. Our reactions to these artifacts, and our determinations about them, are the raw material not only for the ethnologist, but for the historian, the sociologist, the anthropologist, the artist, and the philosopher."[49] These collectors believe that antiquities can communicate because they believe that all humankind shares some essential qualities. The reaction of these essentials in the collector to the evidence of these same essentials in an artist, as displayed in his artwork, allows the collector to intuitively commune with the maker. Ortiz provides a clear statement of such beliefs when describing a Neolithic female figurine in his collection:

> She moved me when I first saw her, and amazingly when I looked at her in moments of anguish or doubt these disappeared. . . . What is

it in this idol that alleviated the anguish of Neolithic man and mine though of an apparently different nature? But were they really of a different nature? . . . The idol's . . . forms are not only physical but contain a spirit, the answer to man's most primeval needs, still a part of us, however deeply buried.[50]

Collectors believe that a person's reasons for making and appreciating art change little through time, and that artworks are particularly good vehicles of communication between makers and collectors.[51] Those who desire to produce beauty are easily understood by those who desire to possess it. The more a piece is a masterwork, the more it communicates the spirit of its maker.[52]

If an ancient object speaks for itself, there is little need for explanatory context. Some collectors believe that objects speak so strongly that any attention to the more ordinary surroundings of their depositions is misplaced. Carlos Picón, curator of the Greek and Roman department at the Metropolitan Museum of Art, has explained that he is interested in the artistic objects found in burials, not the burials themselves, unlike archeologists who "only care about the dirt. I don't care about the bones, and the person buried there. . . . What can you know about them, anyway? That he or she died at the age of thirty-five, with no teeth?"[53]

A collector's desire to obtain aesthetic pleasure from antiquities means that modern collectors seek to purchase high-quality artistic objects rather than the prosaic objects of everyday ancient life. Since it is easier to see the beauty of a fine statue than that of an everyday ancient object, such as a lamp or roof tile, the statue will inspire more appreciation of Greek culture. Thus, collectors focus on the highest, most awe-inspiring monuments of ancient culture, and they also often complain that archeologists are indifferent to the beauty of antiquities.[54] As Picón puts it, "If I want to spend three wonderful hours learning something about sixth-century China, I don't want to see their Tupperware."[55]

Archeologists' interest in the boring or more mundane areas of

ancient life—agriculture, labor, soil erosion, plumbing—seems mysterious or even damaging to a collector intent on appreciating antiquity's beauties. One archeologist reported an interview with some grave diggers and private collectors who pot-hunt in Native American sites in Arkansas, during which

> one man explained to me at length that by . . . studying topics like what foods Indians ate, professional archeologists were actually projecting a degraded image of prehistoric people while he and his associates, because they made no such records and dug up beautiful objects, were the only ones who truly appreciated these people.[56]

Collectors and archeologists, with their different foci, describe and evaluate antiquities in different ways. Because antiquities function for the collector in the same way a more modern work of art would, it is not surprising that both groups of collectors value similar characteristics. Among the most important of these characteristics are an object's aesthetic value and its uniqueness. Thus, the same factors that would lead a collector to acquire a Monet rather than a painting by a mediocre follower of the Impressionists also motivate a choice between available antiquities.

To archeologists, by contrast, an ancient "masterpiece" of this kind has much less value. In their capacity as appreciators of beauty, archeologists might enjoy a masterpiece, and archeologists also realize the power of masterpieces to attract audiences to museums and donations for excavations. However, precisely because masterpieces are so unique and atypical, they do not reveal as much about ordinary life as do other, more quotidian objects. Collectors sometimes disparagingly think of archeologists' interests as a "search for the prosaic," a statement with which archeologists would cheerfully agree.[57]

More important than the fight between the extraordinary and the prosaic is the broader conviction, on the part of collectors, that their special connection to the past gives them special powers of interpretation. Love is not understanding, as the example of Hamilton shows very well. We might almost be convinced that his passion

for his antiquities made him their best interpreter—if it were not for Emma. Hamilton regarded Emma as another collectible ("the prospect of possessing so delightful an object") and showed not the least understanding of her inner life, thoughts, or emotions for the entire extent of their life together. He seems not to have comprehended her relations with Nelson; he was as unable to imagine them as he would have been to think that one of his statues of Venus had taken a lover.

Hamilton did not understand Emma's mind because he had no need to do so. Her whole role in his life was to serve as a living statue, acting out his commands in order to bring to life his vision of the past. So, too, do the interpretations of modern collectors of antiquities speak of their visions of the past rather than any objective truth about antiquity. Of course, collectors, like any viewer of artworks or artifacts, are free to fantasize and construct imagined pasts. But, as we shall see, there are real dangers in fantasy when beliefs about the power of direct connection through touch allows collectors to devalue and destroy archeological context and objective evidence about the past.

6

CHAPTER

Collecting Others

One visitor to the collections of John Woodward, a seventeenth-century antiquarian, bemoaned the strict rules of his reluctant host, who "with much Difficulty and straining of the Voice . . . shows his Curiosities, which when you see, you must take care you Touch not with the tip of your Finger, neither look into his Books except he hold 'em to you in his own Hands."[1] There are a few examples in history of hoarder-collectors like Woodward, who were so protective of their antiquities that they allowed no one else to see them or, if they begrudgingly allowed visitors, made the experience as unpleasant as possible. Yet these misanthropes are far outnumbered by collectors who welcome the interest of others.

Indeed, for many, collecting is a primarily social enterprise. The mere logistics of locating, purchasing, and transporting heavy and fragile antiquities means that very few individuals have succeeded in acquiring antiquities without connections to sources, dealers, expeditors, and fellow collectors from whom to obtain information and objects. Even Queen Christina of Sweden, with her power, wealth, and intense lifelong passions both for the classical past and for acquiring artworks in general, did not manage to collect a significant number of antiquities until she left Sweden and moved into the established collecting networks of the Italian nobility. The history of antiquities collecting is a history of collecting by specific social groups, including eighteenth-century European nobility, Grand Tourists, and newly wealthy modern American businessmen.

The great American antiquities collectors of the twentieth cen-
tury, including William Randolph Hearst, J. P. Morgan, Leon Levy,
and Shelby White, were either born in humble circumstances or
made their money in oil fields, yellow journalism, or other realms
not known for their intellectual sophistication or Old World flavor.
Antiquities allowed these men and women to forge new identities
for themselves as sophisticated connoisseurs who had more in com-
mon with Tiberius than Texas or with Catherine the Great than the
slaughterhouses of Chicago. Like the *bovattieri,* modern collectors
use antiques to display an imaginary ancestry, but this time, instead
of a claim of literal decent, they asserted spiritual ancestry. And they
displayed this ancestry to as many members of the public as they
could.

The most outspoken of these modern American collectors was
J. Paul Getty (1892–1976). He, like Christina, considered men to be
superior to women. But Getty would have thought that Christina,
though a woman, should have thanked her lucky stars that she had
escaped the fate of being a philistine, a barbarian, a cultural illiterate
—in other words, an American.

Americans have long had a conflicted attitude toward classical
antiquity. Like the British peerage, who found in antiquity models
for Parliament's gains in power at the expense of the king, Americans
were also interested in discovering ancient prototypes for their own
desired political changes. The philosophy of the American Revolu-
tion was derived from classical texts, especially those of republican
Rome. Orators, philosophers, politicians, and other educated Amer-
icans steeped themselves in antiquity as they sought justification for
revolution and advice on the establishment of a new governmental
system.[2] But even with the growing interest in antiquity, Americans'
experience of ancient art was generally limited to books, prints, and
a few plaster copies. Few Americans traveled to Europe until the early
nineteenth century. Then, the end of Napoleon's empire made travel
within Europe easier, regular steamship service made crossing the
Atlantic quicker and safer, and a growing and increasingly educated

American middle class began to be able to afford firsthand exposure to European culture.[3]

Not all of the Americans who made the trip were equally impressed with ancient art. Ralph Izzard Middleton of South Carolina wrote home during his 1836 visit to Rome that artists should go to look at the Belvedere Torso but for people "who could not model a dog out of a piece of wax (among which I enroll myself) to go and spend hours together in the middle of winter in the Vatican constantly exclaiming how beautiful, how beautiful, when they are all the while thinking how cold, how cold, this I think utterly absurd." In the same letter, he huffs that "triumphal arches and old tottering columns, the dilapidated statues and smoked frescoes, all these are fudge."[4]

Middleton's attitude (shared by many of the drooping tourists marching through Rome today) was characteristic of many eighteenth- and nineteenth-century Americans. Having formed a nation on the belief that America was capable of producing all that it needed, without assistance from the Old World or its false claims of superior culture, it would have been incongruous to form large-scale collections of antiquities. Such collections were possessed by the aristocracy and, for Americans, would have been especially associated with the same eighteenth-century English elite against whom they had rebelled.

Thus, the Americans who brought home classical souvenirs from their European travels acquired relatively few and minor objects. Exceptions were treated with suspicion. The captain of the USS *Constitution* purchased a Roman sarcophagus in Beirut in 1839 and presented it to the American government to serve as a resting place for Andrew Jackson. Jackson, at that point two years out of office and with six more years to live, agreed with the government that an ancient sarcophagus had too imperial of a flavor, and it was donated to the Smithsonian Museum instead.[5]

Getty was one of the first American collectors to both recognize and crave the imperial qualities that had led to the rejection of works like the sarcophagus.[6] Getty grew up in the quintessentially Amer-

ican settings of the scraped-together oil boom towns of the Great Plains in the late nineteenth century and the brand new expanses of Los Angeles in the early twentieth century. He made his first million by the time he was twenty-four, in 1916, prospecting for oil in Oklahoma. He promptly retired, declaring that he would henceforth live a life of enjoyment of beaches and fast cars.

This California idyll proved so tiresome for Getty that he began to work again after little more than a year. He worked for the rest of his long life, traveling constantly, sleeping little, trusting few, and accumulating a vast fortune—somewhere around $2 billion by the time of his death, thanks to Getty Oil's worldwide network of oil production and distribution. Most crucially, he negotiated a concession to drill in lands belonging to Saudi Arabia and Kuwait. Oil had never been found there, but Getty suspected, quite correctly, that he would strike it.

Getty had two amusements: women and art. Along with constant long- and short-term affairs, he married and divorced five times, always to strikingly beautiful women, all in their late teens or early twenties when they married him and all abandoned when they became pregnant and Getty lost interest. His heart was more constant with art, possibly because he treated collecting as if it were a business.

Getty wrote frequently and self-analytically about his collecting. He gives us a complete history of the development of his collecting habit, which he traces back to visits to the Louvre and the National Gallery in London while traveling with his parents in his late teens, although neither "made much of an impression on me."[7] Nor did the many European museums he saw while a student at Oxford. His first art purchases were two bronzes and some carved ivory, acquired in China when he was twenty, but it would be eighteen years before he purchased any more art. Then came the Great Depression:

> Now, many of the strong hands that formerly held some of the finest examples of art on the face of the earth were forced to relax their grip. Many choice items became available for purchase, and art prices, like all other prices of the time, dropped. . . . As I became

aware of this, my long-dormant urge to collect things of beauty and examples of fine art finally awoke.[8]

Getty made a second burst of purchases from European collectors selling their collections for low prices just before and during World War II.[9] And then, "having been infected by the virus, I proved to have a chronic disease."[10] He kept collecting as prices rose in a recovered postwar art market. He called himself "an apparently incurable art-collecting addict" and noted that he had vowed to stop collecting several times, only to suffer "massive relapses."[11]

He published a book, *The Joys of Collecting*, in 1965, in which he claims, "I continued collecting until 1964, when I more or less stopped. I felt that I had acquired enough, that I had assembled a collection of which I could be proud—and that I should leave the field to others."[12] But in a 1976 autobiography he ruefully noted that as "the history of my art collecting activities between 1965 and 1975 [proves], when it comes to collecting, I am also a chronic prevaricator," for he continued to make substantial purchases despite his promise to stop.[13]

Though Getty joked about his "addiction" to collecting, he also evolved a philosophy of collecting that inextricably linked art to business and business to immortality. He began from the conviction that "great wealth is generally due to imagination," since a businessman will be successful only if he has enough imagination to see or create new ways of investing and risking his capital, ways unexploited by others.[14] Getty thought that an appreciation for culture was key to developing this imagination in several ways.

First was the merely practical: the American must feel comfortable navigating other cultures in order to negotiate business transactions with foreign partners, or else "American businessmen will allow their fears to paralyze them and stop expansion and trade."[15] Getty was consumed with a self-imposed goal of fluency in other cultures. He could have easily afforded the best translators, but he learned languages from records, practicing alone late at night in his hotel rooms.

When traveling, he "did not mimic manners and mannerisms. He assumed them," as one of his wives describes, calling the result his "perfect coloration."[16] Getty even purchased and stored a different wardrobe in various European capitals so that he would not stand out by wearing, for example, a Spanish-made suit in Berlin.

More mystically, Getty saw a crucial role for appreciation of past culture in the life of a businessman. He thought that an interest in the past would stimulate other interests, "invigorating the individual and adding breadth and depth to his whole existence."[17] He repeatedly stressed that "notwithstanding all the demands made on my time and energies, I have consistently striven to live a rounded existence, to avoid becoming bogged down in a narrow groove. . . . Any such one-dimensional course would, I am sure, have proven fatal to my career—to say nothing of my individuality."[18] He believed that if he "concentrated on business to the exclusion of all else, I would soon lose my sense of perspective and proportion. I would atrophy and lose whatever capacity I possessed to decide and direct."[19] The pleasures of collecting were essential to his business.

Getty's beliefs about the importance of art to business were so strong that they led him to found a museum. He began by opening his California home and its collection to visitors, then constructing a special building, the Getty Villa, to house the collection. Ultimately, he left the bulk of his fortune to fund the museum's continued operation (much to the disappointment of various mistresses).[20] He explained his impulse to open his collection to the public as a product of "conscience pangs":

> After acquiring a large number of examples of fine art, one develops conscience pangs about keeping them to himself. The difference between being a barbarian and a full-fledged member of a cultivated society is the individual's attitude toward fine art. If he or she has a love of art, then he or she is not a barbarian. It's that simple, in my opinion. Tragically, fifty per cent of the people walking down any street can be classed as barbarians according to this criterion.

Twentieth-century barbarians cannot be transformed into cultured, civilized human beings until they acquire an appreciation and love for art. The transformation cannot take place until they have had the opportunity to be exposed to fine art—to see, begin to understand and finally to savour and marvel. These were among the many reasons why the Getty Collection "went public."[21]

Getty wanted to transform the "barbarians" of Southern California not because he believed in the value of art for art's sake, but because of the final tenet of his personal philosophy of art and business. After exercising his imagination to find investment opportunities, the truly great businessman would not, Getty thought, rest content with having made his own fortune. Instead, as Getty did after emerging from his premature retirement, a businessman should continue to expand his existing enterprises and create new ones in order to create jobs for as many people as possible:

> I most decidedly do not view my fortune as money that is exclusively mine, nor do I regard my holdings as my personal property. To me they are businesses and industries which produce goods or perform services for the benefit of the entire public. So that they will contribute to the progressive movement of the economic cycle, they must remain productive and whenever possible, expand. I look at my business interests in terms of thousands of jobs which make possible homes, cars, and comfortable living for my associates and employees. Any wealth that comes to me comes from the working partnership of us all. I supply capital and direction and, if I may say so, the inspiration and stimulus. This adds up to a very real partnership. The loyal work of my employees deserves my utmost effort for their welfare, prosperity, and security.[22]

Getty was convinced that the benefits provided by this employment should then rightly render a businessman famous: "I believe that the able industrial leader, who creates wealth and employment, is as worthy of historical notice as the politician or soldier who spends

an ever increasing share of the wealth created by industrial initiative and courage."[23]

In Getty's philosophy, an interest in art would not fully "invigorate" imagination if it were merely passive. Getty was thus intensely personally involved in his collection and every decision surrounding it. He did not use agents to make purchases; he bid on his own behalf at auctions, although he knew that he would be recognized and thus probably pay higher prices. He scrutinized all of the plans for the Getty Villa, even though, phobic of airplanes and too busy for a ship or rail passage, he never visited California after its construction began. He also spent long hours researching both potential purchases and objects he had already acquired. And, most strangely for a hard-boiled oil tycoon with a constant press of business, he wrote and published several short stories about antiquities in his collection.

The longest of these, "A Journey from Corinth," features Getty's favorite antiquity, the Lansdowne Hercules (named after its former owner, the Marquess of Lansdowne) (fig. 14).[24] In the story, a Greek landscape architect named Glaucus emigrates from Corinth to the Bay of Naples in 147 BCE, a year before Corinth's conquest by Rome. He finds employment working for a Roman aristocrat, Lucius Calpurnius Piso, on the construction of his new home in Herculaneum, the Villa of the Papyri. As part of his work, Glaucus attends an auction of the spoils from the sack of Corinth and purchases a statue of Hercules—the very one he had sat by while courting his wife in Corinth's agora. After adorning Piso's villa for a time, the statue is given to the emperor Nero, who "took a great fancy to the young Herakles, and used this young man of marble as his audience when rehearsing roles he was going to play in the theatre."[25]

Much of the story is impossibly anachronistic. Piso was not born until around fifty years after the sack of Corinth, and the Lansdowne Hercules, whose history Getty imagines in the story, was not carved until after the eruption of Vesuvius, nearly 200 years after that. Moreover, a closer inspection shows that much of the story is influenced by Getty's life, with Glaucus as his alter ego. Glaucus purchases the

Figure 14. Roman marble statue of Hercules (Lansdowne Herakles), c. 125 CE. The J. Paul Getty Museum (70.AA.109.1). Digital image courtesy of the Getty's Open Content Program.

Hercules, as Getty did, and designs the landscape surrounding the Villa of the Papyri, as Getty would design the details of the Getty Villa, whose plans he ordered to be based on the Villa of the Papyri. Glaucus and his fiancée Daphne marry in haste in order to leave the threatened Corinth, as Getty had married Teddy Lynch, his wife at the time of the writing of the story, in haste in Rome on the eve of the declaration of war between Italy and America. (Other aspects of the character of Daphne, however, were wishful thinking. By contrast to the independent Teddy, who lived apart from Getty for most of their marriage in order to pursue an opera career, Daphne is described as "rather a shy young woman, she was never anxious for any company other than that of her husband. Strangers made her nervous." And much of her dialogue consists of praising Glaucus with statements such as, "'How wise you are, dearest. And how silly I am.'")[26] During his voyage to Italy, Glaucus offhandedly invents the idea of navigation by means of noon readings of the sun's position, echoing Getty's pride in his wartime training in naval navigation. Glaucus also spouts Getty's unmistakable politics, instructing Daphne that the "Romans are hated by the mob because Rome protects the rule of the propertied classes, doubtless because she deems them less likely to take risks and cause trouble."[27] Anyone familiar with the career of the historical Piso's son-in-law, Julius Caesar, would doubt that the propertied classes of the late Roman Republic, with their habit of raising private armies and engaging in protracted civil war, were so little likely to cause trouble. The story even faithfully reflects Getty's obsession with financial minutia; the reader learns the cost of the fare for Glaucus's passage to Italy, how much he gave each sailor on the ship as a tip, the charge for the customs duties he paid upon arrival in Italy, and his exact financial status upon arrival, when Glaucus's and Daphne's "joint capital consisted of personal belongings of no great intrinsic value and about five thousand drachmae in cash."[28]

Getty knew that such detailed speculations about the history of the objects in his collection were best framed as fiction: "We [collectors] begin by reading a brief catalogue description of our trea-

sure. Then we elaborate on it. And the next thing we know we're reconstructing its life—creating a history, plus."[29] His use of the word "reconstruction" to describe his activities means that he did not regard himself entirely as a fabulist. He believed in the truth of his reconstructions, even if he knew that he could not prove them. After all, he had arrived at them by conducting extensive research, consulting the most eminent of artists, and using his imagination. And imagination, to Getty, was not the flighty and unreliable tool that it so often proves to be for most of us. Instead, it was the source of the investment ideas that had produced billions for him. Why not trust this evidently uniquely capable imagination to discern true from false in the world of antiquities just as it had so successfully discerned bad from good in the realm of investment opportunities?

Because, as the benefit of hindsight proves, Getty knew oil better than marble. His purchase of a number of obvious forgeries shows that the skills he learned as a child, as an unreconstructed American, were stronger than those he acquired as he attempted to turn himself into an art historian later in life. For example, Getty believed that a torso of Venus he purchased in 1939 from an Italian art dealer, who told him it was found off the coast near Anzio (ancient Antium), came from the villa the emperor Nero built there. This belief was partially due to his consultation of an expert, the antiquities dealer, who provided him with the information about where a fisherman had dived to find the work; partially to his research, which showed that the changing coast line meant that villa site was now underwater; and partially to his imagination. In a short story written in the early 1950s, "A Stroll along Minerva Street," Getty describes the emperor Nero purchasing a statue of Venus in Pompeii and installing it in his villa. Although the story is presented as fiction, the tone shifts in the last paragraphs, when Getty writes of his purchase of the torso and asks:

> Is it too far removed from the realm of possibility to suggest that this torso ... might be the remains of a seven-eighths life-sized sta-

tue of Venus, bought by the Emperor Nero from the dealer Trimalchio of Neopolis, nineteen centuries ago? After all, she *was* found in the sea. And on the exact site where Nero's great villa, which time and the elements have since destroyed, once stood.[30]

Unfortunately for Getty's imagination, although the realm of possibility might have allowed the torso to have been a possession of Nero if it were in fact found "on the exact site" of his villa, the dealer was lying. The torso is a nineteenth-century forgery.[31]

Getty bought several expensive works from the Roman dealer in question, Alfredo Barsanti, who knew his client's tastes and especially understood that, for Getty, the most important thing about a potential purchase was its connection to an eminent former owner. Even Nero, the emperor generally known for his bloodthirstiness, depravity, and insanity, could be sufficiently rehabilitated to provide an illustrious provenance. Before it enters into the reconstructed description of Nero's purchase of the statue, Getty's "A Stroll along Minerva Street" begins with a nonfictional defense of the character of Nero. At least, Getty claims, Nero was a pacifist, his taste in art was "discriminating," and "his seizure of property is also modest when compared with the deeds of contemporary confiscators."[32] By "contemporary confiscators," Getty probably means the Internal Revenue Service. His writings are filled with complaints about taxes whose payment meant money would be wasted by the inefficiencies of government instead of turned into new jobs by supporting Getty's further investments.[33]

Though Nero would do, Getty preferred to acquire antiquities previously owned by the emperor Hadrian or by eighteenth-century English aristocrats—or, ideally, by both, as he believed was the case for the Lansdowne Hercules.[34] He purchased this sculpture from the noble English Lansdowne family, which had possessed it since its purchase in 1792 by the first Marquess of Lansdowne, after it was reportedly excavated at the site of Hadrian's Villa in 1790. Getty elevated this claim, which may have been merely part of the sales pitch

offered by the eighteenth-century dealer, into a direct connection with Hadrian: "There is evidence to suggest that this . . . statue was a great favorite of the Roman Emperor Hadrian, who was the most sophisticated of all ancient Roman emperors."[35] He thrills that his purchase of it means that "this magnificent marble sculpture, which once delighted the Emperor Hadrian and for a century and a half was a pride of Britain, is now completely 'Americanized'—on view for all to see at the Getty Museum."[36]

Getty repeatedly claimed that he bought from collections of well-known connoisseurs in order to avoid forgeries, but the attraction of acquiring works with a distinguished provenance went far deeper than that.[37] Getty remarked to one confidant:

> I have always felt I had a great deal in common with two people widely separated in time—[William] Randolph Hearst and Hadrian. I can scarcely be a reincarnation of Mr. Hearst with his being a contemporary of mine, but I have wondered for many years why I have for so long felt such a close affinity with Hadrian. When I read about him and his villa and his life, I feel I already know it all and understand why he made the decisions he did. I would very much like to think that I *was* a reincarnation of his spirit and I would like to emulate him as closely as I can. . . . Hadrian, Hearst and I are alike—we have all liked things on a grand scale.[38]

Getty thought that Hearst, the newspaper magnate and great art collector, "lived like a Roman emperor," and Heart's estate at San Simeon reminded him of Hadrian's Villa.[39]

Getty's belief in his close ties—whether of reincarnation or not—to Hadrian and the Hadrian-like Hearst reflected their shared interest in art and their shared power over the economic lives of their dependents:

> I feel no qualms or reticence about likening the Getty Oil Company to an "Empire"—and myself to a "Caesar." In fact, I'm willing to go so far as to argue that Getty Oil is more of an "Empire" than Exxon

or a great many other oil companies far larger than Getty Oil. This is because there *is* a "Getty." That fact is known to and by every employee of Getty Oil, by every member of the "Empire." And every Getty Oil employee knows that he or she can always make a final and direct appeal to Caesar—to an individual named Getty who is not only the president of the company, but who also owns or controls the majority of the company's stock-shares.[40]

Getty modeled his life on Roman and European aristocracy not only through the power of his rule over the Getty empire, but also by activities characteristic of the leisure time interests of these aristocrats, including his extensive travels, the construction of the Getty Villa, and, most importantly, his art collecting. But why was it so important for Getty to reinforce his belief in his true spiritual ties to the aristocracy? Why did the famously cheap Getty, who installed a pay phone in his English country manor to prevent guests from sticking him with charges for long-distance phone calls, spend millions on his collection and museum?

Getty wanted to display his collections to the public to fix the dangerous weakness he saw at the heart of American society, one that he explores over and over again in his writings: the "cultural illiteracy so often displayed by Americans and particularly by American men."[41] Getty believed that Americans thought that culture is "for women, longhairs and sissies," with the result that "the moment the average American male steps through the doors [of a museum], he assumes a truculently self-conscious half-strut, half-shamble that tries to say: 'I don't really want to be here. I'd much rather be in a bar or watching a baseball game.'"[42] Getty argued for a far different view of the relationship between masculinity and culture:

> Far from emasculating or effeminizing a man, a cultural interest serves to make him more completely male as well as a more complete human being. It stimulates and vitalizes him as an individual—and sharpens his tastes, sensibilities and sensitivity for and to all things in life. The cultured man is almost invariably a self-assured, urbane

and completely confident male. He recognizes, appreciates and enjoys the subtler shadings and nuances to be found in the intellectual, emotional and even physical spheres of human existence—and in the relationships between human beings. Be it in the board room or a bedroom, he is much better equipped to play his masculine role than is the heavy-handed and maladroit . . . barbarian.[43]

The genius businessman Getty and the abdicated queen Christina had something deeply in common: they each believed themselves essentially masculine, felt threatened in this masculinity, and turned to the past for role models to help them forge a persona that would reconcile their self-perceptions with their circumstances.

Christina's manipulation of antiquities had a lasting physical effect. The restorations that she ordered are still intact and change the way that visitors to the Prado Museum, where her antiquities now reside, see the works. The effects of Getty's relationship with antiquities are more subtle, but they are much less easy to disentangle from the true history of objects from his collections. We might simply dismiss Getty's "reconstructions" as harmless story spinning by an involved collector, but the tales told by the founder of a museum do not disappear easily.

For example, in 1953, Getty purchased a much-damaged fragment of a low relief, showing the head and neck of a horse being led by a now-missing bridle by a young man, part of whose upper body remains (fig. 15). The Getty's website describes the relief as Greek work from around 500 BCE and describes its history as follows:

> In 1911 a farm laborer in Cottenham, near Cambridge, England, dug up this relief, known as the Cottenham Relief. How did a Greek antiquity end up in the English countryside? An antiquarian named Roger Gale lived in Cottenham in 1728, and this relief probably belonged to him. How it came to be lost or disposed of by him and then buried remains unknown.

Despite substantial advances in scholarship and opportunities to reexamine the work, the Villa's dating and description of the relief ex-

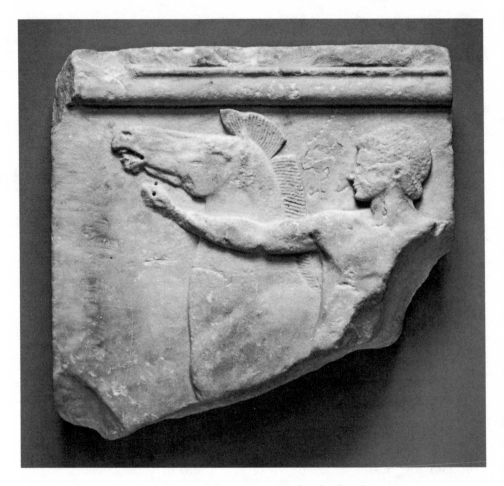

Figure 15. Marble votive relief (Cottenham Relief). The J. Paul Getty Museum
(78.AA.59). Digital image courtesy of the Getty's Open Content Program.

actly follows Getty's thoughts about the work, down to the rhetorical
question:

> How did this sublime example of archaic Greek art reach England
> and become "lost" and "found" there? The precise details will never
> be known, but an entirely satisfactory skeleton of the explanation
> can be readily reconstructed. . . . Somehow, possibly during the
> moving of [Roger Gale's] effects into or out of the house, the frag-

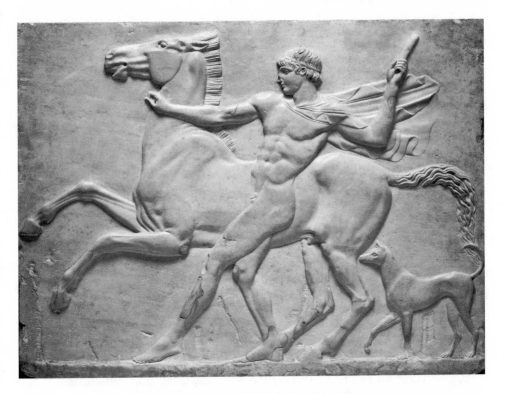

Figure 16. Roman marble relief of a boy with horse, c. 117–150,
purchased by Charles Townley in 1768. British Museum (1805,0703.121).
© Trustees of the British Museum.

ment was dropped on the ground. . . . It is even within the realm of possibility that the fragment was left behind and thrown away by the subsequent occupants.[44]

Getty drew his information about the finding of the relief and the possible connection with Gale from the first publication of the work in a 1917 article by the respected scholar Arthur Bernard Cook. Cook reports that he was informed by one Arthur Bull, a landowner and amateur archeologist interested in Roman Britain, who brought him the relief, that a laborer working on Bull's farm in 1911 had uncovered the relief "at a depth of some eighteen inches below the present surface of the soil." Since the relief "appears to be an isolated relic, thrown out in

all probability from a house formerly existing in the neighbourhood," Cook speculated that "it is at least possible that this relief" had belonged to Gale, "acquired by him one cannot guess when or where," and had "at some later date, and by some less instructed owner, been cast away as a broken and worthless bit of marble."[45]

Much in this account inspires skepticism, if one is not as eager as Getty or the Getty Villa to acquire or possess a work from one of the highest periods of Greek art. Cottingham is the name of both a village and a parish, and we do not know the exact location of Gale's manor, or whether this manor was relatively close to or distant from Bull's farm. Gale died in 1744, and it is improbable that something removed from his manor at that time would remain within eighteen inches of the modern soil surface over 160 years later—or that something, even if deposited much later, would not soon be disturbed, lying at such shallow depth on a farm in one of England's most cultivated agricultural districts.

And if we, like Getty, want to exercise our imaginations to reconstruct an object's history, why not speculate that Bull, seeking to make a splash in his circle of amateur historians, fabricated both the relief and the story of its finding? It would have been relatively easy to obtain a slab of Greek marble and carve this small work, under eleven inches across. Every forger needs inspiration; conveniently, the British Museum has had in its collections, and published illustrations of in its catalogues, an exactly similar relief since 1805 (fig. 16).

This story of forgery might be true or might be false, but it is certainly "within the realm of possibility," as Getty was so fond of writing. Now, so distant from the time of the finding of the relief, we are unlikely to uncover any more evidence than what we have. And the current state of scientific testing tells us simply that the marble is as old as any other piece of marble, but not when it was carved. But the Getty Museum has not challenged the wisdom of its founder, and very few visitors, reading the text next to the relief, will think to question the story it presents as a certainty. Getty's attempts to

transform his own past have transformed our perceptions of the ancient past.

Getty was more interested in using his collections to create relationships with the American public in general than with his friends and family, but such is not the case with all collectors. Many collectors use collecting in order to create and nurture more intimate social networks, and nowhere is this clearer than in the ways collectors describe their first purchases or the birth of their collecting impulse. Collectors rarely attribute their collecting to a solo encounter with an ancient object, or curiosity about the past, or the reading of a textual source. Instead, collectors almost uniformly give credit to a friend or family member for sparking their interest, usually through encountering and discussing a specific antiquity together. Thus, the German-American businessman Walter Bareiss, who formed an important Greek vase collection, asked:

> How could I *not* become a collector! My mother . . . was always interested in the arts, especially in paintings and antiques of the seventeenth and eighteenth centuries, since that was what surrounded her in the castle in Württemberg where she grew up. My father . . . became enamored of British and French paintings of pretty women. So while my appreciation of beautiful things might not have been, strictly speaking, genetic, it was surely bred in the bone.[46]

The most frequently described familial origin of collecting is that of a conversion between spouses. One notable collector of ancient glass wrote that "in the first year of our marriage my wife . . . unwittingly awoke my interest in glass."[47] Similarly, Larry Fleischman, who would eventually sell his major collection of antiquities to the Getty Museum (which returned many of them to Italy after Fleischman's death and the uncovering of evidence of looting), converted his wife to collecting. In turn, she, having been an aspiring actress before their marriage, shaped their collection by favoring purchases of items relating to or illustrating the theater.[48]

Barbara Fleischman is not the only spouse who influenced a husband's collecting practice, even when the husband was the original collector. A. E. Gallatin's wife would not allow her husband to buy vase fragments, calling them "cripples."[49] At times a spouse's influence could persist after death. In the eighteenth century, the newly widowed Lord Bessborough sold the entire collection of ancient cameos and gems he had formed with his wife, although he kept his other extensive collections of antiquities. It seems that he was unable to bear the presence of these objects, now more reminiscent of Lady Bessborough than of the past.[50] For other collectors, the link between antiquities and deceased family members was one to be valued. The eccentric architect and collector Sir John Soane, who transformed his London home into a museum, included monuments to the memory of his deceased wife and child in the wall of an "Egyptian Crypt" that he built in his basement.[51]

For some couples, a collection seems to have served as a more powerful source of attraction than each other. The wife of Elie Borowski, a collector and dealer of antiquities, described their first meeting as follows:

> I met Elie for the first time at the bar of the King David Hotel in 1981. . . . There he was, talking about his collection of ancient Near East artifacts, which was to be displayed at the Royal Ontario Museum in Toronto. He showed us the catalog of the exhibition, and I realized at once what a magnificent thing it was. . . . I knew by the way he was talking about his collection how important it was, yet I couldn't understand—why was it in Canada? It didn't belong there. I took the catalog and couldn't put it down for most of the night. I said to myself, "You are going to marry that man and build a museum for his collection in Jerusalem."[52]

And she indeed did—the Bible Lands Museum opened in Jerusalem in 1992.

The Medici, of course, are the example par excellence of a col-

lecting family. The familial identity as collectors was shared by many Medici, including those out of the public eye:

> In the meantime let me tell you that I have written to Rome to get those medals [ancient coins] that you asked me to provide for your cabinet; all possible diligence will be employed in this matter. . . . And, if I had known about it when I was in Rome, I think I would have been better able to satisfy your wish, being very well pleased to have you as company in this love for medals [*quest'umore delle medaglie*].[53]

Thus the seventeen-year-old Cardinal Giovanni de' Medici wrote to his sister in 1560, pointing out the ties between them in terms of a shared love of collecting ancient Roman coins. The most striking Medici connection between family and antiquities comes from the case of Lorenzino de' Medici, who assassinated his cousin Alessandro de' Medici, duke of Florence, in 1537—but only after being expelled from Rome for drunkenly cutting off the heads of a number of ancient statues on public display.[54] For Lorenzino, the urge to mutilate antiquities proceeded, almost logically, to the urge to decapitate the family.

Many collectors have hoped to strengthen family bonds through a shared interest in antiquities, but not all have succeeded. A 1617 draft of Lord Arundel's will reads:

> That my son James Maltravers may succeed me in my love and reverence to Antiquities & all things of Art, I give unto him all my statues & pictures whatsoever with all inscriptions or monuments of stone, which I desire he may take so much a love unto as that he may increase those I leave; howsoever I charge him deeply that he may never part with any of those things which (God knoweth) I have gathered with so much travail & charge.[55]

The interjection "God knoweth" by which Arundel marks the effort of his collecting is especially poignant. His heir, ten years old at the

time of the writing of the will, had no love for the antiquities he inherited. He sold many and neglected the rest.

Perhaps he resented the antiquities, as have the children of some collectors who seemed to prefer the inanimate to the animate. The oilman Calouste Gulbenkian (1869–1955) accumulated a fabulous collection of artworks, which he referred to as "my children." Claiming that "my children must have privacy" and "a home fit for Gulbenkians to live in," he built a mansion in Paris with barricades, watchdogs, and a private secret service. He routinely refused requests to loan his art to museums and did not allow visitors, explaining that "my children mustn't be disturbed."[56] Unsurprisingly, his flesh-and-blood son and daughter did not become connoisseurs (nor were they given the opportunity, since Gulbenkian left his collection to an eponymous museum in Lisbon).

We might expect that family members would influence one another's habits, but it is striking how many collectors trace the origins of their collecting not to family but to friends. Thus, Shelby White and Leon Levy, founders of one of the largest contemporary antiquities collections—the only one unable to avoid entering into direct negotiations for the return of looted antiquities with the Italian state—attributed their collecting to "our friend" Harry Bober, a professor of art history at New York University, who "accompanied us through the museums of Europe, visited auction galleries, and trooped along from dealer to dealer all the while opening our eyes to the wonders of ancient art."[57]

A dealer who spends time cultivating and encouraging a potential client can sometimes also play this role, as one did for the twentieth-century American diplomat and ancient coin collector Burton Y. Berry, who wrote that a single purchase from "a good friend," an Athenian coin dealer, "marked my start as a coin collector."[58] The inspiration may even come from a chance acquaintance, as when Larry Fleischman, stationed in France during World War II, was invited to dinner by a doctor who introduced him to the study of ancient art.[59] Some collectors have attributed the origins of their interest in an-

tiquities to friendship of a higher sort. Cardinal Alessandro Albani, nephew of Pope Clement XI and a leading player in the antiquities market in eighteenth-century Rome, gave credit to direct inspiration from the Lord himself: "It having pleased the Divine Providence . . . to inspire in my mind a particular inclination towards learning about the most rare works of art. . . . Accordingly, I collected a reputable series of antiquities."[60]

The importance of friendship is not just a feature of the birth of a collection but extends throughout the life of the collector. Friends can shape the form of a collection:

> Sipping retsina with friends on the terrace of the old Casino at Gly-fada [a suburb of Athens] one summer evening, someone said, "You should have a coin of Mende [an ancient Greek city]. Those people raised good grapes and made good wine, and knew how to enjoy life. They put a drunken Dionysus on their coins." This was a challenge and so in my free time in the next weeks I searched the shops for Mende coins.

Thus Berry describes the birth of his interest in the coinage from this particular city, soon to become a notable portion of his collection.[61]

The members of the circle of the eighteenth-century English collector Charles Townley are especially good examples of the importance of friendship. In particular, Henry Blundell, whose Hermaphrodite we have examined, was deeply influenced by his friendship with Townley. Townley's friendship was so important to Blundell that they became synonymous for him; Townley is referred to in Blundell's catalogues, correspondence, and other writings almost exclusively as "a friend" or "a learned friend." Blundell attributed the beginnings of his collecting to Townley; in his catalogue he noted that a statuette of Epicurus was his first purchase and that he bought it because it was "much recommended by a friend."[62]

Blundell was one of many fellow collectors who formed friendships with Townley, based on what Sir Richard Worsley, a noble antiquities collector and another of Townley's correspondents, described

as the "Reciprocal Love that we have for good things," namely, "that delightful softness of the Greek chissel [*sic*] which you & I feel, & that I am sorry to observe in this Country is seldom felt and less understood."[63] Blundell's description of the role of his friends in the publication of his *Engravings,* an illustrated catalogue of his collections completed at the end of his life after many years of fitful progress, is a characteristic example of the importance of such friendships for collecting:

> This work was begun many years ago, by the advice, and with the assistance, of a very intelligent friend. Owing to the illness, and afterwards the death of that friend [Townley], it was interrupted for a considerable time, and the idea of completing it abandoned. However, copper plates having been engraved from many of the principal marbles, it was the request of several friends to have a set of impressions taken from them, and the work was re-assumed, to comply with their wishes.[64]

Here, the advice, assistance, and desires of friends are necessary for conceiving, carrying out, and completing the work. Neither Blundell's own wishes nor the importance of the work for scholarship are mentioned at all. By contrast, we know from his correspondence with Townley that Blundell felt the entire project to be an obligation, since he disliked admitting "foreign" artists to his home to sketch the works. But the wishes of his friends prevailed.

Death was no obstacle to the bonds between the members of Townley's circle of fellow collectors. Townley's collection was purchased by the British Museum after his death, and his close friend Richard Payne Knight changed his will to leave his own collections to the museum, writing that he wished his works to remain close to those of his friend.[65]

The fame of Townley's collections combined with his reputation for hospitality brought him a great variety of distinguished visitors with whom he would otherwise not have had contact, including Lord

and Lady Spencer, the Earl of Darnley, and the Duke of Dorset,[66] since, as one admirer put it:

> Although Townley was closest to his fellow-collectors, he also never disappointed the curiosity of others, less versed in the arts. . . . It was delightful to see him frequently joining himself to these visitants, and as often as he found them desirous of more information than the catalogue contained, freely entering into conversation, and with a gracefulness of manner, peculiarly his own, giving a short dissertation upon any piece of sculpture under consideration.[67]

Some of these visitors seem to have heard of Townley on their own, while others were introduced to him through Jenkins and Hamilton, his dealers in Rome. These dealers frequently included small purchases made by other Grand Tourists in their shipments to Townley, especially in years when war made commercial shipments more hazardous than the special arrangements worked out by Townley. In return, Townley gained opportunities to meet and befriend distinguished travelers, as a 1783 letter from Jenkins to Townley makes clear: "I Sent You a Small Parcel by Lord Algernon, it will Oblige him to Wait of You . . . he is really a very Amiable Young Nobleman, & I hope You will become acquainted."[68]

Townley's world shows how collecting can bring the collector into contact with those normally outside of his social sphere. Collecting can even breach the ivory tower. One especially influential type of collecting-based friendship in the modern world has been the friendship between collectors and scholars, whether university- or museum-based. Evelyn and Norbert Schimmel, important collectors of Mediterranean antiquities, dedicated both the 1964 and 1974 catalogues of their collections "to our friends in the scholarly world," noting, "Only inadequately can we express our indebtedness and gratitude for their frequent counsel, guidance and direction."[69] The category of "friends in the scholarly world" can be wide indeed; one collector's preface to his catalogue of his ancient glass includes

thanks to "Frans Grummer, who kindly photographed the glasses, fulfilling all my expectations. His technical skill and taste I admire, while the tea-drinking sessions in between shoots I treasure."[70]

Nor is it just collectors who claim friendship with scholars—the reverse is also true. The scholar who authored the catalogue of Elie Borowski's extensive catalogue of ancient engraved gems recalls the origins of their relationship as follows:

> I met Batya [the collector's wife] and Elie Borowski for the first time a few years after I joined Christie's in 1992. Following a tour of the Bible Lands Museum I was immediately invited into their Jerusalem home where I spent several hours looking at the many wonderful ancient treasures on display there. Our mutual admiration was instantly transformed into a solid friendship when I mentioned to Elie that I had written my thesis on Greek gems. "You are a gem man! So am I!" he proclaimed.[71]

It is easy to question the sincerity of such friendships between scholars and collectors. Each has much to gain from the other. Scholarly attention and publications can increase the value of objects in a collection, whereas the publication of hitherto unknown objects in a private collection or the attraction of donations of such objects can benefit the career of an academic or a curator. Yet, the purpose of this analysis of the role of friendship in collecting is not to dwell on the qualities of "true" friendship. Rather, I am interested in the ways in which collectors' behaviors are shaped by the role of friendship as they perceive and proclaim it.

The collector who establishes a close relationship with a museum gains large benefits in terms of an expanded and strengthened social network. Take the case of Christos Bastis, characterized by the Metropolitan Museum's antiquities curator as a "loyal museum friend."[72] Bastis emigrated from Greece to New York in 1922 and made a successful career running a series of gourmet restaurants, in which he displayed the ancient art he began to collect in 1941. He had a long relationship with the Metropolitan Museum of Art, beginning with

the long-term loan of an ancient Greek vase from his collection in 1948, continuing with a regular series of donations to support the museum's purchase of antiquities starting in 1954 (including a large donation in 1998 that established the Bastis Purchase Fund), and, after 1964, a number of significant donations of works from his collection.[73]

In return for these benefactions, Bastis was appointed to a number of honorary positions at the museum: fellow for life, benefactor, honorary trustee, and member of the Visiting Committee of the Department of Greek and Roman Art. He and his wife joined the Philodoroi, a group of donors to the Department of Greek and Roman Art organized by the museum in 1988, and hosted these fellow donors and collectors in their home.[74] Most strikingly, the museum presented 166 works from his collection in a 1987 exhibition, *Antiquities from the Collection of Christos G. Bastis.* In the preface to the catalogue for this exhibition, Bastis wrote of the museum's antiquities curator Dietrich von Bothmer that he "introduced me to scholarship and its problems," he "helped in the formation of the collection," and that it was "my good fortune . . . to have been exposed to [his] expert knowledge and, above all, [his] friendship for so many years."[75]

Collectors acquire antiquities in a competitive race for social prestige, eager to outdo both noncollectors and other collectors by buying and hoarding the most valuable objects. At least, such is the view of collectors put forward by most of the scholars who have written about collectors' motivations, beginning with the ancient rhetorician Quintilian. Quintilian held this view about his fellow Romans of the first century CE, writing that those who professed to admire what he considered to be the primitive works of the painters Polygnotus and Aglaophon were motivated by "an ostentatious desire to seem persons of superior taste."[76]

The belief that collectors use antiquities as a form of competitive display was reborn unchanged along with collecting behavior itself during the Renaissance. For example, the sixteenth-century scholar

Fra Sabba da Castiglione wrote about the men who are great "in riches and dignity, but for the rest, ignorant, gross and stupid," who "in order to demonstrate their talent and spirit to the common people, used to make great show of delighting in antiquities . . . though their taste and understanding of these matters was like that of an ass faced with music played on the lyre."[77] The assumption about the competitive nature of collecting continues to be put forward by even the most thoughtful of contemporary scholars of collecting, such as John Elsner, who has insisted that, for collectors, "building a collection of things is inseparable from building up wealth and prestige."[78]

Scholars do not often remain satisfied with a thesis first offered twenty centuries ago—especially one that is called into question by much of the available evidence. In both their public and their private writings, from memoirs to catalogue introductions to letters and diaries, collectors stress the importance to them of the social networks created and strengthened by their collecting. They describe sharing their collections with family, friends, scholars, visitors, and fellow collectors, and very rarely dwell on the type of competitive victories many scholarly observers have imagined to be central to their collecting.

Collectors are well aware of the social connections they form by collecting: "Building a collection is an ongoing adventure and exhibiting it brings us a special pleasure. What makes this odyssey so stimulating is meeting so many talented people, all of whom enrich our lives," as the Fleischmans put it, and, "one advantage of this collecting business is the human aspect," in the words of Norbert Schimmel.[79]

Understanding the importance of social networks to collectors means understanding one key aspect of the difficulties archeologists have faced when attempting to persuade collectors to stop collecting in order to reduce the demand for looted antiquities. Persuading a collector that collecting is harmful when she is embedded in a social network based on collecting is extraordinarily difficult. The collector must be persuaded not only that her own behavior has contributed

to the destruction of a past which the collector genuinely loves, but also that the continuing collecting behavior of the collector's friends, siblings, or spouse continues to harm this valued past. Love for the members of the network is put into conflict with love for the past. Rarely will the abstract idea win.

7

CHAPTER

The History of Looting and Smuggling—and What They Destroy

I have long thought about visiting your Rome again, the pleasantest of all cities, or rather I have made up my mind to do so. Though many things have held up my plan, none is more of an obstacle than the difficulty of finding the money. On a second trip I intend among other things to utterly despoil you—strip you of all your possessions—and I know what reinforcements would be needed to carry off such an assault. That house of yours is so stuffed with riches, so heavily defended by battle-hardened troops, that I realize it can hardly be taken without a great onslaught of money.

—Conyers Middleton (1683–1750), principal librarian,
Cambridge University, writing to the Roman
antiquities dealer Francesco de' Ficoroni

In a 1455 letter, Carlo de' Medici complained to Giovanni de' Medici that the powerful Cardinal Pietro Barbo, the future Pope Paul II, had forced him to give up some ancient coins:

I had just bought around thirty high-quality ancient silver coins from one of [the artist] Pisanello's boys, Pisanello having just died. I don't know how the Cardinal found me, but he took me by the hand and didn't let go until he had dragged me to his chambers; and

there he took what I had in my pockets and refused to give anything back.[1]

Because of episodes like this one, in which the insatiable Barbo did anything and everything to add to his collections, including bursting into tears, Pope Pius II nicknamed Barbo *Maria pientissima*, "Mary Weeps-a-Lot."

Others have shared Barbo's cupidity, if not always his success. Another lover of antiquities, one Bernardo Saragona, was put on trial in Rome in 1517 for taking advantage of the death of the patriarch of the de' Rossi family to steal "certain [ancient] marble heads which he would never be able to obtain from the heirs" of the famous de' Rossi collection.[2] And in 1759, Johann Winckelmann warned his nephew about the notorious Baron d'Hancarville: "When you show him your gems, keep a close look-out to see what he is doing with his hands."[3] Someone neglected to watch the hands of the visitors to the sales room where the collection of Richard Mead was being displayed in 1755, with the result that, as is annotated in a copy of the sale catalogue now in the British Library, "some of the more valuable Coins in this lot had been taken away; & others, common ones, left in their room."[4]

There are many other examples of occasionally unscrupulous collectors, but the greatest of these was the master collector in an age of master collectors: Lorenzo de' Medici (1449–92). Scion of an immensely rich and powerful family of merchants and bankers, Lorenzo ruled Florence in everything but name.[5] Following in the footsteps of his grandfather, Cosimo, he began acquiring antiquities in his teens. Lorenzo's first major acquisitions—busts of Augustus and Agrippa and a large cameo now known as the Tazza Farnese—came through as a mixture of business and diplomatic relations. Pope Sixtus IV gave them to the twenty-two-year-old Lorenzo when he traveled to Rome as Florence's ambassador to the pope's coronation.

Some of the gifts of antiquities received by Lorenzo were small: a coin or a cameo from people seeking work or wishing to remind him

of the friendly relations between their families and the Medici. Other gifts were more magnificent, as when Ferrante d'Aragona sent Lorenzo three ancient statues to thank him for allowing the Florentine artist Giuliano da Sangallo to work in Naples. Sometimes Lorenzo faced difficult choices when receiving presents from those intent on asking for favors in return, most amusingly in the case of Francesco Galiotto, a humanist who sent Lorenzo some coins along with a poem. One of Lorenzo's advisors wrote to Lorenzo that he would surely receive more presents from Galiotto if he wrote to him, but that he might have to invite Galiotto to read his poetry, and "when I think how much your delicate ears detest listening to the screeching of a saw, I remain hesitant about my advice as to which would be greater—the pain or the pleasure."[6]

Since it was well known that Lorenzo enjoyed antiquities, some people went to great lengths to obtain them in order to cultivate his favor. "I convinced Archbishop Niccolini in person to 'steal' another head of a youth complete with nose and ears, and he has sent it to you," wrote Lorenzo's secretary in a 1488 letter from Ostia.[7] The bishop of Ostia was constructing a fortress, and antiquities were being discovered in the pits dug for its foundations—apparently not always with his knowledge. His subordinate, the archbishop, took the opportunity to purloin one of the new discoveries to give to Lorenzo. Lorenzo's status as the papal banker meant that ambitious churchmen were always eager to be on his good side, even at the expense of a venial sin like theft.

Lorenzo's own subordinates were ruthless in procuring antiquities for him. They were members of powerful Florentine families, such as the Tornabuoni and Orsini, who worked with the Medici in business dealings and who hoped for promotion and the chance to marry into the Medici family. With such powerful motivations, these junior executives stole and smuggled antiquities for Lorenzo. On one occasion they snuck into an excavation being conducted by Cardinal Giuliano della Rovere, the future Pope Julius II. Under cover of darkness, they made away with a statue group of three fauns. They

even stole from the dead: when Cardinal Francesco Gonzaga died in 1483 and the executor of his estate was unwilling to sell Lorenzo the ancient carved gems he had collected when Lorenzo attempted to purchase them eight days after the death, Lorenzo's agent broke into the executor's home and took the gems for Lorenzo (who did eventually send payment).[8]

But the craftiest acquirer of antiquities for Lorenzo was Lorenzo himself. And once acquired, they remained; despite receiving many antiquities as gifts, Lorenzo rarely gave any away. As the affair of the horse head shows, sometimes he did not give away antiquities even when he was claiming to do so. In 1471, Lorenzo sent a life-sized bronze horse head to Diomede Carafa, a Neapolitan aristocrat known for his antiquities collection. The grateful Carafa sent a thank-you letter, which makes clear that he understood that this present was made in expectation of future favors:

> I received the head of a horse Your Lordship deigned to send me, about which I remain as content as I could about anything I ever desired and thank Your Lordship infinitely for such a worthy gift. . . . I inform you that I have nicely placed it in my house, so that one can see it from every side, and I assure you that it will be a reminder of Your Lordship not only to me but to my sons, who will constantly remember Your Lordship and will feel obliged to you, valuing the love you have shown by such a gift and ornament to the said house. If I can serve Your Lordship in something, I beg you to command me, because I most gladly and willingly shall do it.[9]

The young Lorenzo had been in power for only two years, and was hard at work defending the independence of the Florentine city-state from its powerful and acquisitive neighbors, including the Kingdom of Naples. At the time of the gift, Carafa was the chief advisor to the king of Naples, Ferdinand I. Fortunately for Lorenzo, he still retained this position seven years later, when Pope Sixtus IV formed an alliance with Ferdinand I and invaded Florence. Lorenzo managed to negotiate peace with Ferdinand I, undoubtedly thanks in

part to the persuasion of Carafa, keeping his promise to serve Lorenzo's interests "gladly and willingly."

Lorenzo did indeed own an ancient bronze horse head, which he inherited from his father's collections and which today resides in Florence's archeological museum. But he did not give this head to Carafa. Instead, the gift he gave—the gift that Carafa thought was ancient—was a modern work, modeled on Lorenzo's ancient horse head and created by none other than the renowned sculptor Donatello. Lorenzo gambled on Carafa's level of connoisseurship and won; the recipient seems to have accepted the present as an antiquity without any suspicions. Had Lorenzo lost the gamble, he may well have ended up losing Florence for the sake of keeping a single antiquity.

Such stories reinforce the stereotype of collectors as avaricious and antisocial, stopping at nothing to increase their collections. But in reality, antiquities collectors who prey on other collectors are rare and are treated as unusual and uncharacteristic by the collectors who report them. After all, why issue a special warning to treat a visitor as a potential thief unless this would be a departure from a general rule of welcoming and trusting fellow collectors?

A variety of factors explain the low level of competition between most antiquities collectors. Unlike collectors of many other types of art, antiquities collectors know that accidents of discovery might reveal new antiquities at any time. Collectors of Old Masters, by contrast, will always be locked in competition for the finite number of remaining Michelangelos or Leonardos. In addition, antiquities collectors outside of Italy and Greece are usually at the end of long and fragile supply chains. The collectors must rely on each other for advice and connections to a limited number of dealers and middlemen. Aggressive competitors will find themselves working alone, unsuccessfully. Antiquities collectors also value the friendship of fellow collectors. There are usually too few collectors in any one community to risk alienating them through misdeeds. Even Lo-

renzo de' Medici stole from Roman collectors, not from his fellow Florentines.

In stark contrast stand collectors' attitudes toward the governments that control the sources of yet-to-be or recently excavated or exported antiquities. Collectors have long flouted the regulations established by these governments without showing any qualms of conscience. One of the first and most ruthless of such collectors was Isabella d'Este (1474–1539). She was the wife of Francesco II Gonzaga, ruler of the small but influential Italian city-state of Mantua.[10] Her marriage soon deteriorated, and she and her husband led essentially separate lives, leaving Isabella free to devote herself to collecting and patronage.

Her collecting was not constant. She did not have much time for it when she acted as regent, first in 1509–10, when her husband was a prisoner of war, and then on the occasions after her husband's death in 1519 when her son was absent on military campaigns. But by 1542, an inventory of her collection lists 1,240 coins and medallions, 46 engraved gems, and a number of statuettes and other items, such as a piece of unicorn horn. Her collection was housed in her Studiolo, a small room in a tower, and the Grotta, a barrel-vaulted space underneath the Studiolo.

Isabella's collecting was intensely private. The works were for her enjoyment or for that of those whom she deemed worthy. Once when loaning a cousin a rare Greek manuscript, she insisted that it not be shown to too many people, lest it be devalued by exposure to the common eye. And she willed her antiquities to her son Federico "for his delight and pleasure [*per suo diletto et piacere*]."[11]

More than 300 letters concerning Isabella's negotiations for antiquities over a period of thirty-five years survive. From these we learn the details of what she called her "insatiable desire for ancient things."[12] Her desire was for "rare and most excellent things," as she told one of her agents when asking him whether an ancient bust was worthy of her collection or was simply "mediocre." She was also alert

to the problem of forgeries, and several times asked artists, including Mantegna, Gian Cristoforo Romano, and Jacopo Sansovino, to judge whether or not certain purchases were authentic, returning them if the artists thought them unsatisfactory.[13]

However insatiable her desire, her collecting ebbed and flowed with her finances, since she paid for art out of her private income. As a result of her limited funds, she drove hard bargains. She haggled with the artist Mantegna over a bust of the empress Faustina, receiving a steep reduction in price even though she had been one of the artist's most ardent patrons and knew that he would never have parted with the bust if he were not debt-ridden and seriously ill.

Her letters often show her asking friends and relatives to give her antiquities as gifts. She once sent a messenger to collect the portion of Galeazzo Sforza's antiquities collection that he had willed to her, despite the fact that he was merely sick and not yet dead. Even more ruthlessly, when Cesare Borgia sacked Urbino, ruled by her brother-in-law, Isabella wrote to her brother three days later to request his help in asking Borgia to give her some antiquities:

> My brother-in-law had in his house a small Venus of antique marble, and also a Cupid, which were given him some time ago by His Excellency the Duke of Romagna. I feel certain that these things must have fallen into the said Duke's hands, together with all the contents of the palace of Urbino, in the present revolution. And since I am very anxious to collect antiques for the decoration of my studio, I desire exceedingly to possess these statues, which does not seem to me impossible, since I hear that His Excellency has little taste for antiquities, and would accordingly be the more ready to oblige others. But as I am not sufficiently intimate with him to venture to ask this favor at his hands, I think it best to avail myself of your most revered Signoria's good offices, and pray you of your kindness to ask him for the said Venus and Cupid, both by messenger and letter, in so effectual a manner that both you and I may obtain satisfaction. I am quite willing, if it so please Your Reverence, that you should men-

tion my name and say that I have asked for them very urgently, and sent an express courier, as I do now, for, believe me, I could receive no greater pleasure or favor either from His Excellency or from your most dear and reverend Signora.[14]

When reinstated, Isabella's brother-in-law asked for the Venus and Cupid back—and Isabella refused. Nor was this the only time she profited from the endless warfare of the period. She also received some ancient alabaster heads she knew had been looted from the Bentivoglio Palace in Bologna after the defeat of Giovanni Benti-voglio by papal forces.[15]

Isabella also went to great lengths to ensure that her purchases reached her. As the value and prestige of antiquities rose during the Renaissance, the papal authorities tightened their control over what was becoming one of Rome's most valuable resources. Those seeking to export important antiquities from Rome needed papal permission, which was not always easily obtained. Even the powerful Cosimo III de' Medici, grand duke of Tuscany, had to engage in prolonged ne-gotiations in 1677 to remove three ancient sculptures, including the Medici Venus, from his Roman villa. Although the works belonged to him, Cosimo had to tender an excuse for moving them to Florence. He claimed that he had been ill and, on the advice of his doctor, had begun to take exercise in the galleries of his palace in Florence, and wished to install artworks there to engage his interest. This justifica-tion was for the benefit of the public; to persuade the pope, Cosimo had to promise to loan Florentine warships to the papal forces for an attack on Turkish pirates. When the pope finally granted his permis-sion, Cosimo III exported the statues on boats with armed guards, worried about protests from the Roman populace.[16]

Isabella's funds did not permit her to make purchases that would require her to fear mob violence. But the Roman authorities did not seek control over the sale of antiquities merely to retain master-pieces, but also to ensure that they received the heavy customs duties assessed on such exports. Isabella's letters repeatedly show her trying

to evade these duties. In 1499, she wrote a number of letters to her agents in Rome concerning the purchase of a slab of an ancient column, which she intended to use as a table top. Isabella stresses the importance of being artful (*usare arte*) in getting the slab out of Rome because she has an "appetite" for it (*siamo apetitose*).[17] She suggested that her agent wrap the slab in a cloth bearing the coat of arms of one of the cardinals friendly to the Gonzaga family. This cloth would convince the customs inspectors that the cargo was the property of the cardinal and thus exempt from inspection. She lists several cardinals in her letter, instructing her agent to choose one, meaning that she did not intend to ask the cardinal in question for permission to carry out this subterfuge. Presumably, she hoped that the inspectors would never make inquiries of the cardinal because they would never see the slab or the cloth, since she also instructed her agent to add the slab to a load of fish being sent from Rome to her husband. Presumably only a very dedicated inspector would spend much time poking through such a shipment.[18]

Isabella's customs ploy took a page from the playbook of Lorenzo de' Medici. In 1488, Lorenzo received a shipment of ancient marbles that his agent had smuggled out of Rome by marking it as the property of Francesco Cibo, Lorenzo's son-in-law. Cibo, the illegitimate son of Pope Innocent VII, had been granted diplomatic immunity.[19] Another early modern collector showed an even greater dedication to the cause of exporting antiquities. He was a seventeenth-century French traveler and antiquary who swallowed twenty ancient coins when his homeward-bound ship was threatened by pirates. Safely arrived, he enterprisingly sold several of the coins to a fellow collector, who had to wait for his purchases to emerge.[20]

English Grand Tour collectors and dealers turned the art of outwitting papal authorities into a science. Previously, few non-Romans aspired to obtain major antiquities from Rome, and those who did, like Isabella or the various Medici, were usually powerful enough to negotiate directly with the pope or well-connected enough to make

claims, even if questionable, of diplomatic immunity for their exports. But the flood of Grand Tourists meant that, for the first time, there was a stream of foreigners with the money to buy antiquities subject to the papal antiquities laws—and who had the persistence to test them.[21]

No antiquity over a certain relatively low valuation, whether newly discovered or long resident in a private collection, could be exported from the Papal States without a license granted by an official known as the papal antiquary. The antiquary also regulated new excavations. He granted permission to dig and then chose a third of the resulting finds for the papal collections. The antiquary did not have similar powers of direct appropriation for sales from existing private collections. However, most of these were aristocratic collections protected by entail that could be broken only with papal permission, leaving room for the antiquary to negotiate good prices with the many Roman families eager to sell their antiquities in the hard economic times of the eighteenth century. Whatever the source of an antiquity, its exporter had to pay customs duties of 3 to 4 percent of its value.

Potential punishments for evading these restrictions included fines, confiscation, corporal punishment, and excommunication. Still, the Grand Tourists and their dealers invented a variety of stratagems for evading these duties and obtaining export licenses for objects that the antiquarian might wish to keep for the papal collections. One method was to have a sculpture inspected after its discovery but prior to cleaning its surface of disfiguring incrustations. In this condition, the inspector might both grant permission for export and assess the work at a low value for customs duties.[22] Since the restorers employed by English dealers and collectors generally worked in Rome, the risk with this approach was that the authorities would see the work after cleaning and restoration and demand higher duties or, as was the case with the relief that Henry Blundell bought twice, refuse permission for export at all.

The ancient Romans frequently made larger sculptures using

multiple pieces of stone joined together, to take advantage of their different colors or to use a finer and more expensive marble for areas with greater detail, such as the head. This sculptural technique proved useful for eighteenth-century exporters, who would sometimes obtain a lower valuation by shipping a sculpture in its separate pieces. Each shipment would thus look like a lower-value fragment, and the recipient collector could easily recombine the work in England.[23] Another chance circumstance that sometimes proved advantageous was the death of a pope. The papal authorities would be distracted during the interregnum, although these did not always come at convenient times. Gavin Hamilton, frustrated at a lack of customers, complains in a letter from February 1775, shortly after the death of Pope Clement XIV, "I am now full of fine things, but we want dilettanti. Never was a time so apropos for sending off antiques as at present, having no Pope nor are we likely to have one soon."[24]

Like fragments, heavily restored antiquities had a lower customs value. In some cases, dealers told different stories to purchasers and customs agents in order to obtain a high price from the former and a low valuation from the latter. Most notoriously, in 1765 the Grand Tourist William Weddell paid a fantastic sum, perhaps as much as £16,000, for a statue of Venus. Weddell, a young and inexperienced collector, had in reality purchased an ancient torso around which the restorer Bartolomeo Cavaceppi had built a complete statue, complete with an unrelated and heavily reworked ancient head. While Weddell must have been unaware of the extent of the restorations, the dealer who exported it certainly was not. The export license application shows that the dealer described the work as having "a reattached head, not its own; right leg and arm and the entire base modern work" and valued it at the equivalent of around £70.[25]

Of course, should a work be too interesting for an export license to be granted or too valuable for duties to be reasonable, dealers could always simply smuggle it out of the country, using judicious bribes to assure success. The correspondence between dealers and collectors treated these bribes as matter-of-fact business expenses.

Thus, Hamilton explained to Townley that smuggling a statue of fauns would "cost a trifle more" in bribes, "but we save in duty," and concludes that "upon the whole it is the safest & best methode."[26] In another letter, Hamilton mentions that he must smuggle a statue of Venus to Townley "as I have done most all the fine things I have sent you."[27] The bribes went to highly placed authorities. Hamilton mentions bribing the papal antiquarian's immediate subordinate, the under antiquarian, and the Earl of Leicester's agent suggested that a "present" to an influential cardinal would "be the best Interest that can be made and fully sufficient" for resolving difficulties over the export of a statue of Isis.[28]

Collectors were by no means shy about revealing knowledge of the import restrictions or boasting about how they had gotten around them. The Duke of Bedford purchased the work known as the Lanti Vase from Lord Cawdor's estate. He then published an elaborate catalogue that proclaims the Vase's illicit origins: "as the Papal Government prohibits the sending away from Rome any large or celebrated work of ancient art, great difficulty and danger attended its clandestine removal."[29] But no one made a more public record of his bribery than did Lord Elgin.

Depending on one's point of view, Thomas Bruce, seventh Earl of Elgin (1766–1841), is either famous or infamous for removing substantial portions of the sculptural decoration of the Athenian Parthenon when serving as ambassador to the Ottoman Empire from 1799 to 1803.[30] Much less well known is the fact that he also procured a wide variety of Greek antiquities during this time for his own private collection.

Elgin's intentions when setting sail for his new post are hard to trace. He reported to the House of Commons that his original plan was merely to employ artists and draftsmen "to measure and to draw every thing that remained and could be traced" of the architecture of the Athenian Acropolis.[31] Elgin claimed that he began to contemplate the idea of removing sculpture, instead of just making drawings and

models, when he visited the Acropolis and realized that less remained than what had been published in 1762 in James Stuart's and Nicholas Revett's influential and heavily illustrated work, *The Antiquities of Athens:*

> From the period of Stuart's visit to Athens till the time I went to Turkey, a very great destruction had taken place. . . . Every traveller coming, added to the general defacement of the statuary in his reach: there are now in London pieces broken off within our day. And the Turks have been continually defacing the heads; and in some instances they have actually acknowledged to me, that they have pounded down the statues to convert them into mortar. It was upon these suggestions and with these feelings, that I proceeded to remove as much of the sculpture as I conveniently could.[32]

Elgin made this claim during the five years of negotiation, from 1811 to 1816, it took to persuade the British government to buy the Parthenon marbles from him. By then, his finances in disarray after several years in France as a political prisoner, detained as he returned to Britain, and facing a growing controversy over the removal of the sculptures, Elgin must have been eager to provide the public with answers that might placate it and cause the House of Commons to vote to approve the purchase. It is not clear at what point Elgin decided that the sculptures from the Acropolis should belong to the British Museum instead of him.

Whatever the nature of his original intentions, Elgin eagerly began to collect antiquities early on in his Ottoman career, mostly through the actions of agents to whom he sent frequent and detailed instructions, checking in on their accomplishments through visits to Greece from his base in Constantinople. His ambitions were grand; in one letter alone, he orders his agent to pursue purchases and excavations in Athens, Eleusis, the fortress of Phyle, and Olympia, where "assuredly excavation is of the greatest consequence. You would be the first, and history assures us that there are statues, riches, monu-

ments of all sorts in such abundance, that this dig is deserving of any effort that can be made there."[33]

The same letter contains a list of items sent by Elgin for his agent to use as bribes when obtaining antiquities:

Three silver telescopes.
Three telescopes in yellow mounting.
One with a foot to rest on a table.
A green narghile with a yellow foot, and also with a foot of green crystal, which are exchanged.
One ditto, white-with a yellow foot, and also one of white crystal.
A small green ditto.
A gold watch.
A compass.
Two crystal bottles, to hold ice and cool the water.
Two crystal covered glasses.
Four yellow cups etc. porcelain.
Three covered cups.
Two covered Wedgewood cups.
Three little pieces of Wedgewood, together forming an inkstand.
A box of instruments with one handle which serves for all the pieces.
A gun, that you must have cleaned.[34]

Elgin concluded this list with the wish that "I beg you to be careful as to the distribution of these articles. I shall regret nothing that assists my acquisitions in Greece."[35] By the end, Elgin may have found it hard not to regret the expense of his bribes. Explaining that he had to offer them on a scale "proportioned to the rank of the parties, the sacrifice to be made, and the eagerness shewn for the acquisition," he reported to the House of Commons that he had spent £15,000 on bribes along with wages for workmen.[36]

Other travelers and collectors also found that a well-placed present was necessary for accessing the Acropolis under the Ottomans,

especially since the site had been turned into a fortress and all visitors were accordingly regarded with suspicion. The Marquis de Nointel gave the disdar, the commander of the fortress, six ells of scarlet cloth and a gift of coffee for admitting his draftsman in 1674. Similarly, Sir Richard Worsley gave a few yards of broadcloth to the wife of the disdar in 1785, and John Hobhouse obtained his admission in the early nineteenth century for "the usual present of tea and sugar."[37] A few years later, Edward Dodwell had to pay fees of around a hundred Turkish piasters, although the disdar continued to ask for further presents until Dodwell accidentally discovered a means of threatening him when showing him the camera obscura he was using to obtain reflections to trace the monuments:

> He . . . looked into the camera obscura with a kind of cautious diffidence, and at that moment some of his soldiers happening to pass before the reflecting glass, were beheld by the astonished Disdar walking upon the paper: he now became outrageous; and after calling me pig, devil, and Bonaparte, he told me that, if I chose, I might take away the temple and all the stones in the citadel; but that he would never permit me to conjure his soldiers into my box. When I found that it was in vain to reason with his ignorance, I changed my tone, and told him that if he did not leave me unmolested, I would put him into my box; and that he should find it a very difficult matter to get out again. His alarm was now visible; he immediately retired, and . . . never afterwards gave me any further molestation.[38]

The disdar would not vanish into Dodwell's camera obscura, but he and his successors would not linger long in Athens. The Greek War of Independence freed Greece from Ottoman rule in 1832. Not much later, Italian unification welded together disparate kingdoms and states into a single nation. No longer would collectors have to ask permission from—or bribe—Constantinople or the papal authorities to obtain and export antiquities.

Yet, a change in the authorities overseeing antiquities did not lead

to a change in the behavior of collectors. They continued to break the laws of the new states by smuggling antiquities, generally with the aim of avoiding paying high customs duties. Edward Perry Warren, both a private collector and a buyer for the Boston Museum of Fine Arts, recorded some of the stratagems employed by himself and his associate Wolfgang Helbig for lowering or avoiding Italian customs duties in the late nineteenth century:

> About the Eleusinian vase and the Polygnotus. . . . The Polygnotus I shall doctor myself, just painting the [signature] out with something that will wash off. . . . The Eleusinian, Helbig thinks "a man he knows" can put through Customs for about a hundred lire. The man is a rogue of course, "but there is no danger" . . . it is very strange, but "the dirtier the business the more secure you are in trusting to the honour of certain Italians. . . . The reason is that the priests to whom they always confess such things, always bid them to carry the matter out and keep their word." The same man it was who got the Copenhagen busts out of Rome [for the Ny Carlsberg Museum, Copenhagen] for almost nothing. . . . "He covered the noses and chins with stucco as though they had been repaired, and made them look so bad the authorities thought them valueless."[39]

Bribery and false restorations that would make the objects seem like near-worthless fragments or anonymous works—in other words, business as usual.

But the twentieth century changed everything, with two major and related developments. First was a growing rise in demand for antiquities. As it became easier for both information and people to travel, knowledge of the past and desire to possess its artifacts grew. In place of collectors from only a few nationalities active through the nineteenth century, modern collectors come from all over the world, and Greek and Roman antiquities can now be found in nearly every country.

The second development was the passage of national ownership laws in Italy and Greece and almost every other source country for

antiquities.[40] Previously, antiquities unearthed on private land belonged to the landowner (although in the Papal States and some other countries, the authorities could claim a share). The owner of the antiquities could restore, sell, or do whatever he wished with his antiquities except export them, which required permission and a license. The rise in demand for antiquities and the continued circumvention of export laws, along with a rise in patriotic feeling concurrent with the world wars, led both Italy and Greece to feel that rich, unscrupulous foreigners were draining them of their cultural heritage. In an effort to tighten state control of antiquities, both countries declared that all newly discovered antiquities, whether on private land or not, would belong to the state. At the same time, licenses for the export of the remaining privately owned antiquities were dramatically curtailed, nearly destroying the legitimate market for antiquities sales.

These new regulations did little to decrease the demand for antiquities—and much to drive this demand into black market channels. With export almost completely banned, exporters no longer sought licenses, as they had before, even if they had done so while also attempting to reduce the customs duties. Instead, the number of antiquities smuggled out of Italy and Greece grew exponentially, with the result that we do not have even the laconic customs records of previous centuries to help track their source.

The twentieth century saw a general decrease in the amount of information associated with antiquities for sale. The collectors and dealers of previous centuries, unashamed of breaking or bending the laws of source countries, openly discussed where their antiquities came from and how they left their country of origin. But a growing secrecy cloaked the source of antiquities after the passage of export bans and national ownership laws. Dealers became reluctant to speak openly about the sources of the antiquities they sold. A dealer who boasted about breaking the law would soon find few willing to sell antiquities to him, and he might face prosecution. The ever-larger bureaucracies in charge of protecting antiquities meant that a well-

placed bribe could no longer assure immunity, as it had in the eighteenth century.

As for collectors, most became content to purchase antiquities without any specific information as to their source. Getty, with his obsession with information about former owners, is very much the exception here. By contrast, most collectors bought what are known as "unprovenanced" antiquities—objects that are sold without an indication of either their archeological find-spot or their chain of ownership history. Around 95 percent of the antiquities sold at auction at Sotheby's and Christie's in London from World War II through 2000 had no indication of a find-spot, and 89 percent had no historical information listed.[41] In recent years, the number of small antiquities, such as coins, sold on eBay and other online retailers has exploded. Nearly all of these antiquities are unprovenanced. And a number of investigations have revealed that in the rare cases where provenance information is given for an antiquity, it is often faked in an attempt to show that the work came from a country where export is legal, such as Switzerland, rather than its true country of origin.

Smuggling leads to the loss of information about the source of antiquities, but it is not the most harmful change wrought by the shifts in the antiquities markets in the twentieth century. Far more problematic has been the increase in the number of looted antiquities. The term "looted" describes any set of acts by which an antiquity is illegally obtained. The looseness of this definition is necessary because antiquities can be obtained in a number of ways contrary to law: deliberately dug up from archeological sites, stolen from museums, accidentally uncovered during construction projects and sold instead of being reported to the authorities, and so on.

If an antiquity is unprovenanced, it is difficult to ascertain whether it was legally exported from its country of origin. Legal export means that an antiquity either left its country of origin before the passage of national ownership laws or that it was accompanied by proper export permissions after the passage of these laws. The

consensus among archeologists is that the large number of antiquities that entered the market in the last fifty years (after most source countries for antiquities banned their export) is too great to be accounted for by the history of legal collecting. Instead, most antiquities purchased by modern collectors were looted from archeological sites and smuggled out of their countries of origin.

Scholars have extensively documented the existence of looted ancient Greek and Roman archeological sites,[42] as well as sites from many other ancient cultures, including Mesopotamia, Pre-Columbian cultures in South and Central America, ancient China, prehistoric Europe, various African sites, and Native American sites in the United States.[43] The amount of scholarship documenting looting is extensive, and the problem of looting shows no signs of abating.[44] Indeed, the reverse is true, with recent conflicts in Iraq, Afghanistan, Egypt, and Syria creating new opportunities for looting.

Looting causes incalculable harm. Although looters are careful to preserve aesthetically pleasing, high-value antiquities, they often destroy fragile and nonsalable materials, such as animal or plant remains, wood, cloth, and architectural structures, when they use everything from shovels to bulldozers and dynamite to open and search graves, settlements, and other archeological sites. The artifacts destroyed by looters are not valuable to private collectors but are priceless for archeologists, whose interest in the quotidian areas of ancient life—agriculture, labor, soil erosion, plumbing—seem mysterious, boring, or even malicious to a collector intent on appreciating antiquity's beauties.

Antiquities are useful insofar as they reveal information about the past cultures. Artifacts need not be aesthetically pleasing to reveal such information. Archeologists study the minute detail of an artifact's relations to all other objects on a site—a level of detail not preserved by anything other than slow, exacting, professional archeological excavations. An object on the market has been removed from these connections and thus is valueless. For example, an analysis of the lipid residues adhering to insides of uncleaned pottery can reveal

information about what ancient cultures ate, how they farmed, and what sort of environmental climate they experienced. Looters scrub away these residues before they sell the pottery in order to elude analysis by police seeking to determine the origins of illicit antiquities.

In the past, museums would sometimes turn a blind eye to the suspicious provenance of antiquities they wished to acquire, but after a recent series of high-profile repatriation demands and criminal cases backed with proof of looting, many major museums have changed their acquisition policies and now require information about an antiquity's provenance.[45] With museums refusing to buy, it is now private collectors who are driving the market in illicit antiquities.

8

Collectors' Failed Justifications for Looting and Smuggling

Theodoric the Great, king of the Ostrogoths in the sixth century CE, permitted his subjects to take artifacts from ancient graves as long as they did not disturb any human remains. He believed that "it is not greedy to take what no owner can complain of having lost."[1] The idea of looting as a victimless crime has a long history. At its core is Theodoric's belief that the ancient Greek and Roman dead have no further claims to their former possessions (and, unlike the apparently more wrathful Egyptians, pose no threat to those who seek to invade their graves).

Equally key to this justification for looting is the accompanying belief that it is not a crime to take antiquities from those who currently own or control them. Many collectors have justified breaking the law to acquire antiquities by claiming that those who have passed laws restricting exports are being selfish. In the words of one English visitor to Rome in the early seventeenth century:

> There is moreover no house of any worth, that is not replenished with infinite numbers of ancient Statues. . . . Courts, Galleries, every room is adorned with them, and in many rooms heaped one upon another, there be so many. And yet, for all this multitude, it is a strange thing to see at what inestimable prices they hold every one of them; nay, it is almost an impossibility, by any means, or for any money to get one of them away, they hold them in so great estima-

tion. Nevertheless, every day amongst their Vineyards, and in the ruins of old *Rome,* they find more, which, in whose ground soever they be found, at a certain price, do now belong to the Popes, who distribute them in their own Palaces, to their favorites or kinsmen, and sometimes as presents to Princes.[2]

If there is truly such an abundance of antiquities, it would be greedy for the Italians to keep them all for themselves. They have enough to heap them in their galleries and to fill all the popes' needs for presents, so why not let English collectors purchase them as well? Seeing an abundance of antiquities, collectors can regard export restrictions as unjust and therefore disregard them. John Bacon Sawrey Morritt, who traveled to Athens in 1795, drew the connection between abundance and lawbreaking very clearly: "Over almost every door is an antique statue or basso-rilievo, more or less good though all much broken. . . . Some we steal, some we buy, and our court is much adorned with them."[3]

Contemporary collectors, although more careful to avoid admitting directly that their activities are illegal, often give similar justifications about the sheer number of antiquities in source countries. They believe that source countries have already excavated so many antiquities that these finds are now buried in warehouses and museum basements, moldering away without anyone able to study or appreciate them. As Norbert Schimmel, a prominent New York collector, put it:

> We've all become concerned over the destruction of [Egyptian] tombs. It's disgusting, and all the efforts being made to stop it seem to amount to nothing. But on the other hand . . . [t]here's a lot of material collecting dust in such countries that might be better off in museums, where it would be well-protected, taken care of and, most important, published.[4]

A second justification for breaking the laws of source countries is collectors' belief that the current possessors of antiquities are unworthy owners who are neglecting or damaging artifacts:

> Here in Rhodes, there are many very excellent sculptures, especially in the garden of the Illustrious and most Reverend Grand Master [of the Knights of Malta]. Since these have not received recognition they are neglected, berated, and kept in such vile conditions that they lie exposed to wind, rain, snow, and storm, and so they are eaten up or ruined. I was so moved with pity for their cruel fate, no differently than if I had seen the disinterred bones of my own father in such conditions.[5]

Thus Fra Sabba da Castiglione complains to his patron, the collector Isabella d'Este, about the neglect of the ancient sculptures she hoped to buy with his help in the early sixteenth century. A hundred years later, Henry Peacham was expressing similar thoughts about the Ottomans, no doubt with the smuggling of antiquities out of Turkey by his patron Lord Arundel firmly in mind:

> In Greece and other parts of the Grand Seignior's Dominions (where sometime there were more Statues standing than men living, so much had Art out-stripped Nature in these days) they may be had for the digging and carrying. For by reason of the barbarous religion of the Turks, which alloweth not the likeness or representation of any living thing, they have been for the most part buried in ruins or broken to pieces, so that it is a hard matter to light upon any there that are not headless and lame, yet most of them venerable for their antiquity and elegancy.[6]

Stories of destruction pervade collecting narratives, from early Renaissance antiquarians complaining about the barbarians who burnt Rome's classical monuments to make lime to contemporary collectors claiming that uneducated looters melt down artifacts for the sake of the value of their metal:

> Until the sixteenth century of our era hoards of ancient coins found in Italy and Sicily normally went directly into the melting pot. The same practice was followed in Greece up to the nineteenth century, while in Egypt and Asia Minor it is often still the practice.[7]

Collectors most often level accusations about the deliberate destruction of antiquities against the inhabitants of Islamic countries, on the theory that they have no connection to the pre-Islamic past and also have an animus against figural art. But sometimes even those who might be presumed to have closer connections with antiquity are painted as its destroyers. When the collector Sir Richard Worsley visited the Church of St. George at Cape Sigeum, Greece, in 1786, to see an ancient relief of mothers and babies that had been turned into a bench outside of the church door (fig. 17), he recorded:

> It has been much injured by the inhabitants of the place to prevent its being taken away, as I was informed by Signor Sabatea, the British Vice-Consul at the Dardanelles, who acquainted me that he had accompanied an English gentleman to the spot, who had bid 400 Venetian sequins for this beautiful fragment. The Governor of the castle had given his consent to the sale and had sent some Turks to assist the gentleman in getting it away, but they met with a violent opposition from the Inhabitants, who immediately began to beat off the heads of four of the figures out of the five . . . alleging that the reason why they would not be prevailed with to part with the fragment was that upon a former occasion they had sold a fragment, and soon after their village was infested with a dreadful plague.[8]

Seeing this neglect and destruction, the collector aspires to rescue antiquities and provide them with a better, safer home. As Charles-François Olier, Marquis of Nointel, France's ambassador to the Ottomans, wrote in a dispatch from Athens in 1674, asking (unsuccessfully) for funds to bring the Parthenon marbles to Paris: "There they would be safe from the insults and injuries done to them by the Turks, who, in their horror of what they call idolatry, deem it a worthy act to break off a nose or some other part."[9]

When stories of destruction are used as justifications for "rescue," they are sometimes exaggerated. For example, four out of the five figures on the relief from Cape Sigeum are indeed missing their heads. But the entire top portion of the relief is missing, too. The slab

Figure 17. Greek marble trapeza with relief decoration showing women
making offerings to a seated female (Cape Sigeum Relief) (detail),
c. 350 BCE. British Museum (1816, 0610.324). © Trustees of the British
Museum.

was trimmed at some point with a straight cut, probably to make it suitable for use as building material. Afterwards, someone made up the story about the locals removing the heads in order to prevent the loss of the relief. Such stories of destruction are powerful; in this case, the story justified Lord Elgin when he later obtained this relief for his collection.

A story told by another English traveler to Cape Sigeum illustrates another strand of collectors' thoughts about their actions. Elgin's agents had removed the figural relief along with another stone carved with an inscription from the church, and the priest lamented their loss:

> The sighs and tears with which the Greek Priest accompanied his story did not, however, arise from any veneration he bore to the antiquity of these marbles, from any knowledge of their remote history, or any supposed relation they bore to the tale of Troy divine, but because, as he told us, his flock had thus lost an infallible remedy for many obstinate maladies. . . . The custom was to roll the patient on the marble stone which contained the Sigean inscription, the characters of which . . . were supposed to contain a powerful charm. This practice had, however, nearly obliterated the inscription.[10]

Sometimes, the current possessors of antiquities are not neglecting or destroying them. They might be protecting and cherishing the antiquities, regarding them as a crucial part of their lives and culture. The collector who wishes to take these antiquities has to tell another story to justify his taking. Often this story turns on the failure of the current possessors to understand or appreciate the true nature of the antiquity. This type of story was already in use by the first foreign travelers interested in antiquity who visited ancient Greek and Byzantine sites, such as Pierre Gilles, who spent the years 1544 to 1547 in Constantinople and complained that:

> The difficulties I labored under [in Constantinople] in the search for antiquity were very great. I was a stranger in the country, had

very little assistance from any inscriptions, none from coins, none from the people of the place. Having a natural aversion for anything that is valuable in antiquity, they rather prevented me in my inquiries so that I scarcely dared tackle the dimensions of anything [that is, measure any ancient buildings]; and I was menaced and cursed by the Greeks themselves if I did. A foreigner has no way to allay the heat and fury of these people, except by a large dose of wine. If you don't invite them and tell them "you'll be as drunk as a Greek," they'll treat you in a very coarse manner. Their whole conversation is frothy and insipid, retaining none of the customs of the old Byzantines except a habit for fuddling. . . . They are so fond of change and novelty that anything may be called "antique" among them that is beyond their memory or was transacted in the first stages of human life. Not only have the magnificent structures of ancient times been demolished by them, but their very names are quite lost. A more than Scythian barbarity prevails among them.[11]

Again and again in the diaries and letters of those undertaking a Grand Tour we read similar complaints about crime, dirt, poverty, bad food, and bedbugs of Italy and Greece. Grand Tourists generally regarded even the high society of these countries as uncultured, unlettered cheats and seductresses. The contempt shown for the conversation, drinking habits, and other social graces of the modern inhabitants of ancient places went hand in hand with the accusations that they do not know or care about the ancient past. If they had failed to master modern culture, who could expect them to be proper custodians of ancient culture?

A required correlate belief is that the collector will be a superior owner because of his deeper understanding and appreciation for the past. Most of the foreigners who sought to acquire antiquities until the eighteenth century did have some special interest in the past. As for collectors of the eighteenth and nineteenth centuries, "Rome is the first world which we have known," in the words of one French traveler.[12] Ancient literature, mythology, history, and languages had

become the basis for education, first in the education of elites, and then in schools open to all. As a result, as Michel de Montaigne wrote: "I was familiar with the affairs of Rome long before I was with those of my own house. I knew the Capitol and its position before I knew the Louvre, and the Tiber before the Seine."[13] Especially when facing the rigors of travel, collectors saw antiquities as familiar beacons of home, reminders of the ancient history and literature they mastered as children. With such strong personal connections, it was easy to overlook or deny the validity of the connections between these antiquities and the modern inhabitants of Greece and Italy.

Another, more recent, justification for collecting looted antiquities deals with the case in which an antiquity would have remained buried, in no danger of harm, if not for the looters seeking to supply the black market. Some contemporary collectors justify buying such an antiquity by believing that being owned by a collector is important for the object. These collectors think that objects must be lived with, touched, and cared for, and to do so gives one the right to own them. As one contemporary collector of Greek vases explains it:

> Who owns ancient objects? Ideally the people who truly love them —the people who go to museums, who study them, who publish them, who preserve them, who want them to be around for future generations. They may not have legal title to them, but they own them in an emotional way. Others, even with legal title, only possess them.[14]

Elie Borowski, who thought his collection of antiquities could prevent another Holocaust, shows these justifications in play. Borowski was born in Poland in 1913, the sixth of seven children. His studies took him to Paris, where, as World War II threatened, he volunteered to fight with a Polish division of the French army. He spent most of the war interned in Switzerland, where he was allowed to work part time at a museum in Geneva. There, in 1943, he saw an ancient Near Eastern cylinder seal that sparked his interest in collecting antiquities:

The chalcedony cylinder's inscription, "*le-Shallum*," had a strange fascination for me, even though I suspected that my interpretation that it referred to Shallum ben Yavesh, king of Israel in 741 B.C.E., was doubtful. I was . . . working in the museum in a state of emotional isolation and deep depression, for I had already known for a year of the fate of my family in Warsaw.[15]

Borowski's family had met the fate shared by so many of Poland's Jews: extermination by the Nazis. Isolated and depressed, Borowski seized upon an antiquity that inspired in him thoughts of a very different state of affairs, a time when the Jews possessed a powerful and feared state. Although he knew that the seal he held, and ultimately purchased, probably did not actually refer to a king of Israel, it caused him to form a plan for a collection:

I visualized, perhaps dreaming, that the acquisition of this [seal] might form the beginning of a spiritual apothecary, filled with healing, cultural medicines which would prove to be efficacious against the horrors of those times [World War II]. How wonderful it would be if I succeeded in forming a collection of works of art, the aim of which would be to strengthen the historical truths of the Bible, and thereby challenge individuals to rise above their ephemeral materialism in order to return to the eternal, spiritual values and beauty of the Bible and humanism. Thus began my collection of the art of the ancient world and the Bible.[16]

Borowski was one of the many people who, after the horrors of Nazism, thought that society needed to be reconstituted on a new foundation to ensure that similar regimes could never again arise. For Borowski, what was needed was the revival of an old foundation that had weakened, namely, biblical morality combined with Greek humanitarianism:

The Torah, with its emphasis on ethical and moral behavior, is the essence of all human spirituality. Greek culture, with its emphasis on beauty and the human body and the glorification of athletes, is

the essence of physical aesthetics. In short, Jerusalem symbolizes the soul, and Athens the body.[17]

Accordingly, Borowski "solemnly pledged" that he would "dedicate my life to creating a world centre for education about biblical cultures and art history."[18] He made his fortune as an art dealer and founded first the Lands of the Bible Archeology Foundation in Canada and then the Bible Lands Museum in Jerusalem, to which he donated more than 1,700 objects from his collection along with nearly all of its $12 million construction cost.

Borowski's vision of the purpose of his collection was so strong that it easily overcame any scruples about antiquities laws. He bought directly from notorious antiquities smugglers, working with them so closely that his name appears on an organization chart detailing the most important participants of the illicit trade, written by one smuggler and seized by Italian authorities in 2001.[19]

Borowski's wife and partner in his museum-founding vision responded to questions about the questionable origin of many of their collected antiquities by saying:

> You're right. It's stolen. But we didn't steal it. We didn't encourage it to be stolen. On the contrary, we have collected it from all over the world and brought it back to Jerusalem. Elie's not a stealer of artifacts. He has saved and preserved so much of our history and heritage by collecting these artifacts.[20]

Borowski's wife may be unusual in her willingness to admit the looted origin of the antiquities in her and her husband's collection, but her statement interlinks a number of common justifications for collecting looted antiquities. She believes that his collecting has "saved and preserved" antiquities, presumably from some sort of neglect or harm present in their original location, such as the act of looting itself. She also claims that saving these antiquities by collecting them has saved "our history and heritage." Borowski's special powers of discernment were able to find history in antiquities—history that

would otherwise have been lost along with the antiquities, if not rescued by him. She refers to Borowski bringing the antiquities to his museum, where their display is intended to reform the moral foundations of society and prevent the recurrence of Nazism. The force of her conviction is clear. Yes, the antiquities in the Borowski collection were stolen by being looted and smuggled out of their countries of origin. But who can care about such petty national laws when abiding by them means losing not only antiquities but also the past and the future of mankind?

Collectors do not always keep the promises to protect, appreciate, and understand antiquities that they make when justifying their purchases. "To the shades of the deceased T. Flavius Hermetes, the sweetest husband, Octabia Pollitta Cyriace made this for her well-deserving husband and herself." Thus reads the inscription on a second-century CE sarcophagus, but the fates did not believe that Hermetes was quite as deserving as did his wife. The sarcophagus continues to be used where it was first placed in the eighteenth century—as a plant pot in the gardens of Holkham Hall.[21] Another sarcophagus, purchased by another Grand Tourist, had a slightly grander destiny. After being excavated by Richard, Duke of Buckingham and Chandos, from the tomb of Caecilia Metella in Rome, it was placed in a flower garden at Stowe House in order to serve as a coffin for the duke's aged pet dog. Yet another sarcophagus was used at Kedleston Hall to store logs by a fireplace, and Francis Charles Seymour-Conway, third Marquess of Hertford, sent home a sarcophagus from Italy in 1829 to become a drinking trough for his cows. In other cases, the collector's heirs are the ones to blame for damage to the collected antiquities. The unfortunate history of Lord Arundel's marbles has already been discussed, but we can add one detail: James Theobald purchased the drum of an ancient column from Arundel's heirs and took it to his house in Berkshire to use as a roller on his bowling green (*"sic transit gloria mundi"* was the comment of the disgusted Adolf Michaelis, the Victorian art historian who uncovered its fate).[22]

Collectors can even subject antiquities to the risk of harm from religious fanatics—the same risk from which collectors claim they are rescuing them. We have already seen the duc de Mazarin at work with his hammer on the nude antiquities he inherited from Cardinal Mazarin. Another example, involving another hammer, is the fate of the antiquities purchased by Charles I of England from the collection of Ferdinando Gonzaga, duke of Mantua. After the execution of the king and the establishment of a Commonwealth under the fiercely puritan Oliver Cromwell, sixteen of these statues were placed in the Privy Garden in Whitehall. In 1659 a cook attacked the statues with a blacksmith's hammer, but he was not punished. His supporters believed that the antiquities deserved their fate. Most of the rest of Charles I's antiquities were restored to royal possession with the accession of Charles II, only to be destroyed in the Whitehall fire of 1698.

Unorthodox uses and unappreciative heirs have caused only so much damage. Of far greater concern are the incalculable damages done during the act of looting. Collectors are mainly concerned with safeguarding individual, collectible antiquities, such as statues. Such antiquities are usually carefully sought out and protected by looters since they are the source of profit. If collectors worry about damages caused by looting, they focus on the potential damage to collectible antiquities during illegal excavation, such as when looters accidentally break objects, miss or fail to appreciate important material, or conceal information about where antiquities were found.

In reality, looting must be stopped not because of its potential to damage some valuable objects but because such digging always destroys most of the archeologically valuable information associated with ancient sites. Collectors think that collecting preserves the past. But in fact, collecting looted antiquities destroys the past just as surely as Mazarin's hammer.

9

C H A P T E R

Conclusion
Collecting to Save the Past

Collectors have long been satirized as pretenders to taste, purchasing antiquities that they know and care nothing about in order to show off to other, equally ignorant, members of the elite. I have argued against this simplistic picture, presenting evidence of the complex roles that antiquities play in the lives of their collectors, from their use to create and display a self-conception, to their involvement in the erotic lives of their owners and admirers, to their ability to strengthen social networks.

I have also argued that the ways in which antiquities change collectors means that collectors, in turn, changed antiquities to increase their usefulness. These changes include manipulations of physical antiquities in ambitious restorations and intellectual manipulations of the interpretations of antiquities. Currently, collectors' most profound and urgent impact on antiquities is the destruction caused by looters who supply the market.

Demand drives looting. If no one purchased antiquities, there would be no reason to supply them. Most major museums are adopting new acquisition policies that stop them from acquiring unprovenanced antiquities. Private collectors are the remaining major sources of demand for potentially looted works.

Archeologists, seeing this direct connection between demand and looting, command collectors to stop buying. Such finger wagging has had little effect on collectors. Collectors have long faced dis-

approval, in forms much harsher than archeologists' condemnations. Collectors persisted though disapproval from all-powerful Roman emperors, howls of angry fundamentalist mobs, and threats of excommunication. The unhappiness of a few academics will not cause them to give up their beloved acquisitions. Even if collectors pay attention to the objections of archeologists, they can counter these objections with a variety of deep-rooted and complex justifications for collecting looted antiquities.

A collector is hardly likely to accept a legal or voluntary regime that requires giving up something he highly privileges—the ability to make direct, personal connections with the past—in favor of something he does not value—the preservation of the archeological record, post holes, latrines, pottery shards, and all. Yet, this sacrifice is exactly what most proposals intended to decrease looting require. Many archeologists even advocate the abolishment of private ownership of antiquities, a proposal obviously contrary to private collectors' fundamental beliefs.

Rather than continue to struggle in stalemates between beliefs that will never be reconciled, we need to find new ways to preserve the past. We must understand the importance of antiquities to collectors. We must give collectors what they value in forms that do not encourage looting and destruction.

One such way would be to pay attention to one often-expressed justification for collecting: usefulness. Borowski thought his collection was useful because it would inculcate beliefs that would strengthen the moral foundations of society, but other collectors have more practical views of the usefulness of their collections. Hamilton published illustrations of his vase collections so English artists and manufacturers would have patterns to revitalize their work. Josiah Wedgewood made his fortune by using these designs. Many modern collectors have professed their desire to be useful to scholars by publishing catalogues of their collections, even though many archeologists do not find unprovenanced works to be helpful to scholarship. Thousands of collectors donated their collections to public

institutions, often accompanying these gifts with statements about their hopes that the public will benefit from seeing their antiquities.

The sponsorship of archeological excavations is an obvious, but curiously uncommon, way to combine collectors' desire to be useful with their urge to be intimately involved with antiquities. Leon Pomerance stands as the foremost example of a collector converted to an archeologist's point of view through his involvement in excavations.[1] Pomerance attributed his interest in ancient art to a chance meeting. He and his wife were traveling to Europe when Pomerance started talking to Borowski, who was standing behind him in a shipboard line. Pomerance was fascinated by Borowski's life history and shared his passion for Jewish causes. Borowski soon converted both Pomerance and his wife to a passion for antiquities by showing them "his pockets full of paper cartons, metal cartons, with Etruscan gold earrings, with Mesopotamian seals, stuff that I saw in museums but never knew that you could buy them, had no idea."[2] Borowski took the Pomerances to dealers in Europe, and "we were like kids in a bakery shop with our noses pressed against [the case]. I mean this was a world that we didn't even know was open to ordinary people and, boy, did we bite!"[3]

Though the Pomerances began like many other collectors we have seen, their collecting soon took a turn. In 1954, Pomerance joined the main professional organization for American archeologists, the Archaeological Institute of America, whose membership is also open to interested laymen. Having made his fortune in the paper business, he offered to supply the paper for the Institute's publication, *Archeology*, at a discounted rate. He went on to serve as the president of the New York branch and then as vice president of the national organization. He was offered the presidency but declined, believing that this post required a professional archeologist rather than the "buff" he considered himself. Pomerance had a profound effect on the course of archeological scholarship in the United States through establishing and funding several distinguished awards through the Institute, including the Pomerance Award for Scientific Contributions to Archaeology,

which rewards the use of scientific analysis to study excavated material, and the Harriet Pomerance Fellowship, which funds the study of the Bronze Age Aegean in honor of his wife, who died of cancer in 1972.

Pomerance also sponsored an entire excavation, at the Minoan palace site of Kato Zakro, Crete. In 1958, his wife was given two to five years to live after a radical mastectomy, and Pomerance determined "to do something to give my wife an excitement which few women of her age and time would have."[4] Fortunately for the course of archeology, Harriet Pomerance found archeological excavations exciting. But Pomerance almost did not succeed: "I tried to get involved with an excavation in Turkey that was run by Harvard that I knew about, but I was turned down by the prestigious professor, largely, I found out later, because my gifts to this excavation were not of a high enough schedule."[5]

Instead, Pomerance happened, "one rainy Saturday afternoon" in 1960, to browse through the Herakleion Museum Guide, "and there in the text the curator or the director of the museum had said there were still some great sites in Crete, undug, undiscovered."[6] Pomerance contacted the director of the Herakleion Museum and offered $3,000 to fund an excavation "if my wife and I can be present when you open it up."[7] The Pomerances eventually participated in ten years of excavations that uncovered an entire Bronze Age palace complex.

Pomerance's writings show that he continued to believe firmly in the importance and value of private collecting and to resist acknowledging the scope of looting. Nevertheless, he purchased fewer and fewer antiquities as his involvement with the excavation increased. In part this was for practical reasons, since he claims he was "diverted" from collecting by the excavation: "my money went into this hole in the ground" instead of toward purchases.[8] But he also began to see ethical dimensions of the problem of private collecting that would never have been revealed to him if he were not sponsoring an excavation: "I never bought anything in Crete for fear . . . that people would say that I got it from the digs."[9]

There are a few other examples of collectors who became deeply

involved in patronage for excavations, such as Ada Small Moore. Beginning in 1930, she donated a total of $90,000 to the Greek government for a new museum in Corinth, named in honor of her father, to hold the finds of the excavations of the American School of Classical Studies at Athens.[10] But the trend in more recent years has been for archeologists to regard such offers by collectors with deep suspicion. Leon Levy, a hedge fund pioneer, and his wife, Shelby White, formed a large collection of antiquities and also donated substantial amounts to archeological institutions: $20 million to renovate the Greek and Roman galleries at the Metropolitan Museum, $200 million to New York University to establish an institute of ancient studies, and millions more to the Shelby White–Leon Levy Program for Archaeological Publications at Harvard, which supports the publication of archeological excavations, and to Harvard's excavations at the ancient Canaanite city of Ashkelon, Israel.

But Levy's and White's donations have proven profoundly controversial. Levy died in 2003, and in 2006 White agreed to return some antiquities from her collections to Italy, which claimed to have evidence that they had been smuggled out of its borders. White gave back the objects with the proviso that Italy would not make any more repatriation claims against her. However, 84 percent of the objects from her collection, as exhibited at the Metropolitan Museum in 1990 in *Glories of the Past: Ancient Art from the Shelby White and Leon Levy Collection,* surfaced for the first time after 1973. They thus are likely to derive from looting rather than legitimate sales.[11]

As a result of the ties of White's and Levy's collections to looting, many archeologists have condemned all of their involvement in the ancient world. Several scholars and institutions have refused their donations, even those unrelated to collecting. One professor resigned from a position with New York University's Center for Ancient Studies, the group that coordinated White's donation to the university, saying, "I simply no longer wanted my name to be affiliated with an organization that would accept such a gift without expressing severe reservations or even protest."[12] And the University of Cincin-

nati has refused to accept money from the Levy-White publications fund, with one of its professors explaining, "I can't imagine that we would, under any circumstances, accept money from Shelby White for any purpose. Buying antiquities, collecting antiquities in any way—whether it be licit or illicit antiquities—creates a demand for more antiquities."[13]

Yet, as the example of Pomerance shows, a collector is much more likely to slow or cease collecting of potentially looted objects if archeologists engage rather than refuse any ties. "I've published my collection, I've exhibited it," White told the *New York Times*. "I'm not hiding things. If it turns out there is something I shouldn't have bought, I will act appropriately."[14] Acting appropriately might mean listening to the suggestions of archeologists—if they will talk to her.

Some collectors, like White, Levy, or Pomerance, accumulated large numbers of antiquities. But large-scale collectors are not the only ones whose collecting behavior poses risks to antiquities. Small-scale collectors, even those who buy a single ancient object, also contribute to looting. Looters usually must dig hundreds, if not thousands, of pits before finding the type of antiquity—like the contents of an elite burial or a well-preserved statue—that will sell for millions of dollars to a wealthy collector. Most looted graves contain a modest selection of goods, perhaps a few coins and pots to accompany the deceased. Most ancient settlements contain objects too trivial to have been packed up by departing inhabitants or scavenged by the many who passed by afterwards. So, although looters dig with the hope of striking it big with an exquisitely valuable work of art, they make a living by selling the odds and ends they discover in poorer graves and picked-over settlements. These small antiquities, so common in form that they are nearly impossible to trace back to any particular country of origin, are increasingly being sold online, including through large, general-purpose sales sites such as eBay.com. There, anyone can purchase a piece of the past for fifty or a hundred dollars—and, in doing so, help destroy our eroding archeological heritage.

Archeologists have focused on dissuading existing large-scale collectors from continuing to collect, but we also need to think of ways to prevent people from engaging in cheap, casual collecting. One method that will work on all types of potential collectors is education about the risk of purchasing forgeries. Forgers who take advantage of collectors' willingness to buy antiquities without accompanying paperwork can profit by selling several expensive fakes or many cheap ones. In the case of mold-made or die-cast objects, such as coins or terra-cotta figurines, mass production of forgeries is easily accomplished. Collectors need to know that the only guarantee of authenticity is reliable information about archeological find-spot, even if this means that the number of authentic antiquities available for purchase is small. It is easy to learn this lesson—and sadly easy for subsequent collectors to forget. For example, Getty made a rule of purchasing well-documented antiquities, with no suspicion of a looted origin, because such purchases are "obviously risky": "In the first place, the buyer is contravening, or at least conspiring to contravene the law, and is liable to penalties ranging from heavy fines to actual imprisonment. Then, the 'rare object' he is buying may not be at all what it is represented to be. It could be a forgery."[15] Getty knew that dealers would try to spark buyers' interest with tales of illicit origins, and writes, with a ruefulness born of personal experience, that "more than one otherwise prudent individual has been stung—and stung badly—by allowing himself to be talked into buying some mud-caked figurine which the seller purported to be a fourth-century B.C. Greek work or an example of second-century A.D. Roman art."[16] If only the Getty Museum had listened to the advice of its founder instead of using the funds it inherited from him to purchase unprovenanced antiquities from suspicious sources. As a result, the museum returned antiquities valued at more than $44 million to Italy and Greece in 2007.[17]

The prospect of wasting money on a forgery may deter some potential collectors, but we need to provide carrots as well as sticks. We must provide the experiences collectors prize in a way that does not

damage the past. One simple avenue to explore is rethinking our attitude toward touch. Collectors greatly value the experience of touching antiquities. They believe that touch puts them in contact with past creators and owners of the objects, or with the abstract idea of antiquity. In an imaginative sense, this idea—that contact leads to inspiration—can be perfectly true. A confession: my career as a classicist began when, as a child, I reached up and stroked the cheek of an ancient Roman statue and was shocked that something so full of life could feel so cold. I phrase this as a confession because it happened at a museum, where touch is forbidden. The rules against touch were instituted relatively recently; as late as 1710, a visitor to Oxford's museums sniffed that "people impetuously handle everything in the usual English fashion and . . . even the women are allowed up here for sixpence; they run here and there, grabbing at everything and taking no rebuff."[18] One is rather jealous of those women, getting good value for their sixpence.

Of course, some restrictions on touching are reasonable. Even careful touches from seemingly clean hands can cause damage, since oils and perspiration from fingertips can stain materials like marble. Still, some museums recognize the power of touch to enhance visitor experiences and spark long-lasting interest in the touched subject matter. If, at the natural history museum, we can feel a lizard under the guidance of a docent and run our fingertips along the ridges of a reproduction of a dinosaur bone displayed below an entire fossilized skeleton, why cannot we have similar experiences in an art museum? Some antiquities, like gold coins, are made of materials very resistant to harm from touch, and others, like the tons of pottery fragments that cover every ancient settlement site, are so common that a few could be sacrificed for the sake of touch. Meanwhile, 3-D printing and other digital reproduction techniques offer opportunities for producing low-cost replicas of antiquities that the public can handle.

Collectors have repeatedly stated that one of their main motivations in buying antiquities is to be able to touch them, since touch is not allowed in museums. But if it were, the wonder of that moment

of connection with the past could become an opportunity to educate the visitor about archeological context and what it reveals—to convince potential collectors that their love is not the only context that an antiquity needs.

Touch is powerful because it connects the collector to an object, but collectors are not motivated solely by a love of objects. Collecting is also a way of creating and strengthening bonds with others: parents, spouses, siblings, close friends, fellow collectors, scholars, networks of potential business partners and other aristocratic or wealthy individuals, and even with the general public, as when a museum puts on an exhibition of a collector's works.

Understanding the importance of these social networks points to another possible way to ensure that collectors preserve rather than damage the past. Collecting is not the only way to tie together a social network. Archeologists sharing drinks with colleagues at the end of a conference day or taking their children on tours of ancient sites know very well that a shared dedication to preserving the past can tie together friends and family. And museum professionals know that the best way to cultivate potential donors is to create social opportunities: tours, outings, parties, and other encouragements for links of friendship to grow between the museum and its supporters, who will thus be more likely to donate what they have collected to the museum. Archeologists and museums should work together to create and support new social networks focused on stopping looting.

Museums have a long history of establishing opportunities for the growth of such social networks. Indeed, the origin of museums in aristocratic private collections means that museums have always been in the business of supporting the relationships between collectors. But to take advantage of these museum opportunities, one has to participate in collecting, either by donating the antiquities one has collected or by giving money to support the museum's collecting. And both private and museum collecting behaviors have proven deeply problematic in terms of encouraging a market for looted antiquities.

Someone who wants both to preserve the past and also to have the rewards offered by museums has few alternatives to museum "friendship." A non-archeologist will find it very difficult to achieve a satisfactory level of involvement with an archeological project. For example, the website for the American excavations at the ancient site of Morgantina, Sicily, informs the prospective visitor:

> We are unable to answer general questions, give tours of the site or museum, etc. during the season. Specific inquiries about our research may be addressed to info@morgantina.org. There is no guarantee of a timely reply![19]

There are many explanations for such attitudes. Archeologists must excavate in short seasons with limited staff and funding; any time dedicated to escorting visitors is taken away from their work. By contrast, most museums have special staff dedicated to their donor outreach and relations.

Many archeological excavations make at least some effort to attract donors, and some have formed groups that resemble museums' social networks. However, the non-archeologists attracted to such groups usually have a far deeper preexisting knowledge and interest about antiquity than do those attracted to museum groups. For example, one can join a group called "Friends of Morgantina." The website advertising this opportunity describes the group's activities as follows: "In choosing which projects to fund, the board members review proposals for merit or relevancy. . . . Funds raised are escrowed for particular projects and progress reports are provided in an annual report."[20] The Friends are expected to give money, raise money, and allocate money, with the promise of a reward measured in progress reports—not even one of the site tours so strenuously denied to the general public.

Malcolm Bell, director of the Morgantina excavations, is dedicated to educating the public about the problem of archeological looting. In light of his commitment to lecturing and testifying about looting, it may seem frivolous to complain that he and other arche-

ologists are not throwing parties to attract the interest of potential supporters. Yet, the social aspects of collecting are far from frivolous. For many collectors, the social bonds associated with collecting are the cause for decisions about the formation, continuation, and eventual disposition of their collections. Social networks shape behavior, and archeologists cannot afford to ignore these social networks when attempting to reshape collecting behaviors.

The differences between collectors and archeologists may seem insurmountable, but we must remember that they both cherish the past and believe in the importance of preserving antiquities. This underlying agreement may furnish just enough common ground for collectors and archeologists to work together. Change is possible —think, for example, of the in-retrospect somewhat miraculous replacement of the gun with the camera in the hands of what would have seemed, in the early twentieth century, the unstoppable reign of the big game hunter. In that case, what succeeded was an appeal to the hunters' love of and appreciation for the animals—a love and appreciation that environmentalists found hard to believe existed before they recognized its power. Similarly, the collector's love of the past must be understood and harnessed if we are to be able to have a past to love at all. Exploring the complexity of this love, as this book has done, is merely the first step.

NOTES

INTRODUCTION

1. Ernst L. Freud, ed., *Letters of Sigmund Freud,* trans. Tania Stern and James Stern (New York: Basic Books, 1975), 403.

2. Jeffrey Moussaieff Masson, ed., *The Complete Letters of Sigmund Freud to Wilhelm Fleiss* (Cambridge: Belknap Press of Harvard University Press, 1985), 363.

3. Janine Burke, *The Sphinx on the Table: Sigmund Freud's Art Collection and the Development of Psychoanalysis* (New York: Walker, 2006), 7. The most sustained analysis by Freud of the collecting impulse, although with no reference to his own activities, is contained in a letter theorizing that obsessional ideas are a defective use of the mechanism of substitution: "When an old maid keeps a dog or an old bachelor collects snuffboxes, the former is finding a substitute for her need for a companion in marriage and the latter for his need for a multitude of conquests. Every collector is a substitute for a Don Juan Tenorio, and so too is the mountaineer, the sportsman, and such people. These are erotic equivalents." Letter of Freud to Wilhelm Fleiss, January 24, 1895, Masson, ed., *Letters of Freud to Fleiss,* 110.

CHAPTER 1. THE POWERS AND PERILS OF THE ANTIQUE

1. For the Attalids, see Esther V. Hansen, *The Attalids of Pergamon* (Ithaca: Cornell University Press, 1971); Edouard Will, *Histoire Politique du Monde Hellénistique* (Paris: Seuil, 2003); Elizabeth Kosmetatou, "The Attalids of Pergamon," in *A Companion to the Hellenistic World,* ed. Andrew Erskine (Oxford: Blackwell, 2003), 159–74.

2. Polybius *Histories* 32.8.10; Max Frankel, ed., *Die Inschriften von Pergamon,* vol. 1 (Berlin: W. Spemann, 1890–95), nos. 47–49; Pausanias *Description of Greece* 6.14.11, 8.42.7; *Palatine Anthology* 9.238.

3. Livy *History of Rome* 31.45.1–47.3; Frankel, ed., *Inschriften von Pergamon,* no. 50.

4. For the history of Rome's relationship to Greek art, see Mary Beard, *The Roman Triumph* (Cambridge: Belknap Press of Harvard University Press, 2007); Steven H. Rutledge, *Ancient Rome as a Museum: Power, Identity, and the Culture of Collecting* (Oxford: Oxford University Press, 2012); Jerome J. Pollitt, "The Impact of Greek Art on Rome," *Transactions of the American Philological Association* 108 (1978), 155–74.

5. Pliny *Natural History* 7.126, 35.24; Polybius *Histories* 39.2; Strabo *Geography* 8.6.28.

6. Livy *History of Rome* 39.5.14.

7. J. B. Churchill, "*Ex qua quod vellent facerent:* Roman Magistrates' Authority over *Praeda* and *Manubiae*," *Transactions of the American Philological Association* 129 (1999), 85.

8. Varro *On the Latin Language* 5.46; Pliny *Natural History* 34.34.

9. Livy *Roman History* 5.21.1–4, 5.22.3–8; Lactantius *Divine Institutes* 2.7.11.

10. Livy *Roman History* 6.29.8–10.

11. Plutarch *Morals* 198B–C; Valerius Maximus *Memorable Deeds* 4.4.9; Pliny *Natural History* 31.142; Plutarch *Life of Aemilius Paulus* 28.11.

12. Plutarch *Life of Fabius Maximus* 22.6 and *Life of Marc Antony* 21. He did take from Tarentum a bronze colossus of Hercules by Lysippus, which he set up on the Capitoline Hill in Rome next to a bronze equestrian statue of himself: Strabo *Geography* 6.3.1; Pliny *Natural History* 34.40; Plutarch *Life of Fabius Maximus* 22.6.

13. See Livy *Roman History* 43.4.7 and Cicero *Against Verres* 2.1.55, 2.2.4, 2.4.120–21 for the prosecution of C. Lucretius Gallus for illegal appropriation of cultural property after his conquest of Boeotia in 170 BCE.

14. Pollitt, "Impact of Greek Art on Rome."

15. Livy *Roman History* 34.4.4.

16. Livy *Roman History* 25.40.1–3.

17. Plutarch *Life of Marcellus* 21.5.

18. Pliny *Natural History* 33.150.

19. Pollitt, "Impact of Greek Art on Rome," 164–65.

20. Pliny *Natural History* 35.26.

21. Pliny *Natural History* 34.62, 34.84.

22. Pliny the Younger *Letters* 6.

23. There were some exceptions; e.g., in the late fifth century CE, twenty camel loads of idols from the Temple of Isis at Memphis, Egypt, were detected hidden behind a false wall in a house, taken to Alexandria, exposed to pub-

lic ridicule, and destroyed. Similarly, in the mid-sixth century CE, a number of pagan statues were derided by being hung in the streets of Antioch. Cyril Mango, "Antique Statuary and the Byzantine Beholder," *Dumbarton Oaks Papers* 17 (1963), 56.

24. Mango, "Antique Statuary and the Byzantine Beholder," 59.

25. Ibid., 60–61.

26. Ibid., 61–62; Richard Stoneman, *Land of Lost Gods: The Search for Classical Greece* (London: Hutchinson, 1987), 15.

27. G. Rushforth, "*Magister Gregorius de mirabilibus Urbis Romae*: A New Description of Rome in the Twelfth Century," *Journal of Roman Studies* 9 (1919), 51.

28. The fourteenth-century chronicler Almaricus Augerius claimed that Pope Gregory the Great (c. 540–604) ordered that "all the images of demons, found both inside and outside of Rome, have their heads and limbs amputated and thoroughly crushed into pieces, so that once depraved hereticism had been rooted out, the palm of Christian truth could more fully grow." Tilmann Buddensieg, "Gregory the Great, The Destroyer of Pagan Idols: The History of a Medieval Legend Concerning the Decline of Ancient Art and Literature," *Journal of the Warburg and Courtauld Institutes* 28 (1965), 45.

29. J. B. Ross, "A Study of Twelfth-Century Interest in the Antiquities of Rome," in *Medieval and Historiographical Essays in Honor of James Westfall Thompson,* ed. James Lea Cate and Eugene N. Anderson (Chicago: University of Chicago Press, 1938), 308.

30. Ristoro d'Arezzo, "Delle Vase Antiche," quoted and translated in Patricia Fortini Brown, *Venice and Antiquity: The Venetian Sense of the Past* (New Haven: Yale University Press, 1996), 60.

31. For Frederick, see David Abulafia, *Frederick II: A Medieval Emperor* (London: Allen Lane, 1998); Ernst Kantorowicz, *Frederick the Second, 1194–1250* (New York: F. Ungar, 1957); Antonino De Stefano, *La Cultura alla Corte di Federico II Imperatore* (Bologna: N. Zanichelli, 1950).

32. Frederick's actual collecting of classical art distinguishes him from the emperor Charlemagne, who is more often credited with classical interests, but who seems to have been far more concerned with using classical style as a model instead of collecting and displaying examples of classical antiquities.

33. For these reuses, see Salvatore Settis, "Des Ruines au Musée: La Destinée de la Sculpture Classique," *Annales: Économies, Sociétés, Civilisations* 48.6 (1993), 1347–80.

34. Anthony Alan Shelton, "Cabinets of Transgression: Renaissance Collec-

tions and the Incorporation of the New World," in *Cultures of Collecting*, ed. John Elsner and Roger Cardinal (Cambridge: Harvard University Press, 1994), 178.

35. Jean Taralon, *Les Trésors des Églises de France* (Paris: Caisse Nationale des Monuments Historiques, 1965), 289. For other examples of reused classical works, see W. S. Heckscher, "Relics of Pagan Antiquities in Mediæval Settings," *Journal of the Warburg Institute* 1.3 (1938), 2014–20.

36. Ivan Golikov, *Anecdotes of Peter the Great,* quoted and translated in Oleg Neverov, *Great Private Collections of Imperial Russia* (New York: Vendome Press, 2004), 15–16.

37. Gisela Richter, *The Engraved Gems of the Greeks, Etruscans and Romans,* vol. 2 (London: Phaidon, 1968–71), 104.

38. Kathleen Christian, *Empire without End: Antiquities Collections in Renaissance Rome, c. 1350–1527* (New Haven: Yale University Press, 2010), 96–97.

39. Ibid., 94.

40. Ibid.

41. Notebook of Claude Bellièvre, Paris, Bibliothèque Nationale, MS Lat. 13123 (c. 1514), fol. 208v, translated by Christian, *Empire without End,* 94.

42. Joseph Alsop, *The Rare Art Traditions: The History of Art Collecting and Its Linked Phenomena Wherever These Have Appeared* (New York: Harper and Row, 1982), 390–91; Platina, *Platynae historici: liber de vita Christi ac omnium pontificum,* quoted and translated by Christian, *Empire without End,* 114.

43. Quoted and translated in Alsop, *Rare Art Traditions,* 304.

44. Id.

45. Herbert Kühn, *Geschichte der Vorgeschichtsforschung* (Berlin: De Gruyter, 1976), 15.

CHAPTER 2. COLLECTING IDENTITIES

1. Scholarship on the use of art to fashion public identities has been especially fruitful for the Renaissance period; see Stephen Greenblatt, *Renaissance Self-Fashioning: From More to Shakespeare* (Chicago: University of Chicago Press, 2005); Lisa Jardine, *Worldly Goods: A New History of the Renaissance* (New York: W. W. Norton, 1998); Dora Thornton, *The Scholar in His Study: Ownership and Experience in Renaissance Italy* (New Haven: Yale University Press, 1998); Luke Syson, *Objects of Virtue: Art in Renaissance Italy* (London: British Museum, 2001).

2. Alsop, *Rare Art Traditions,* 70.

3. Pierre Cabanne, *The Great Collectors* (New York: Farrar, Straus, 1963), viii.

4. For the *bovattieri* and their collecting practices, see Christian, *Empire without End*, 68–74.

5. *Corpus Inscriptionum Latinarum*, vol. 6, 9,978 and 14,814.

6. Christian, *Empire without End*, 71.

7. Ibid., 259.

8. Pier Luigi Tucci, *Laurentius Manlius: La Scoperta dell'Antica Roma* (Rome: Quasar, 2001), 191–92, translated by Christian, *Empire without End*, 74.

9. Letter to Giovanni de' Medici, March 22, 1443, quoted and translated by Christian, *Empire without End*, 70.

10. Kathleen Christian, "The Birth of Antiquity Collections in Rome, 1450–1530" (PhD diss., Harvard University, 2003), 63–64; Henning Wrede, "Römische Antikenprogramme des 16. Jahrhunderts," in *Il Cortile delle Statue: Der Statuenhof des Belvedere im Vatikan: Akten des internationalen Kongresses zu Ehren von Richard Krautheimer*, ed. Matthias Winner et al. (Mainz am Rhein: P. von Zabern, 1998), 87–91.

11. Jennifer Montagu, *Alessandro Algardi* (New Haven: Yale University Press, 1985).

12. Thomas Howard is sometimes called the second Earl of Arundel, i.e., the second after the title was inherited through marriage by his father, Philip Howard, in 1580; however, some, including the *Oxford Dictionary of National Biography*, designate him the twenty-fourth earl, acknowledging no break in the lineage.

13. G. S. Gordon, ed., *Peacham's Compleat Gentleman, 1634* (Oxford: Oxford University Press, 1906), 231.

14. For Arundel's life, see David Howarth, *Lord Arundel and His Circle* (New Haven: Yale University Press, 1985) and Jonathan Scott, *The Pleasures of Antiquity: British Collectors of Greece and Rome* (New Haven: Yale University Press, 2003).

15. Howarth, *Lord Arundel and His Circle*, 69.

16. Letter of Roe to Arundel, March 28, 1626, quoted in Adolf Michaelis, *Ancient Marbles in Great Britain* (Cambridge: Cambridge University Press, 1882), 195.

17. Letter of Roe to Arundel, January 27, 1621, quoted in Michaelis, *Ancient Marbles in Great Britain*, 185.

18. Ibid.

19. Letter of Roe to Arundel, May 1, 1623, quoted in Michaelis, *Ancient Marbles in Great Britain*, 187.

20. Letter of Roe to Buckingham, May 8, 1626, quoted in Michaelis, *Ancient Marbles in Great Britain*, 196.

21. Letter of Roe to Buckingham, January 24, 1624, quoted in Michaelis, *Ancient Marbles in Great Britain*, 188.

22. Letter of Roe to Arundel, March 28, 1626, quoted in Michaelis, *Ancient Marbles in Great Britain*, 195.

23. Letter of Roe to Buckingham, May 11, 1625, quoted in Michaelis, *Ancient Marbles in Great Britain*, 189.

24. Letter of Roe to Arundel, March 28, 1626, quoted in Michaelis, *Ancient Marbles in Great Britain*, 196.

25. Letter of Roe to Buckingham, May 11, 1625, quoted in Michaelis, *Ancient Marbles in Great Britain*, 189.

26. Letter of Roe to Buckingham, November 3, 1626, quoted in Michaelis, *Ancient Marbles in Great Britain*, 198.

27. Letter of Buckingham to Roe, July 19, 1626, quoted in Michaelis, *Ancient Marbles in Great Britain*, 198.

28. A 1731 inventory of Arundel's gems, drawn up after some had been given away after Arundel's death, lists 133 intaglios and 130 cameos. British Library, Add. MS 38166.

29. J. Kennedy, *A Description of the Antiquities and Curiosities in Wilton-House* (Salisbury: E. Easton, 1769), xiii. Mary Anne Everett Green, ed., *The Calendar of State Papers, Domestic Series, 1656–1657* (London: HM Stationery Office, 1965), 110 (entry of September 15, 1656) recorded 103 statues in the house.

30. For the history of English Grand Tour collecting, see Ilaria Bignamini and Clare Hornsby, *Digging and Dealing in Eighteenth-Century Rome* (New Haven: Yale University Press, 2010) and Scott, *Pleasures of Antiquity.*

31. Roger Ascham, *The Schoolmaster,* quoted in Scott, *Pleasures of Antiquity,* 6.

32. Letter of Winckelmann to Genzmar, December 12, 1764, quoted in Michaelis, *Ancient Marbles in Great Britain*, 86.

33. Gervase Jackson-Stops, ed., *The Treasure Houses of Britain: Five Hundred Years of Private Patronage and Art Collecting* (New Haven: Yale University Press, 1985), 47.

34. Quoted in Scott, *Pleasures of Antiquity,* 109 (emphasis in the original).

35. Letter of Winckelmann to Muzel-Stosch, February 1768, quoted in Michaelis, *Ancient Marbles in Great Britain*, 87.

36. For the impact of this history on Grand Tourists, see Philip Ayres, *Clas-*

sical Culture and the Idea of Rome in Eighteenth-Century England (Cambridge: Cambridge University Press, 1997).

37. The same would later be true in the United States, whose Revolutionary thinkers were similarly eager to adopt the Roman Republic as a model: Richard M. Gummere, *The American Colonial Mind and the Classical Tradition* (Cambridge: Harvard University Press, 1963), viii.

38. E.g., John Oldmixon, *History of England during the Reigns of the Royal House of Stuart* (1730), iv–v (describing the Whigs as *patres patriae*); Edward Wortley Montagu, *Reflections on the Rise and Fall of the Ancient Republicks Adapted to the Present State of Great Britain* (1759); Nathaniel Lee, *Lucius Junius Brutus* (1681); Joseph Addison, *Cato* (1712).

39. Letter of December 16, 1749, Philip Dormer Stanhope, *The Letters of Philip Dormer Stanhope, 4th Earl of Chesterfield*, vol. 4 (London: Eyre and Spottiswoode, 1932), 1466, no. 1678.

CHAPTER 3. "BY MEANS OF A LITTLE CASTRATION"

1. *Corpus Inscriptionum Latinarum*, vol. 6, 9403.

2. For Blundell's Hermaphrodite, see Seymour Howard, "Henry Blundell's Sleeping Venus," *Art Quarterly* 21.4 (1968), 405–20.

3. Henry Blundell, *Engravings and Etchings of the Principal Statues, Busts, Bass-Reliefs, Sepulchral Monuments, Cinerary Urns, etc. in the Collection of Henry Blundell, Esq. at Ince*, vol. 1 (Liverpool: n.p., 1809), pl. 41.

4. For Blundell's life and collections, see Scott, *Pleasures of Antiquity* and Jane Fejfer et al., eds., *The Ince Blundell Collection of Classical Sculpture* (London: HM Stationery Office, 1991–).

5. Blundell, "Letter to a Friend" (1808), Paul Mellon Centre for Studies in British Art, Brinsley Ford Archive, RBF/1/187.

6. Blundell, *Engravings*, pl. 78.

7. Fejfer, *Ince Blundell Collection*, vol. 1, 8.

8. For descriptions of this restoration work, see ibid., vol. 1.

9. Quoted in Scott, *Pleasures of Antiquity*, 154.

10. Letter of Blundell to Townley, April 11, 1801, British Museum, Townley Archive, TY 7/1333.

11. Letter of Blundell to Townley, November 25, 1787, British Museum, Townley Archive, TY 7/1316.

12. Blundell, *Engravings*, pl. 41.

13. Blundell also applied sculpted fig leaves to cover the genitals of his nude male statues. Gerald Vaughan, "Henry Blundell's Sculpture Collection at Ince Hall," in *Patronage and Practice: Sculptures on Merseyside*, ed. Penelope Curtis (Liverpool: Tate Gallery Publications, 1989), 20.

14. Viccy Coltman, *Classical Sculpture and the Culture of Collecting in Britain since 1760* (Oxford: Oxford University Press, 2009), 215.

15. Letter of Blundell to Townley, April 15 and 21, 1800, British Museum, Townley Archive, TY 15/11/1.

16. Letter of Blundell to Townley, quoted in Coltman, *Classical Sculpture and the Culture of Collecting*, 215.

17. Blundell, *Engravings*.

18. Ibid.

19. Letter of Blundell to Townley, December 6, 1799, British Museum, Townley Archive, TY 15/11.

20. Jane Fejfer, "Restoration and Display of Classical Sculpture in English Country Houses: A Case of Dependence," in *History of Restoration of Ancient Stone Sculptures*, ed. Janet Burnett Grossman et al. (Los Angeles: J. Paul Getty Museum, 2003), 89.

21. Fejfer, *Ince Blundell Collection*, vol. 1, 81.

22. Fejfer, *Ince Blundell Collection*, vol. 1, 111.

23. C. Munius Serenus; Hylas; Rufrius Phlapfiphus; Iulia Meroe; Publilius Severianus; Fejfer, *Ince Blundell Collection*, vol. 2, 11.

24. Fejfer, *Ince Blundell Collection*, vol. 2, 11.

25. Seymour Howard, "Ancient Busts and the Cavaceppi and Albacini Casts," *Journal of the History of Collections* 3.2 (1991), 204.

26. For Cavaceppi, see Seymour Howard, *Bartolomeo Cavaceppi: Eighteenth-Century Restorer* (New York: Garland, 1982) and Carlos A. Picón, *Bartolomeo Cavaceppi: Eighteenth-Century Restorations of Ancient Marble Sculpture from English Private Collections* (London: The Gallery, 1983).

27. Allan Cunningham, *Lives of the Most Eminent British Painters, Sculptors, and Architects* (1830), quoted in Picón, *Bartolomeo Cavaceppi*, 16.

28. Howard, *Bartolomeo Cavaceppi*, 36.

29. Ibid., 17, n. 2.

30. Letter of Hamilton to Lord Shelburne, dated March 25, 1776, quoted in Picón, *Bartolomeo Cavaceppi*, 24.

31. Francis Haskell and Nicholas Penny, *Taste and the Antique: The Lure of Classical Sculpture, 1500–1900* (New Haven: Yale University Press, 1982), 103.

32. Brown, *Venice and Antiquity,* 260.

33. Miranda Marvin, "Possessions of Princes: The Ludovisi Collection," in *History of Restoration of Ancient Stone Sculptures,* ed. Janet Burnett Grossman et al. (Los Angeles: J. Paul Getty Museum, 2003), 226–27.

34. Ibid., 229.

35. Blundell, *Engravings,* no. 338.

36. Fejfer, *Ince Blundell Collection,* vol. 2, 12.

37. Quoted in Elizabeth Angelicoussis, *The Holkham Collection of Classical Sculptures* (Mainz: P. von Zabern, 2001), 37.

38. E.g., the earl writing to his architect about a statue of Agrippina: "As for the Empress she won't fit my nich over the chimney better than the Diana, wch. I have measured just over six foot high so that if only in the common rank won't be worth my buying, but sh. she be of a very fine kind & the drapery very fine, she must be so cheap at 300 crowns that I wd. buy her tho' I have at present no place to put her in, so that I shall leave to yr. sons judgement." Quoted in Angelicoussis, *Holkham Collection of Classical Sculptures,* 38.

39. For Holbech, see Scott, *Pleasures of Antiquity,* 82–83.

40. Ian Jenkins, *Cleaning and Controversy: The Parthenon Sculptures, 1811–1939* (London: British Museum, 2001), 7.

41. Statue of Isis-Fortuna, Angelicoussis, *Holkham Collection of Classical Sculptures,* 101.

42. On the determination of quarries, see Harmon and Valerie Craig, "Greek Marbles: Determination of Provenance by Isotopic Analysis," *Science* 176 (1972), 401–3; Norman Herz, "Stable Isotope Analysis of Greek and Roman Marble: Provenance, Association, and Authenticity," in *Marble: Art Historical and Scientific Perspectives on Ancient Sculpture* (Malibu: Getty Publications, 1990), 101–10; K. Germann et al., "Determination of Marble Provenance: Limits of Isotopic Analysis," *Archaeometry* 22.1 (1980), 99–106.

43. For examples of scholars pessimistic about the ability of testing to determine the age of marble antiquities, see Jeffrey Spier, "Blinded with Science: The Abuse of Science in the Detection of False Antiquities," *Burlington Magazine* 132 (1990), 623–31 and Kenneth Lapatin, "Proof: The Case of the Getty Kouros," *Source* 20.1 (2000), 43–53.

44. For these frescoes and their fate during excavation, see Paola D'Alconzo, "Naples and the Birth of a Tradition of Conservation: The Restoration of Wall Paintings from the Vesuvian Sites in the Eighteenth Century," *Journal of the History of Collections* 19.11 (2007), 203–14.

45. These eighteenth-century collectors were following, although no doubt unknowingly, a Roman example. The aediles of 59 BCE, Varro and Murena, brought back a series of frescoes from Sparta which they had cut out of the walls of the conquered city of Sparta, put in wooden frames, and hung in the Comitium, a meeting space in the Forum. Pliny *Natural History* 35.173.

46. Arthur MacGregor, *Curiosity and Enlightenment: Collectors and Collections from the Sixteenth to the Nineteenth Century* (New Haven: Yale University Press, 2007), 199.

CHAPTER 4. IRRESISTIBLE FORGERIES

1. Karl Meyer, *The Plundered Past* (New York: Atheneum, 1973), 108.

2. For discussion of the tests performed and the debate between those who consider it ancient and those who consider it modern, see *The Getty Kouros Colloquium: Athens, 25–27 May 1992* (Athens: Kapon Editions, 1993); Lapatin, "Proof: The Case of the Getty Kouros." For a deep exploration of the difficulty of using any information other than the record of an archeological find-spot to authenticate an object, see Elizabeth Marlowe, *Shaky Ground: Context, Connoisseurship and the History of Roman Art* (London: Bloomsbury Academic, 2013).

3. The existence of forged antiquities is certain, but it is true that a healthy level of caution can sometimes turn into an overbroad suspicion of authentic objects—or even full-blown paranoia, as was exhibited by the seventeenth-century French classicist Jean Hardouin, the librarian of Paris's Lycée Louis-le-Grand, who came to believe that all ancient literature from Greece and Rome, except certain (but not all) works by Homer, Herodotus, Cicero, Pliny the Elder, Virgil, and Horace, had been created in the thirteenth century CE; he also believed that almost all ancient works of art were forgeries.

4. Phaedrus *Aesop's Fables* prologue to book 5, 4–9; Martial *Epigrams* 4.35, 9.56.

5. John Henry Middleton, *The Engraved Gems of Classical Times* (Cambridge: Cambridge University Press, 1891), 101.

6. Gerald Vaughan, "The Passion for the Antique," in *Fake? The Art of Deception,* ed. Mark Jones (London: British Museum, 1990), 146.

7. Vaughan, "The Passion for the Antique," 151–52.

8. Giancarlo Carabelli, *In the Image of Priapus* (London: Duckworth, 1996), 26.

9. Letter of Hamilton to Townley, March 21, 1774, British Museum, Townley Archive, TY 7/556.

10. Sepp Schüller, *Forgers, Dealers, Experts: Strange Chapters in the History of Art,* trans. James Cleugh (New York: Putnam, 1960), 164.

11. Vaughan, "Passion for the Antique," 148.

12. Ibid.

13. For Pembroke, see Scott, *Pleasures of Antiquity;* Michaelis, *Ancient Marbles in Great Britain,* 42–43.

14. Letter of September 25, 1723, Scottish Record Office DG 18, 5030, I, quoted in Joseph Levine, *Dr. Woodward's Shield: History, Science, and Satire in Augustan England* (Berkeley: University of California Press, 1977), 284.

15. These numbers are given by Stukeley, *Itinerarium curiosum* (1776), 185–87. The handwritten manuscript of "A Copy of ye Book of Antiquities at Wilton" does not specify an author, but it repeatedly slips into the first person, suggesting that Pembroke is the author: see, e.g., British Library, Stowe MS 1018, "A Copy of ye Book of Antiquities at Wilton," 92. The subsequent catalogues of the collection by Cowdry and Kennedy draw heavily on the material in the "Book of Antiquities": Richard Cowdry, *A Description of the Pictures, Statues, &c., at Wilton House* (1751) and Kennedy, *A Description of the Antiquities and Curiosities in Wilton House.* For the relations between these publications, see Scott, *Pleasures of Antiquity,* 40.

16. "Copy of ye Book of Antiquities at Wilton," 11.

17. Joseph Spence, *Observations, Anecdotes, and Characters of Books and Men,* vol. 1 (Oxford: Clarendon Press, 1966), 350.

18. British Museum, Townley Archive, TY 15/8/1.

19. Frederik Poulsen, *Greek and Roman Portraits in English Country Houses* (Rome: L'Erma di Bretschneider, 1968).

20. Ralph Thoresby, recalling a visit in 1701. Ralph Thoresby, *Diary,* quoted in Scott, *Pleasures of Antiquity,* 43.

21. Which supposedly were "the Isis, the Jupiter Ammon set up in Thrace by Sesostris, & this Diana [of the Ephesians]": quoted in Scott, *Pleasures of Antiquity,* 44.

22. "Copy of ye Book of Antiquities at Wilton," 34.

23. Quoted in Michaelis, *Ancient Marbles in Great Britain,* 43.

24. D. J. Jansen, "Jacapo Strada et le Commerce d'Art," *Revue de l'Art* 77 (1987), 11–21; Scott, *Pleasures of Antiquity,* 5.

25. The additions of inscriptions are especially obvious when images of the

objects were published multiple times and gain inscriptions along the way. The dealer Thomas Jenkins often ordered the addition of inscriptions to works he purchased from Roman collections before he sold them to English collectors. Publications show that some objects were uninscribed when they were in the Villa Mattei collection, but had inscriptions by the time Blundell purchased them. Michaelis, *Ancient Marbles in Great Britain,* 100.

26. Rutilia Romana; Fejfer, *Ince Blundell Collection,* vol. 2, 10.

27. See, e.g., British Museum GR 1978.3–23.3, an ancient vase with modern painted decoration, probably from the collection of William Hamilton; British Museum GR 1856.12–26.212, an ancient vase with modern incised decoration; and British Museum GR 1824.4–89.4, an ancient bronze jug with modern engraved scene, given to the museum by Richard Payne Knight.

28. Letter of Thomas Hearne to James West, December 13, 1733, British Library, Lansdowne MS 778; Scott, *Pleasures of Antiquity,* 45–46. For another example of a collector with a habit of forging inscriptions, see Étienne Michon, "L'Hermès d'Alexandre dit Hermès Azara," *Revue Archéologique, Quatrième Série* 7 (1906), 79–110.

29. For Poniatowski, see Claudia Wagner, "Fable and History: Prince Poniatowski's Neoclassical Gem Collection," in *Excalibur: Essays on Antiquity and the History of Collecting in Honour of Arthur MacGregor,* ed. Hildegard Wiegel and Michael Vickers (Oxford: Archaeopress, 2013).

30. Stanislas Poniatowski, *Catalogue des Pierres Gravées Antiques de S.A. le Prince Stanislas Poniatowski* (Florence: n.p., 1830–1833).

31. E.g., Henry Howard, fourth Earl of Carlisle (1694–1758), who assembled a collection of 170 gems, letting his dealers know that he was especially interested in signed gems, with the result that signatures were added to many of them before they were sold to him. Kim Sloan, ed., *Enlightenment: Discovering the World in the Eighteenth Century* (London: British Museum Press, 2003), 136.

32. A cameo is a type of carved gem. Cameos are made from materials with layers of different colors and carved so that the relief image is of a different color than the background layer. For this gem, see Vaughan, "Passion for the Antique," 138.

33. Wagner, "Fable and History: Prince Poniatowski's Neoclassical Gem Collection," 148.

34. John Tyrrell, *Remarks Exposing the Unworthy Motives and Fallacious Opinions of the Writer of the Critiques on the Poniatowski Collection of Gems:*

Contained in the British and Foreign Review, and the Spectator (London: H. Graves, 1842).

35. The fate of Poniatowski's gems is thus unusual, since a revelation that an object is a forgery usually means that few desire to possess it. Sometimes the mechanism by which a lack of authenticity leads to the downfall of an object is indirect. For example, O. M. Dalton's rather euphemistically named publication *Catalogue of the Engraved Gems of the Post-Classical Periods in the Department of British and Mediaeval Antiquities and Ethnography in the British Museum* (London: British Museum, 1915) re-catalogued as modern many of what had been thought to be the museum's ancient gems. These gems were accordingly considered expendable and were kept on display during the Blitz of 1941, during which they were destroyed. Sloan, *Enlightenment,* 139.

36. John Bold, *Wilton House and English Palladianism: Some Wiltshire Houses* (London: HM Stationery Office, 1988), 69.

37. For Poniatowski, see Oleg Neverov, "The Art Collections of the Two Poniatowski's," *Muzei* 2 (1981), 171–96, and Vaughan, "Passion for the Antique," 149–50.

38. "Copy of ye Book of Antiquities at Wilton," 20 (emphasis in the original).

39. Letter from Sir Thomas Roe to the Countess of Bedford, December 1626, quoted in Scott, *Pleasures of Antiquity,* 10.

40. For Christina, see Enzo Borsellino, "Cristina di Svezia collezionista," *Ricerche di Storia dell'Arte* 54 (1994), 4–16; Anne-Marie Leander Touati, *Ancient Sculptures in the Royal Museum: The Eighteenth Century Collection in Stockholm* (Stockholm: Swedish National Art Museums, 1998); Lilian H. Zirpolo, "Severed Torsos and Metaphorical Transformations: Christina of Sweden's Sale delle Muse and Clytie in the Palazzo Riario-Corsini," *Aurora* 9 (2008), 29–53; Ferdinand Boyer, "Les Antiques de Christine de Suède à Rome," *Revue Archéologique* 35 (1932), 254–67; Veronica Buckley, *Christina Queen of Sweden* (London: Fourth Estate, 2004); Jean-François de Raymond, *Christine de Suède: Apologies* (Paris: Les Editions de Cerf, 1994); Susanna Åkerman, *Queen Christina of Sweden and Her Circle: The Transformation of a Seventeenth-Century Philosophical Libertine* (Leiden: E. J. Brill. 1991).

41. Raymond, *Christine de Suède: Apologies,* 94 (translated by author).

42. Queen Christina, *Histoire,* quoted in Oskar Garstein, *Rome and the Counter-Reformation in Scandinavia: Jesuit Educational Strategy, 1553–1622* (Leiden: E. J. Brill, 1992), 547 (translated by author).

43. Quoted in Åkerman, *Queen Christina of Sweden and Her Circle,* 298 (translated by author).

44. Ibid., 282.

45. D. Riesman, "Bourdelot, a Physician of Queen Christina of Sweden," *Annals of Medical History* 9 (1937), 191.

46. Quoted in Åkerman, *Queen Christina of Sweden and Her Circle,* 297.

47. Letter of Monsignor Falconieri to Cardinal Leopoldo de' Medici, January 30, 1671, quoted and translated in Edward L. Goldberg, *Patterns in Late Medici Art Patronage* (Princeton: Princeton University Press, 1983), 95–96.

48. Quoted in Taylor, *Taste of Angels,* 308 (translated by author).

49. For the Room of the Muses, see Zirpolo, "Severed Torsos and Metaphorical Transformations."

50. Her other statues are also extensively restored, and some, like the Pan/Faun with Amorino and the Colossal Apollo (both currently in the Prado Museum), are composites of unrelated limbs, torsos, heads, and other fragments.

51. This text comes from a document, *Rovesci di Medaglioni con li loro Motti* [Versos of medallions with their mottoes], produced by Christina's associate Cardinal Azzolino in order to provide interpretations of the series of 118 medals whose designs were commissioned by Christina as an allegorical autobiography. Quoted and translated in Zirpolo, "Severed Torsos and Metaphorical Transformations," 44–47.

52. Johan Arckenholtz, *Mémoires concernant Christine, Reine de Suède,* vol. 3 (Amsterdam: n.p., 1751), 249 (translation by author).

53. Carl Bildt, *Les Médailles Romaines de la Reine Christine de Suède* (Rome: Loescher, 1908), 45ff; Åkerman, *Queen Christina of Sweden and Her Circle,* 263.

CHAPTER 5. THE PRIVILEGES OF LOVERS

1. Pliny *Natural History* 36.20.

2. Pliny *Natural History* 34.61–62.

3. We know the *Apoxyomenos* only through later, marble copies, so we cannot be certain about what materials were used. However, surviving Greek bronzes do show the focus on realism described here; the Charioteer of Delphi, for example, has copper lids and eyelashes, a silver headband, and onyx eyes. Other surviving Greek bronzes have inlaid teeth, lips, and nipples.

4. See Lucian of Samosata (attrib.) *Dialogue Comparing Male and Female Love.*

5. Taylor, *Taste of Angels*, 28.

6. British Library, Sloane MS 3962, fol. 258, quoted in Scott, *Pleasures of Antiquity*, 67.

7. Quoted in Paul Horgan, *A Certain Climate: Essays in History, Arts, and Letters* (Middleton: Wesleyan University Press, 1988), 224.

8. Quoted in Dyson, *Ancient Marbles to American Shores*, 5.

9. Johann Wolfgang von Goethe, *Italian Journey, 1786–1788*, trans. W. H. Auden and Elizabeth Mayer (New York: Pantheon Books, 1962) (January 6, 1787).

10. Letter from Joseph Banks to Willem Bentinck, London, 1773, quoted in Carabelli, *In the Image of Priapus*, 39.

11. *Visitez la Grèce* (Paris: Plon, 1968), 45–46.

12. Peggy Guggenheim, *Confessions of an Art Addict* (New York: Macmillan, 1960), 25–26.

13. Christian, *Empire without End*, 268, 273.

14. Quoted in Michaelis, *Ancient Marbles in Great Britain*, 45.

15. Hayes Trowbridge, *Court Beauties of Old Whitehall: Historiettes of the Restoration* (London: T. F. Unwin, 1906), 25.

16. For Hamilton, see David Constantine, *Fields of Fire: A Life of Sir William Hamilton* (London: Weidenfeld and Nicolson, 2001); Nancy H. Ramage, "Sir William Hamilton as Collector, Exporter, and Dealer: The Acquisition and Dispersal of His Collections," *American Journal of Archaeology* 94.3 (1990), 469–80; Brian Fothergill, *Sir William Hamilton: Envoy Extraordinary* (New York: Harcourt, Brace and World, 1969); Ian Jenkins and Kim Sloan, *Vases and Volcanoes: Sir William Hamilton and his Collection* (London: British Museum Press, 1996).

17. Alfred Morrison, ed., *The Hamilton and Nelson Papers*, vol. 1 (London: privately printed, 1893–94), 63.

18. Quoted in S. C. Herbert, *Pembroke Papers*, vol. 1 (London: n.p., 1938–50), 294.

19. Morrison, *Hamilton and Nelson Papers*, 142.

20. Ibid., 149.

21. Ibid., 152.

22. Letter of Hamilton to Joseph Banks, British Library, Add. MS 34,048, fol. 30, quoted in Jenkins and Sloan, *Vases and Volcanoes*, 20.

23. Morrison, *Hamilton and Nelson Papers*, 130.

24. Letter of Hamilton to Lord Palmerston, June 1764, Paris, Museum National d'Histoire Naturelle, Krafft Bequest (not numbered), quoted in Constantine, *Fields of Fire*, 30 (emphasis in the original).

25. William Hamilton, *Collection of Engravings from Ancient Vases Mostly of Pure Greek Workmanship Discovered in Sepulchres in the Kingdom of the Two Sicilies but Chiefly in the Neighbourhood of Naples during the Course of the Years MDCCLXXXIX and MDCCLXXXX Now in the Possession of Sir Wm. Hamilton,* vol. 1 (Naples: n.p., 1791), 10.

26. Hamilton also acted as guide for visiting royalty of various nations, which posed even greater of a challenge, as he was expected to accompany such visitors on their excursions. Such babysitting could be tiresome. When the future Russian czar Paul I and his wife visited Naples in 1782, Hamilton reported that "Their Imperial Highness[es] were quite knocked up on Mount Vesuvius, without being able to get up the mountain. The Duke's lungs are very weak, and his body ill formed and not strong, and the Duchess is rather corpulent. However, the novelty pleased them. The Duchess' feet came through her shoes, but I had luckily desired her to take a second pair." Morrison, *Hamilton and Nelson Papers,* 115.

27. This price also included the additional antiquities Hamilton sold to the museum at the same time: 175 terra-cottas, 300 pieces of glass, 627 bronze items, 150 ivory objects, 150 gems, 150 pieces of jewelry, 6,000 coins, and a few additional works, including some marbles. Michaelis, *Ancient Marbles in Great Britain,* 110–11.

28. Johann Heinrich Wilhelm Tischbein, *Aus meinem Leben* (Berlin: Henschelverlag, 1956), 352, 356–57, quoted and translated in Constantine, *Fields of Fire,* 162.

29. Morrison, *Hamilton and Nelson Papers,* 140.

30. Goethe, *Italian Journey,* May 27, 1787.

31. Bodleian Library, MS Beckford c.31, fol. 120.

32. Horace Walpole, *Correspondence,* vol. 9 (New Haven: Yale University Press, 1937–83), 337, 349.

33. John B. S. Morritt, letter of February 14, 1796, quoted in G. E. Marindin, ed., *A Grand Tour: Letters and Journeys, 1794–1796, John B. S. Morritt of Rokeby* (London: Century Publishing, 1985), 281.

34. Lady Holland, mocking Emma's accent, wrote that she, impersonating a water nymph, was resting her head on one of Hamilton's vases, and said, "Don't be afeard Sir Willum; I'll not break your joug." Quoted in Constantine, *Fields of Fire,* 210.

35. Quoted in Constantine, *Fields of Fire,* 166.

36. E.g., "We have no want of Lovers of the Arts in England . . . but of true Connoisseurs I know but few & when I have named Townley, Mr Lock &

Charles Greville I know not where to look. I mean that are capable of judging of the Sublime & are truly sensible of the great Superiority of the Ancient Greek Artists over all that have existed since." British Library, Add. MS 36495, fol. 208v, quoted in Constantine, *Fields of Fire,* 162.

37. Quoted in Constantine, *Fields of Fire,* 57.

38. British Library, Add. MS 42071, quoted in Constantine, *Fields of Fire,* 226–27.

39. George Ortiz, "In Pursuit of the Absolute," in *In Pursuit of the Absolute: Art of the Ancient World from the George Ortiz Collection* (Berne: Benteli-Werd Publishers, 1994), n.p.

40. Quoted in John Oleson, *Greek Numismatic Art: Coins of the Arthur Stone Dewing Collection* (Cambridge, Mass.: Fogg Art Museum, 1975), n.p.

41. J. L. Theodor, "Collector's Foreword," in *The J. L. Theodor Collection of Attic Black-Figure Vases,* ed. Pieter Heesen et al. (Amsterdam: Allard Pierson Museum, 1996), 8.

42. Michael S. Shutty, *One Coin Is Never Enough: Why and How We Collect* (Iola, WI: Krause Publications, 2011), 14 (emphasis in original).

43. Quoted in Arielle P. Kozloff, ed., *Animals in Ancient Art from the Leo Mildenberg Collection* (Cleveland: Cleveland Museum of Art, 1981), 1.

44. Derek J. Content, "Thoughts on Portable Sculpture in Precious Stone," in *Content Family Collection of Ancient Cameos,* ed. Martin Henig (Oxford: Ashmolean Museum, 1990), v.

45. Ortiz, "In Pursuit of the Absolute."

46. Ibid.

47. Ibid.

48. Quoted in Linda S. Ferber, "Profile of a Collector," in *The Collector's Eye: The Ernest Erickson Collections at the Brooklyn Museum,* ed. Linda S. Ferber et al. (New York: Brooklyn Museum, 1987), 20–21.

49. Douglas C. Ewing (as president of the American Association of Dealers in Ancient, Oriental, and Primitive Art), quoted in Karen D. Vitelli, "The Antiquities Market," *Journal of Field Archaeology,* 6.4 (1979), 471–88, 478.

50. Ortiz, "In Pursuit of the Absolute."

51. Ortiz defines this common idea of art: "Art is a projection of the ego . . . a need for beauty and the absolute." Ibid.

52. Pearce, borrowing concepts from Roland Barthes, has a theory for how collected objects can be perceived both as unique masterworks and as typical representatives of their culture. This is possible because "collected objects are

both the signifier, that is the medium that carries the message, and the signified, the message itself." Thus, an object is selected as a representative of the body of material from which it comes, but, once selected, it "becomes an image of what the whole is believed to be"—that is, it gains a greater significance than as a mere member of a set. Susan M. Pearce, *Museums, Objects, and Collections: A Cultural Study* (Leicester: Leicester University Press, 1992), 38.

53. Rebecca Mead, "Den of Antiquity," *New Yorker,* April 9, 2007, 61.

54. E.g., "It is meaningless to [archeologists] that an object may be ravishingly beautiful, that we may respond with pleasure and amazement at its aesthetic qualities." Peter Marks (former president of the National Association of Dealers in Ancient, Oriental and Primitive Art), "The Ethics of Art Dealing," *International Journal of Cultural Property* 1 (1998), 123; "We do not, of course, have identical interest with archaeologists. Aesthetic considerations weigh more heavily with us. But who can honestly say that they are not thrilled by the beauty of the Lydian hoard ... ? Would a pile of coarse-ware sherds (however exciting their context) have had the same effect?" James Ede, "The Antiquities Trade: Towards a More Balanced View," in *Antiquities: Trade or Betrayed: Legal, Ethical, and Conservation Issues,* Kathryn Walker Tubb, ed. (London: Archetype Publications, 1995), 212.

55. Quoted in Mead, "Den of Antiquity," 61.

56. Ann M. Early, "Profiteers and Public Archaeology: Antiquities Trafficking in Arkansas," in *The Ethics of Collecting Cultural Property: Whose Culture? Whose Property?,* ed. Phyllis Mauch Messenger (Albuquerque: University of New Mexico Press, 1999), 39–50.

57. G. Griffin, "In Defense of Collectors," *National Geographic,* 169.4 (1986), 465.

CHAPTER 6. COLLECTING OTHERS

1. Christopher Erndtel, *De Itinere suo Anglicano et Batavo,* quoted and translated in Levine, *Dr. Woodward's Shield,* 123.

2. Stephen L. Dyson, *Ancient Marbles to American Shores: Classical Archaeology in the United States* (Philadelphia: University of Pennsylvania Press, 1998), 4. See also Charles F. Mullett, "Classical Influences on the American Revolution," *Classical Journal* 35.2 (1939), 92–104.

3. For the early history of American relationships to antiquities, see Dyson, *Ancient Marbles to American Shores.*

4. Letter of Ralph Izzard Middleton to Nathaniel Russell Middleton, March 28, 1836, South Carolina Historical Society, Middleton Family Papers 1736–1929 (1168.00).

5. J. Ward Perkins, "Four Roman Garland Sarcophagi in America," *Archeology* 11.2 (1958), 98–104; Dyson, *Ancient Marbles to American Shores,* 22.

6. For Getty's collecting, see Ralph Hewins, *The Richest American: J. Paul Getty* (New York: Dutton, 1960); J. Paul Getty, *The Joys of Collecting* (New York: Hawthorn Books, 1965); J. Paul Getty, *How to Be Rich* (Chicago: Playboy Press, 1965); Ethel Le Vane and J. Paul Getty, *Collector's Choice: The Chronicle of an Artistic Odyssey through Europe* (London: W. H. Allen, 1955); J. Paul Getty, *As I See It: My Life as I Lived It* (New York: Berkley Book, 1986); J. Paul Getty, *The Golden Age* (New York: Trident Press, 1968); Kenneth Lapatin, "The Getty Villa: Art, Architecture, and Aristocratic Self-Fashioning in the Mid-Twentieth Century," in *Pompeii in the Public Imagination from Its Rediscovery to Today,* ed. Shelley Hales and Joanna Paul (Oxford: Oxford University Press, 2011).

7. Getty, *Joys of Collecting,* 11.

8. Ibid., 12.

9. Getty, *Golden Age,* 97.

10. Ibid., 98.

11. Getty, *As I See It,* 256–57.

12. Getty, *Joys of Collecting,* 12.

13. Getty, *As I See It,* 258.

14. Quoted in Hewins, *Richest American,* 360.

15. Ibid., 366.

16. Ibid., 212.

17. Getty, *Golden Age,* 105.

18. Ibid., 16.

19. Ibid., 40.

20. In his writings Getty details, at exhaustive length, the cost of constructing his museum. He claims that he paid out of his own pocket nearly $17 million to construct the Getty Villa (he also calculates the total as a pretax amount) and gives its annual maintenance costs of $1.5 million as a per-visitor investment of $10. Getty, *As I See It,* 268.

21. Ibid., 259–60.

22. Quoted in Hewins, *Richest American,* 373.

23. Ibid., 360.

24. For an analysis of this story, see Lapatin, "Getty Villa," 275–77.

25. Le Vane and Getty, *Collector's Choice,* 325.

26. Ibid., 313–14.

27. Ibid., 287.

28. Ibid., 310.

29. Ibid., 68.

30. Ibid., 337 (emphasis in the original).

31. Lapatin, "Getty Villa," 277.

32. Le Vane and Getty, *Collector's Choice,* 330.

33. Getty also published one further short story in this genre, "The Emperor's Birthday," which provides a speculative history for his bust of the empress Livia. The story claims that the bust might have been a birthday gift for Livia's husband, the emperor Augustus, from the citizens of Nola, his birthplace.

34. Getty is not the only American collector to have sought out antiquities from aristocratic British collections. See, e.g., the collection of Gilbert M. Denman, Jr., who, later in the twentieth century, would purchase a Trajan, a Marcus Aurelius, and a Cupid and Psyche from the Lansdowne collection; a Sleeping Ariadne and a bust of a woman from Wilton House; a statue of Athena possibly from the Hope collection; a fragment of a sculpture of two men cooking a boar from Lowther Castle; and a seated philosopher from Wentworth Woodhouse. Herbert Hoffmann, *Ten Centuries That Shaped the West: Greek and Roman Art in Texas Collections* (Houston: Institute for the Arts, Rice University, 1970), 34, 100, 104.

35. Getty, *Joys of Collecting,* 17.

36. Ibid., 18.

37. Getty purchased most of his antiquities through dealers or directly from collections, but he also obtained a few works by acquiring and privately excavating several ancient villa sites on Italian coast. Italian law prohibited him from exporting most of the objects he uncovered.

38. Lapatin, "Getty Villa," 283.

39. Getty, *As I See It,* 234.

40. Ibid., 315.

41. Getty, *How to be Rich,* 158.

42. Ibid., 158–59.

43. Ibid., 172.

44. Getty, *Joys of Collecting,* 19.

45. Arthur Bernard Cook, "A Pre-Persic Relief from Cottenham," *Journal of Hellenic Studies* 37 (1917), 116.

46. Walter Bareiss, "Recollections of a Book Addict," in Julie Melby, *Splendid Pages: The Molly and Walter Bareiss Collection of Modern Illustrated Books* (New York: Hudson Hills Press, 2003), 17.

47. Dolf Schut, preface, in *The Fascination of Ancient Glass: Dolf Schut Collection,* Martine Newby and Dolf Schut (Lochem: Uitgeversmaatschappij Antiek, 1999).

48. John Walsh and Robert Bergman, foreword, in *A Passion for Antiquities: Ancient Art from the Collection of Barbara and Lawrence Fleischman* (Malibu: J. Paul Getty Museum, 1994), 1.

49. Janice Firth Tompkins, ed., *Wealth of the Ancient World: The Nelson Bunker Hunt and William Herbert Hunt Collections* (Fort Worth: Kimbell Art Museum, 1983), 43.

50. Scott, *Pleasures of Antiquity,* 110.

51. *Description of the House and Museum on the North Side of Lincoln's Inn Fields* (London: Levey, Robson, and Franklyn, 1835), 34–40.

52. Peggy Cidor, "A Love Story of Biblical Proportions," *Jerusalem Post,* May 14, 2010.

53. Letter of Cardinal Giovanni de' Medici to Lucrezia de' Medici, March 3, 1560, quoted and translated in Andrea Gáldy, "Lost in Antiquities: Cardinal Giovanni de' Medici, 1543–1562," in *The Possessions of a Cardinal: Politics, Piety, and Art, 1450–1700,* ed., Mary Hollingsworth and Carol M. Richardson (University Park: Pennsylvania State University Press, 2010), 160.

54. Christopher Hibbert, *The House of Medici: Its Rise and Fall* (New York: Morrow Quill Paperbacks, 1980), 255.

55. Quoted in Scott, *Pleasures of Antiquity,* 15.

56. Ralph Hewins, *Mr. Five Per Cent: The Story of Calouste Gulbenkian* (New York: Rinehart, 1958), 194.

57. Shelby White and Leon Levy, introduction, in *Glories of the Past: Ancient Art from the Shelby White and Leon Levy Collection,* ed. Dietrich von Bothmer (New York: Metropolitan Museum of Art, 1990), ix.

58. Burton Yost Berry, *A Numismatic Biography* (New York: privately printed, 1971), 18.

59. Walsh and Bergman, foreword, in *Passion for Antiquities,* 1.

60. "Il Testamento del Cardinale Alessandro Albani," in *Cardinale Alessandro Albani e La Sua Villa: Documenti* (Rome: Bulzoni, 1981), 15.

61. Berry, *Numismatic Biography,* 23.

62. Fejfer, *Ince Blundell Collection,* vol. 1, 12.

63. Quoted in Coltman, *Fabricating the Antique,* 189.

64. Blundell, *Engravings.*

65. Sloan, *Enlightenment,* 138.

66. Lord and Lady Spencer: British Museum, Townley Archives, TY 7/428; Earl of Darnley: TY 7/499; Duke of Dorset: TY 7/308.

67. J. Dallaway, *Of Statuary and Sculpture among the Ancients, with Some Account of Specimens Preserved in England* (London: J. Murray, 1816), 328–29.

68. Letter of Jenkins to Townley, April 30, 1783, British Museum, Townley Archive, TY 7/418.

69. Herbert Hoffmann, ed., *The Norbert Schimmel Collection* (Mainz: P. von Zabern, 1964); Oscar White Muscarella, ed., *Ancient Art: The Norbert Schimmel Collection* (Mainz: P. von Zabern, 1974).

70. Dolf Schut, preface, in Newby and Schut, *The Fascination of Ancient Glass.*

71. G. Max Bernheimer, preface, in *Ancient Gems from the Borowski Collection,* ed. G. Max Bernheimer (Ruhpolding: Rutzen, 2007).

72. Carlos Arturo Picón, "Christos G. Bastis: An Appreciation," in *Antiquities from the Collection of the Late Christos G. Bastis: Auction, Thursday, December 9, 1999, at 6:30 p.m.* (New York: Sotheby's, 1999).

73. Ibid.

74. Ibid.

75. Christos Bastis and Jo Bastis, preface, in *Antiquities from the Collection of Christos G. Bastis,* Emma Swann Hall, ed. (Mainz: P. von Zabern, 1987), vii.

76. Quintilian *Institutes of Oratory* 12.10.3.

77. Sabba da Castiglione, *I Ricordi,* quoted and translated by Thornton, *The Scholar in his Study,* 117.

78. John Elsner and Roger Cardinal, eds., *Cultures of Collecting* (Cambridge: Harvard University Press, 1994), 6.

79. Barbara Fleischman and Lawrence Fleischman, preface, in *Passion for Antiquities,* ix; Grace Glueck, "Art Collector Finds Lore in Fragments," *New York Times,* December 17, 1975.

CHAPTER 7. THE HISTORY OF LOOTING AND
SMUGGLING—AND WHAT THEY DESTROY

Epigraph: Letter of Conyers Middleton to Francesco de' Ficoroni, August 16, 1726, quoted and translated in Jeffrey Spier and Jonathan Kagan, "Sir Charles

Frederick and the Forgery of Ancient Coins in Eighteenth-Century Rome," *Journal of the History of Collections* 12.1 (2000), 53.

1. Letter from Carlo de' Medici to Giovanni de' Medici, October 31, 1455, quoted in Vittorio Rossi, *L'Indole e gli Studi di Giovanni di Cosimo de' Medici: Notizie e Documenti* (Rome: L'Accademia dei Lincei, 1893), 130 (translation by author).

2. Kathleen Wren Christian, "The De' Rossi Collection of Ancient Sculptures, Leo X, and Raphael," *Journal of the Warburg and Courtauld Institutes* 65 (2002), 142.

3. Quoted and translated in *Treasure Houses of Britain*, 428.

4. Quoted in Scott, *Pleasures of Antiquity*, 37.

5. For Lorenzo, see Laurie S. Fusco, *Lorenzo de' Medici: Collector and Antiquarian* (Cambridge: Cambridge University Press, 2006).

6. Quoted and translated in Fusco, *Lorenzo de' Medici*, 20.

7. Ibid., 16.

8. Clifford M. Brown et al., "Lorenzo de' Medici and the Dispersal of the Antiquarian Collections of Cardinal Francesco Gonzaga," *Arte Lombarda* 90–91 (1989), 86–103.

9. Fusco, *Lorenzo de' Medici*, 11. For the horse head, see also Bianca de Divitiis, "New Evidence for Sculptures from Diomede Carafa's Collection of Antiquities," *Journal of the Warburg and Courtauld Institutes* 70 (2007), 99–117.

10. For Isabella d'Este, see Clifford Brown, "*Lo insaciabile desiderio nostro de cose antique*: New Documents on Isabella d'Este's Collection of Antiquities," in *Cultural Aspects of the Italian Renaissance: Essays in Honour of Paul Oskar Kristeller,* ed. Cecil H. Clough (Manchester: Manchester University Press, 1976), 324–53; David Chambers and Jane Martineau, eds., *Splendours of the Gonzaga* (London: British Museum, 1981); Clifford Brown et al., *Per Dare Qualche Splendore a la Gloriosa Cita de Mantua: Documents for the Antiquarian Collection of Isabella d'Este* (Rome: Bulzoni, 2002).

11. Quoted in Chambers and Martineau, *Splendours of the Gonzaga*, 170.

12. Brown, "*Lo insaciabile desiderio nostro de cose antique*," 324.

13. Chambers and Martineau, *Splendours of the Gonzaga*, 54.

14. Letter from Isabella d'Este to Ippolito d'Este, June 30, 1502; quoted and translated in Taylor, *Taste of Angels*, 83–84.

15. Chambers and Martineau, *Splendours of the Gonzaga*, 54.

16. Edward L. Goldberg, *Patterns in Late Medici Art Patronage* (Princeton: Princeton University Press, 1983), 227–41.

17. Brown, *Per Dare Qualche Splendore,* 135.

18. Ibid., 133–35.

19. Fusco, *Lorenzo de' Medici,* 27.

20. Constantine, *Early Greek Travellers,* 18.

21. For the details of papal antiquities laws, see Ronald T. Ridley, *The Eagle and the Spade: Archeology in Rome during the Napoleonic Era* (Cambridge: Cambridge University Press, 1992), 14–34; Bignamimi, *Digging and Dealing,* 17–28.

22. E.g., letter of Hamilton to Townley, November 28, 1775, British Museum, Townley Archive, TY 7/599.

23. E.g., letter of Hamilton to Townley, March 27, 1776, British Museum, Townley Archive, TY 7/607.

24. Quoted in Scott, *Pleasures of Antiquity,* 85.

25. Esportazione MSS, May 27, 1765, quoted in Howard, *Bartolomeo Cavaceppi,* 68 (translation by author).

26. Letter of Hamilton to Townley, January 24, 1775, British Museum, Townley Archive, TY 7/577.

27. Letter of Hamilton to Townley, October 8, 1776, British Museum, Townley Archive, TY 7/618.

28. Letter of Hamilton to Lord Shelburne, July 1772: "As to the [sculpture of] Antinous, I am afraid I shall be obliged to smuggle it, as I can never hope for a licence"; letter of Hamilton to Lord Shelburne, August 1772: "The Under Antiquarian alone is in the secret, to whom I have made an additional present, and hope everything will go well." Quoted in Scott, *Pleasures of Antiquity,* 95. Isis: Angelicoussis, *Holkham Collection of Classical Sculptures,* 35.

29. John Russell Bedford, *Outline Engravings and Descriptions of the Woburn Abbey Marbles* (London: privately printed, 1822), 77.

30. For Elgin, see Philip Hunt and A. H. Smith, "Lord Elgin and His Collection," *Journal of Hellenic Studies* 36 (1916); William St. Clair, *Lord Elgin and the Marbles* (Oxford: Oxford University Press, 1983).

31. *Report from the Select Committee of the House of Commons on the Earl of Elgin's Collection of Sculptured Marbles* (London: J. Murray, 1816), 40.

32. Ibid.

33. Letter of Elgin to Giovanni Battista Lusieri, December 26, 1801, quoted in Hunt and Smith, "Lord Elgin and His Collection," 207.

34. Ibid.

35. Ibid.

36. *Report on the Earl of Elgin's Collection of Sculptured Marbles,* vii.

37. J. C. Hobhouse, *A Journey through Albania and Other Provinces of Turkey in Europe and Asia to Constantinople during the Years 1809 and 1810*, vol. 1 (London, J. Cawthorn, 1833), 292.

38. Edward Dodwell, *A Classical and Topographical Tour through Greece: During the Years 1801, 1805, and 1806*, vol. 1 (London: Rodwell and Martin, 1819), 294.

39. Quoted in David Sox, *Bachelors of Art: Edward Perry Warren & the Lewes House Brotherhood* (London: Fourth Estate, 1991), 62.

40. For the antiquities laws of Italy and Greece, see Marilyn Phelan, ed., *The Law of Cultural Property and Natural Heritage: Protection, Transfer, and Access* (Evanston, Ill.: Kalos Kapp Press, 1998); and G. N. Carugno et al., *Codice dei Beni Culturali: Annotato con la Giurisprudenza* (Milan: Giuffrè, 1994). For the relevant international legal regime, see Alessandro Chechi, *The Settlement of International Cultural Heritage Disputes* (Oxford: Oxford University Press, 2014).

41. Christopher Chippindale et al., "Collecting the Classical World: First Steps in a Quantitative History," *International Journal of Cultural Property* 10.1 (2001), 19–20. Similarly, less than 1 percent of Mayan objects auctioned between 1971 and 1999 by Sotheby's were listed with any indication of findspot. E. Gilgan, "Looting and the Market for Maya Objects: A Belizean Perspective," in *Trade in Illicit Antiquities: The Destruction of the World's Archaeological Heritage*, ed. Neil Brodie et al. (Cambridge: McDonald Institute, 2001), 73–88. There are similar studies of lack of provenance for other categories of antiquities: e.g., David Gill and Christopher Chippindale, "Material and Intellectual Consequences of Esteem for Cycladic Figurines," *American Journal of Archeology* 97 (1993), 601–59 (around 90 percent of known Cycladic figurines have no provenance); Ricardo J. Elia, "Analysis of the Looting, Selling, and Collecting of Apulian Red-Figure Vases: A Quantitative Approach," in *Trade in Illicit Antiquities*, 145–53 (around 89 percent of known Apulian red-figure vases have no known find-spot); and Christopher Chippindale and David Gill, "Material Consequences of Contemporary Classical Collecting," *American Journal of Archeology* 104 (2000), 463–511 (91 percent of ancient objects in the collections published in 1990s have no known find-spot and are not documented before 1945).

42. R. M. Cook, "Excavations and the Antiquities Trade," in *Periplous: Papers on Classical Art and Archaeology presented to Sir John Boardman*, ed. G. R. Tsetskhladze et al. (London: Thames and Hudson, 2000), 68–69; Mead,

"Den of Antiquity"; Diura Thoden van Velzen, "The World of Tuscan Tomb Robbers: Living with the Local Community and the Ancestors," *International Journal of Cultural Property* 13.1 (1996), 111–26; Roger Atwood, *Stealing History: Tomb Raiders, Smugglers, and the Looting of the Ancient World* (New York: St. Martin's, 2004); Peter Watson and Cecilia Todeschini, *The Medici Conspiracy: The Illicit Journey of Looted Antiquities: From Italy's Tomb Raiders to the World's Greatest Museums* (New York: Public Affairs, 2006).

43. Among many other sources, see Zainab Bahrani, "Iraq's Cultural Heritage: Monuments, History, and Loss," *Art Journal* 62.4 (2003), 10–17; M. C. Coe, "From Huaquero to Connoisseur: The Early Market in Pre-Columbian Art," in *Collecting the Pre-Columbian Past,* ed. Elizabeth Hill Boone (Washington: Dumbarton Oaks, 1983), 271–90; Folarin Shyllon, "The Nigerian and African Experience on Looting and Trafficking in Cultural Objects," in B. T. Hoffman, ed., *Art and Cultural Heritage: Law, Policy, and Practice* (Cambridge: Cambridge University Press, 2006), 137–44; Ann M. Early, "Profiteers and Public Archaeology: Antiquities Trafficking in Arkansas," in *The Ethics of Collecting Cultural Property: Whose Culture? Whose Property?,* ed. Phyllis Mauch Messenger (Albuquerque: University of New Mexico Press, 1999), 29–50.

44. E.g., Neil Brodie et al., *Stealing History: The Illicit Trade in Cultural Material* (Cambridge: McDonald Institute 2000); Neil Brodie et al., eds., *Trade in Illicit Antiquities: The Destruction of the World's Archaeological Heritage* (Cambridge: McDonald Institute, 2001); Simon Mackenzie, *Going, Going, Gone: Regulating the Market in Illicit Antiquities* (Leicester: Institute of Art and Law, 2005); Neil Brodie and David Gill, "Looting: An International View," in *Ethical Issues in Archeology,* ed. Larry J. Zimmerman et al. (Walnut Creek, Calif.: Altamira, 2003), 31–44; Julie Hollowell-Zimmer, "Digging in the Dirt—Ethics and 'Low-End Looting,'" in *Ethical Issues in Archeology,* 45–56; Patrick J. O'Keefe, *Trade in Antiquities: Reducing Destruction and Theft* (London: Archetype Publications, 1997); Brodie, *Stealing History;* Giles Constable, "The Looting of Ancient Sites and the Illicit Trade in Works of Art," *Journal of Field Archaeology* 10.4 (1983); Colin Renfrew, *Loot, Legitimacy and Ownership: The Ethical Crisis in Archaeology* (London: Duckworth, 2000).

45. For the Medici case, see Watson and Todeschini, *The Medici Conspiracy.* The Getty Museum's acquisitions policy, revised in 2006, is available at http://www.getty.edu/about/governance/policies.html; the Metropolitan Museum's collections management policy, revised in 2008, is available at http://www.met museum.org/about-the-museum/collections-management-policy.

CHAPTER 8. COLLECTORS' FAILED JUSTIFICATIONS
FOR LOOTING AND SMUGGLING

1. Cassiodorus *Variae* 4.34.

2. W. Cavendish (attr.), *Horae Subsecivae* (1620), quoted in Scott, *Pleasures of Antiquity*, 2–3. Similarly, Giacomo Martorelli describes an oversupply of ancient vases in a letter written from Naples in 1748: "You can have all the vases in Naples in the palaces of gentlemen and the houses of citizens, and also in peasant hovels, not to mention the libraries of monks who appreciate them even less than kitchen pots. Your grace cannot imagine what a pile of such vases there are in Calvi . . . [and] in Naples, there is no manner of person of however common a station who does not have vases for decoration. The same goes for Nola." Quoted in Claire Lyons, "The Neapolitan Context of Hamilton's Antiquities Collections," *Journal of the History of Collections* 9 (1997), 233.

3. Quoted in Scott, *Pleasures of Antiquity*, 219.

4. Grace Glueck, "Art Collector Finds Lore in Fragments," *New York Times*, December 17, 1975.

5. Letter of Fra Sabba da Castiglione to Isabella d'Este, undated, quoted and translated by Christian, *Empire without End*, 195.

6. Henry Peacham, *The Compleat Gentleman* (1622), quoted in Scott, *Pleasures of Antiquity*, 91.

7. Berry, *Numismatic Biography*, 9.

8. Quoted in Hunt and Smith, "Lord Elgin and His Collection," 182.

9. Quoted and translated in Constantine, *Early Greek Travellers and the Hellenic Ideal*, 12.

10. Quoted in Hunt and Smith, "Lord Elgin and His Collection," 183. For another story of a modern Greek refusing to sell an antiquity because of its medical value, see Joan Evans, *Time and Chance: The Story of Arthur Evans and His Forebears* (London: Longmans, Green, 1943), 317, describing the archeologist Arthur Evans trying to buy ancient engraved gems in Crete in the late nineteenth century but often failing, since they were regarded as "milk stones"— amulets for nursing mothers: "The woman only pointed to a small bairn and declared that if she parted with the stone it would die for want of nourishment."

11. Pierre Gilles, *The Antiquities of Constantinople*, trans. John Ball (1729; 2nd ed., New York: Italica, 1988), 221.

12. Pierre Jean Grosley, *Observations sur l'Italie et sur les Italiens* (1770), quoted and translated in Haskell and Penny, *Taste and the Antique*, 45.

13. Michel de Montaigne, "De la vanité" (1580), translated and quoted in Haskell and Penny, *Taste and the Antique,* 45.

14. William Suddaby, March 8, 2009, review of *Who Owns Objects?: The Ethics and Politics of Collecting Cultural Artefacts,* Amazon.com, http://www .amazon.com/review/R2IIVNUCBAEPNW/ref=cm_cr_rdp_perm.

15. Elie Borowski, introduction, in *Seals and Sealing in the Ancient Near East: Proceedings of the Symposium Held on September 2, 1993, Jerusalem, Israel,* ed. Joan Goodnick Westenholz (Jerusalem: Bible Lands Museum Jerusalem, 1995), 11.

16. Elie Borowski, "The Development of the Glass Collection," in *Reflections in Ancient Glass from the Borowski Collection,* ed. Robert Steven Bianchi et al. (Mainz: P. von Zabern, 2002), 3.

17. Elie Borowski, preface, in *Glories of Ancient Greece: Vases and Jewelry from the Borowski Collection,* ed. G. Max Bernheimer et al. (Jerusalem: Bible Lands Museum Jerusalem, 2001), 5.

18. Elie Borowski, introduction, in *Seals and Sealing in the Ancient Near East,* 17.

19. Jason Felch and Ralph Frammolino, *Chasing Aphrodite: The Hunt for Looted Antiquities at the World's Richest Museum* (Boston: Houghton Mifflin Harcourt, 2011), 151.

20. Doug Struck, "Museum Brings Wealth of Controversy to Israel; Theft Encouraged, Archaeologists Say," *Baltimore Sun,* May 11, 1992.

21. Oval Sarcophagus of T. Flabius Hermetes, Angelicoussis, *Holkham Collection of Classical Sculptures,* 150.

22. Michaelis, *Ancient Marbles in Great Britain,* 38.

CHAPTER 9. CONCLUSION

1. For Pomerance, see Joseph W. Shaw. "Leon Pomerance, 1907–1988," *American Journal of Archaeology* 93.3 (1989), 459–60; transcript of an interview with Leon Pomerance conducted by Dorothy Horowitz, September 13, 1984, New York Public Library, Corot Jewish Division, Oral Histories, box 228, no. 1.

2. Transcript of an interview with Leon Pomerance, 26.

3. Ibid., 27.

4. Ibid., 42.

5. Ibid.

6. Ibid.

7. Ibid., 43.

8. Ibid., 65.

9. Ibid., 45.

10. David Ake Sensabaugh and Susan B. Matheson, "Ada Small Moore: Collector and Patron," *Yale University Art Gallery Bulletin* (2002), 30–49.

11. Chippindale and Gill, "Material Consequences of Contemporary Classical Collecting."

12. Randall White, quoted in Robin Pogrebin, "$200 Million Gift Prompts a Debate over Antiquities," *New York Times,* April 1, 2006.

13. Jack L. Davis, quoted in ibid.

14. Ibid.

15. Getty, *Joys of Collecting,* 21.

16. Ibid.

17. "The Italian Ministry of Culture and the J. Paul Getty Museum Sign Agreement in Rome," Getty Trust press release, August 1, 2007; "Ministry of Culture for the Hellenic Republic and J. Paul Getty Museum Sign Agreement Finalizing Return of Objects to Greece," Getty Trust press release, February 7, 2007; Felch and Frammolino, *Chasing Aphrodite.*

18. Zacharias Conrad von Uffenbach, quoted and translated in W. H. Quarrell and William James Chance Quarrell, *Oxford in 1710: From the Travels of Zacharias Conrad von Uffenbach* (Oxford: Blackwell, 1928), 31.

19. "Visit & Contact," http://morgantina.org/visit-contact/.

20. "Friends of Morgantina," http://morgantina.org/friends-of-morgantina/.

INDEX

Illustrations are indicated by "f" following page numbers.

Correggio, 28
Cottenham Relief, 125, 126*f*
Cowdry, Richard, 193n15
Cremona, 18
Crete: engraved gems from, 209n10; excavations of, 175
Cromwell, Oliver, 171
Cupid, 146–47
Curtius, 69
Cyriace, Octabia Pollitta, 170

Dalton, O. M., 195n35
Daphne (wife of Glaucus), 120
Darnley, Earl of, 135
David, Jacques-Louis, 74*f*, 75
dealers: in acquisition chain, 53, 65, 72–73, 111, 144; in ancient Rome, 10; British dealers in Rome (eighteenth century), 36; cultivating clients, 65, 132; Getty's reliance on, 121–22, 178, 202n37; lowering value by fake restorations or alterations, 150–51, 156; and papal authorities, 148–49; secrecy of, 156. *See also* forgeries; Hamilton, Gavin; Jenkins, Thomas
dedications of artworks to gods, 8–9
Del Drago collection, 80
della Rovere, Giuliano (cardinal), 142
Denman, Gilbert M., Jr., 202n33
Dentatus, M. Curius, 7–8
Dewing, Arthur Stone, 105
Dido, 102, 102*f*
Diomedes, 52–53, 54*f*
Dionysus, 51, 96, 133
Dioscorides/"Dioskourides," 66, 72
Discobolus, 52–53, 54–55*f*
Dodwell, Edward, 154
Donatello, 144
Dorset, Duke of, 135
Dürer, 28
Dying Seneca, 56, 57*f*

eBay.com, 177
Egypt: ancient coins from, 162; idols from Temple of Isis (Memphis), 184–85n23; looting opportunities in, 158; Ptolemies in, 6; Temple of Tyche (Alexandria), 14
Elements of Art (Shee), 86

Eleusis excavations, 152
Elgin, seventh Earl of (Thomas Bruce) and Elgin marbles, 151–53, 165
Elizabeth I (queen), 27–28
Elizabeth (sister of Prince of Wales), 28
Elsner, John, 138
Emma. *See* Hamilton, Emma Hart
"The Emperor's Birthday" (Getty), 202n33
England: aristocracy as source for American purchases of antiquities, 122–27; Arundel as collector, 27–30, 32–36; Blundell's collection in, 40–47; classical education in, 36–37; early collecting of Roman and Greek antiquities in, 16, 27–37; English antiquities dealers in Rome (eighteenth century), 36; estate sales in, 43; friendship of collectors in, 133–34; Grand Tour collecting, 148–50, 188n30; Pembroke collection in, 67–71, 75–77, 85; portraits of elite in Roman garb in, 37; Roman antiquities found in, 127
English Civil War, 36
Engravings and Etchings of the Principal Statues, Busts, Bass-Reliefs, Sepulchral Monuments, Cinerary Urns, etc. in the Collection of Henry Blundell, Esq. at Ince, 42*f*, 46, 58, 134
Enlightenment, 95
Epicurus, 42, 133
Erickson, Ernest, 107
eroticism, 86–110, 183n3; archeologists vs. collectors' delight in antiquities, 108–9; and attachment to antiquities, 89, 92, 106–7; and communication between makers and collectors, 107–8; and contemporary collectors, 104–7; destruction of antiquities due to, 90–91; and Hamilton and Emma, 91–102, 93*f*, 99*f*, 104, 110; and Pompeii excavations, 90, 95; and Tiberius, 87–89; and touch, 105; and women compared to ancient statues, 89–90
d'Este, Isabella, 145–48, 162, 205n10
Etruscans, 7, 98–99
Eumenes, 5
Eumenes II, 5
Euphrosyne (empress), 15, 95

Getty, J. Paul (*continued*)
 and Lansdowne Hercules, 118–20, 119*f*,
 122–23; publications and opinions on col-
 lecting, 114–15, 118, 122, 202n33; purchas-
 ing artwork during Depression, 114–15;
 reconstructing and obtaining history
 for objects in his collection, 120–21, 125,
 128–29, 157, 178; on taxes, 122; on Venus
 torso, 121–22. *See also* Getty Villa; J. Paul
 Getty Museum
Getty Kouros, 63, 192n2
Getty Museum. *See* J. Paul Getty Museum
Getty Oil Company, 114, 123–24
Getty Villa, 116, 118, 120, 124, 201n20. *See also*
 J. Paul Getty Museum
Ghiberti, Lorenzo, 21–22
Gilles, Pierre, 165
Gillray, James, 102–3*f*
Giuliano da Sangallo, 142
Giustiniani, Vincenzo (Marchese), 28
Glaucus, 118–20
Glorious Revolution, 36
gods, dedication of seized images of, 8–9
Goethe, 89, 97–98, 100
Golden Gate of Constantinople, 31
Gonzaga, Federico, 145
Gonzaga, Ferdinando (duke of Mantua), 171
Gonzaga, Francesco (cardinal), 143
Gonzaga, Francesco II (marquess of Man-
 tua), 145
Graces: mirror with relief of, 80–81; sculp-
 ture of, 6
Grand Tour, 4, 34, 35–37, 41, 43, 50, 76, 97, 111,
 135, 148–50, 166, 188n30
Great Depression, 107, 114–15
Greece: Elgin procuring marbles from
 Parthenon, 151–52; Grand Tourists com-
 plaining about conditions in, 166; inde-
 pendence from Ottoman Empire, 154;
 locals refusing to part with antiquities,
 163; modern collectors in, 106; national
 ownership laws in, 155–56, 207n40
Greece, ancient: Arundel's collecting from,
 33–34; coins from, 162; demand for Greek
 artists in Rome, 10; Greeks collecting, 9;
 and Hellenistic kingdoms, 6; Ortiz col-
 lecting, 106–7; Pembroke collecting from,

69; and Pergamum, 5–6; re-creations of,
 11; Romans collecting, 7–13, 87, 184n4;
 vases (painted), 96. *See also* Acropolis
Greek War of Independence, 154
Gregorius, Magister, 15–17, 20, 21
Gregory the Great (pope), 15, 185n28
Gregory XV (pope), 56
Greville, Charles Francis, 93–95, 97, 199n36
Grummer, Frans, 136
Guerra, Giuseppe, 64
Guggenheim, Peggy, 90
Gulbenkian, Calouste, 132
Gustav III (king of Sweden), 50
Gustavus Adolphus (king of Sweden), 77–78

Hackert, Philip, 98
Hadrian (emperor), 3, 122–23
Hadrian VI (pope), 90
Hamilton, Emma Hart, 92–102, 93*f*, 99*f*, 104,
 110, 198n34
Hamilton, Gavin, 36, 52–53, 65–66, 135,
 150–51
Hamilton, William, 91–92, 94–104, 109–10,
 173, 194n27, 197n16, 198nn26–27, 206n28
d'Hancarville, Baron, 141
Hardouin, Jean, 192n3
Harriet Pomerance Fellowship, 175
Hart, Emma. *See* Hamilton, Emma Hart
Harvard University's Shelby White–Leon
 Levy Program for Archaeological Publi-
 cations, 176
Hearst, William Randolph, 112, 123
Helbig, Wolfgang, 155
Hellenistic kingdoms, 6–7
Henry VIII (king), 27–28
Henry (bishop of Winchester), 16–17
Henry Frederick (elector), 28
Herakles. *See* Lansdowne Hercules
Herbert, Thomas. *See* Pembroke, eighth
 Earl of
Herculaneum, 61, 64, 95–96, 98, 100, 118,
 191n44
Hercules, 19. *See also* Lansdowne Hercules
Hercules of Lysippos (statue), 15, 184n12
Hermaphrodite, 40, 41–42*f*, 44, 62, 133
Hermaphroditus, 40, 56
Hermetes, T. Flavius, 170

Hertford, third Marquess of (Seymour-
Conway, Francis Charles), 170
Hippocrene Fountain, 82
hoarder-collectors, 111
Hobhouse, John, 154
Holbech, William, 59
Holbein, Hans, 29
Holkham Hall, 51, 58, 60, 170, 191n38
Holland, Lady, 198n34
Homer, 72
Hope collection, 68–71
Horace, 71
Howard, Catherine, 27–28
Howard, Henry (fourth Earl of Carlisle),
194n31
Howard, Thomas. *See* Arundel, Earl of
humanism, 106
hypocrisy of collecting, 23

identities of antiquities, changes to. *See*
restoration
identities of collectors, 23–37, 62; bovattieri,
23–26, 112; change of identity enabled by
collecting, 112; connection to republican
Rome, 76; crafting public identity through
use of art, 186n1; creating through forg-
eries, 77; and masculinity, 124–25. *See also*
collectors and collecting: self-perceptions
of collectors
idolatry, 13–19, 21–22
imported antiquities preferred over local
antiquities, 27
Ince Blundell Hall, 45
Innocent VII (pope), 148
Inquisition, 35
inscriptions, 70–71, 73, 193–94n25, 194n28
Internal Revenue Service, 122
interpretation of antiquity, 26
The Intervention of the Sabine Women
(David), 74f, 75
Iphegenia, 95
Iraq, looting in, 158
Isis, 20, 46
Isis-Fortuna, 60
Italy: Arundel's collecting from, 28, 33, 34;
Blundell's collecting from, 42–43; English
suspicions of travelers to, 34–35; gem

carvers in, 75; Grand Tour including, 35, 37;
Grand Tourists complaining about condi-
tions in, 166; Leicester's collecting from, 58;
national ownership laws in, 155–56, 207n40;
painted vases from, 96; restoration skills in,
50; return of antiquities to, 176; unification
of, 154. *See also* Rome, ancient

Jackson, Andrew, 113
Jack the monkey, 91–92, 101
James I (king), 28, 29, 32–33, 35
Jefferson, Thomas, 89
Jenkins, Thomas, 36, 42–43, 46, 47, 135,
194n25
"A Journey from Corinth" (Getty), 118
The Joys of Collecting (Getty), 115
J. Paul Getty Museum, 123, 128, 129, 178,
201n20, 208n45
Julius II (pope), 142
Julius Caesar, 7, 49, 120
Juno, 15, 89
Jupiter, 9, 19, 66

Kapaneus, 72, 73f, 75
Kauffman, Angelica, 99f
Kedleston Hall, 170
Kennedy, J., 193n15
Kensington, 34
Kingdom of Naples. *See* Naples
Knidos. *See* Aphrodite of Knidos

Lambeth, 34
Lands of the Bible Archeology Foundation, 169
Lansdowne, Marquess of, 118, 122
Lansdowne collection, 122, 202n33
Lansdowne *Discobolus*, 52–53, 54f
Lansdowne Hercules, 118–20, 119f, 122–23
Lanti Vase, 151
Leda, 81–82
Leicester, Earl of, 58, 60, 151
Levy, Leon, 112, 132, 176–77
Livia (empress), 202n33
Livy, 8, 10, 36
Lombards, 18
looting and smuggling, 34, 140–59; arche-
ological value destroyed by, 158–59, 171;
and Elgin (Parthenon) marbles, 151–53;

Poniatowski, Stanislas (prince), 71–72, 74–77, 85, 195n35
Ponsonby, William, 40. *See also* Bessborough, second Earl of
Porcari family, 24
Portici Museum (Naples), 98
Poulsen, Frederik, 69
power: of antiquities, 17, 20–22; of English elite, 37
Prado Museum, 125, 196n50
Praeneste, 9
Praxiteles, 6, 64, 86
Pre-Columbian archeological sites, 158; Mayan objects at auction, 207n41
prehistoric European archeological sites, 158
Priam (of Troy), 30
Priapus, 64
private ownership of antiquities, movement to abolish, 173
Protestantism, 79; and Christina (queen of Sweden), 85
Ptolemies, 6
public vs. private collecting, 87
Publius Valerius Publicola, 24
Pygmalion, 86
Pyrrhic War, 7–8

Quintilian, 137
Quirini Diptych, 20

Raphael, 28
recommendations for ways to avoid looting and destruction, 173–74
religion: England, religious differences in, 34; fanaticism, 171; suspicions and destruction of "pagan" art, 13–19, 87, 184–85n23, 185n28. *See also specific religious groups*
Renaissance: collectors worried about uneducated looters in, 162; competitive collecting during, 137; early period of, 15, 16, 18; restorations in, 55–56; value of antiquities increasing during, 147
replicas, production of, 179. *See also* forgeries
restoration, 27, 38–62, 172; beliefs of owners, effect of, 62; Blundell's Hermaphrodite and collection, 40–47, 62, 133; Cavaceppi's

workshop, 50–53, 150; change of identities in, 52; Christina's (queen of Sweden) collection, 82, 125, 196n50; complicity of collectors, dealers, and restorers, 53–54; contemporary standards of, 39, 59; display considerations as a driving force for, 58–59; eyes of statues, 38; false restoration to lower customs duties, 150, 155; of frescoes, 60–62; hair of statuary, 44; Ludovisi collection, 56; marble statuary, 38–39, 44; moralistic manipulation as part of, 45; removal of portions from works, 56–58; from Renaissance through nineteenth century, 39–49; techniques of eighteenth century, 44; testing marble to determine, 60; uncertainty in, 45–47, 60
Revett, Nicholas, 152
Richard, Duke of Buckingham and Chandos, 170
Ridley, Matthew White, 64
Ristoro d'Arezzo, 17
Roe, Thomas, 29–33, 76
Romagna, Duke of, 146
Roman Empire. *See* Rome, ancient
Roman Forum, 28, 36
Romano, Gian Cristoforo, 146
Roman Senate, 37
Rome: abundance of antiquities in, 160–61; appearance of, in 1440s, 25; Arundel's visit to, 28; Blundell's visit to, 42; Cardinal Ottoboni's collection in, 73; Christina (queen of Sweden) in, 79–80; Cosimo III moving antiquities from, 147; elites in fourteenth century in, 23; Grand Tour including, 35; Holy Roman emperor's revival of imperial power of, 18; Ludovisi collection in, 56; de' Medici (Lorenzino) damaging antiquities in, 131; Middleton's visit to, 113, 140; regulation of antiquities sales, 147–48; restorers in, 55, 149
Rome, ancient: American relationship with, 112, 189n37; Attalid alliance with, 5–7; bath complexes, artwork in, 88; as bedrock of Western civilization, 166–67; Christian views of art of, 15–19; collecting antiquities in, 7–13, 137, 184n4; English emulation of, 37; first culture with private collecting,